ROY H. KRUSE 10/89

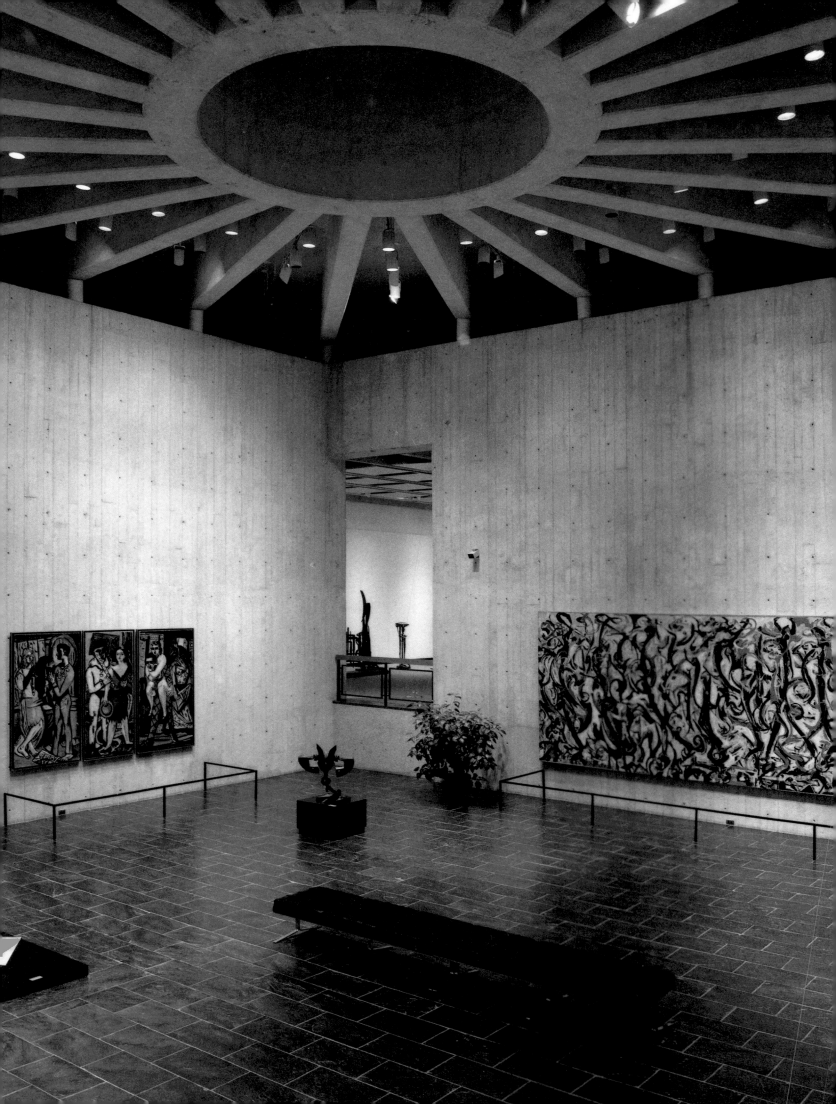

THE UNIVERSITY OF IOWA
MUSEUM OF ART

101 Masterworks · With introduction and essays by Robert Hobbs

Iowa City, Iowa 1986

Page 2: Sculpture Court, The University of Iowa Museum of Art, Max Abramovitz, architect, 1968

Printed in Japan.

Published on the occasion of the exhibition *101 Masterworks*, April–August 1986, at The University of Iowa Museum of Art, Iowa City.

Production of the catalogue *The University of Iowa Museum of Art: 101 Masterworks* was made possible by the generous support of The Friends of the Museum and the 1984 Art à la Carte Auction.

Library of Congress no. 85-51718
ISBN 0-87414-040-4

First Edition

LIBRARY OF CONGRESS CATALOGING-
IN-PUBLICATION DATA
University of Iowa. Museum of Art.
The University of Iowa Museum of Art.
Catalog of an exhibition.
Includes index.
1. Art—Exhibitions. 2. University of Iowa.
Museum of Art—Exhibitions. I. Hobbs, Robert
Carleton, 1946– . II. Title.
N582.I58A66 1986 708.177'655 85-51718
ISBN 0-87414-040-4

Contents

Acknowledgments

The primary purpose of this book is to provide material for pure enjoyment. It would require pages merely to list the names of all those who have contributed significantly to the growth of the Museum, and those who have helped would surely prefer that these pages be reserved for pictures.

Acknowledgments must be, for the most part, categorical. First, I would like to thank all the collectors who have wished to share their treasures with the public and who have believed that art contributes significantly to the liberal education of students and to the greater understanding of us all. People involved in the Museum of Art have been remarkable both for their generosity and for their recognition that although art can be privately enjoyed, it is ultimately a public resource. The Museum of Art was established as the result of a challenge by Owen N. and Leone Elliott of Cedar Rapids, Iowa, who offered the University their collection if a suitable space were built to house it. The magnitude of their gift can be measured by the fact that one-third of the masterworks contained in this book comes from their collection. And their generosity was matched fifteen years later by C. Maxwell and Elizabeth Stanley, of Muscatine, Iowa, who have given a magnificent collection of African sculpture that is merely hinted at in this volume and more fully represented in Christopher D. Roy's series of catalogues on the Stanley Collection.

Second, I would like to thank the past and present staff of the Museum of Art, who have believed in quality and who have nurtured and developed the Museum's collection. Deserving special recognition is Ulfert Wilke, founding director of the Museum of Art, who has a discerning eye for quality and a wonderful ability to persuade others to share his enthusiasms. Present staff members who have contributed significantly to this exhibition and catalogue, the production of which has taken many months of thought and consideration, include the following, all of whom deserve special thanks: Jo-Ann Conklin, for great patience and attention to detail in helping to assemble the list of works and for overseeing the photography; Nancy DeDakis, for helping with the final stages of production; David Dennis, for sensitively staging the exhibition so that the inherent quality of each work of art is emphasized; Honee Hess, for her thoughtful contribution in the early process of developing the catalogue; James Lindell, for assisting in all stages of the installation; Joann Moser, for overseeing the initial steps of assembling a list of the Museum's masterworks; and Jean Schroeder, for continuous optimism and for her insights into the relative quality of many of the works included in the catalogue.

Gail Parson Zlatnik has served as research assistant and copyeditor for this project; her dedication has been greatly valued, and her excellent help has been essential to the completion of this catalogue. I also wish to thank J. G. Bell, Ann Walston, and Joyce Kachergis, all of whom have significantly contributed to this book's editing, design, and final production. And I am grateful to Dee Eaker, Robert Fellows, and Fredrick Woodard for their careful reading of the introduction.

Among those who have provided special assistance and expertise in the compilation of the catalogue are Keith Achepohl, Ida Bader, Wayne Begley, Charles Cuttler, Richard DePuma, John Fix, Helen Haroutunian, Linda Hartigan, Rudolf Kuenzli, Alastair Macdonald, Nancy Purington, Ann Roberts, Harlan Sifford, and Michael Willis, and typists Eva Huber, Linda Walshire, and William Yock.

Special thanks are due Professor Christopher D. Roy, Adjunct Curator of African Art, for writing the catalogue entries for the African and Peruvian masterworks, thereby providing insight into their function as well as their aesthetic merits.

It has been a pleasure to rely on the expertise of Iowa City photographer C. Randall Tosh for the color photography, and on the sensitivity of student photographers Steven Tatum and Mark Tade for the black-and-white images.

This survey of masterworks would be far less rich were it not for an astute School of Art and Art History faculty that felt the need in the 1940s and 1950s to acquire a number of adventuresome and provocative works of art that became part of the Museum's collection in 1968 when it was formed. Among these works were Miró's *Rosalie*, Beckmann's *Karneval*, and Hartley's *E*. The faculty of that period established a tradition for acquiring works of art that challenge current assumptions of good taste—a tradition that fortunately places emphasis on quality rather than merely on representation of a particular style. Frank Seiberling, who was head of the School of Art and Art History in 1968, encouraged the Museum to become a resource for the entire University and the State of Iowa.

In 1983 the Museum's Friends Development Council organized the benefit auction "Art à la Carte," which provided monies for this publication. The members of the committee for this project were Buffie Tucker and Marcia Nagle, General Chairpersons; Andrea Balmer, Margaret Bevers, Alice Bowers, Miriam Canter, Mary Cilek, Jo-Ann Conklin, Marjorie Day, Nancy DeDakis, Dorothy Durrenberger, Ann Feddersen, Dot Gay, Becky Gelman, Gloria Gelman, Susann Hamdorf, Shirley Harrison, Honee Hess, Mary Ann Kainlauri, Maureen Keough, Tom Keough, Trish Koza, Mary Lea Kruse, Loretta LaVelle, Herb

Lyman, Mary Lyman, Kathy Moyers, Anne Perkins, Helen Phelan, Ellen Ramsey, Mary Frances Ramsey, Patty Rossmann, Jane Rowat, Elsie Sakuma, Betty Savage, Russ Schmeiser, Bob Sierk, Harlan Sifford, Micki Soldofsky, Marlene Stanford, and Joyce Summerwill. On behalf of the Museum of Art, I wish to thank them all. Their contributions make it clear that art museums are concerned with people as well as objects and the two joined together form a vital, living culture.

In addition I wish to thank Darrell Wyrick, President of The University of Iowa Foundation, and the Foundation staff, who have consistently supported the Museum and its programs. It is thanks to them that the catalogue contains two recently acquired masterworks, Hannah Höch's *Sperrende Kräfte* and Grant Wood's *Plaid Sweater*.

Final responsibility for this book and its contents must remain with me. Deciding which works to incorporate into the book and exhibition was not easy; there are so many wonderful works in the collection that a number of impressive exhibitions could be organized. Putting together this exhibition and catalogue has been a great pleasure and a tremendous learning experience. It has provided me many delightful hours of concentrated looking, and it has made me even more appreciative of the generosity of all those who have willingly shared their works of art with others. Many of these people have reiterated to me their belief that art in the public domain helps enormously to strengthen a culture by providing it with believable and enduring images of itself. I hope this book will help to further their goals.

ROBERT HOBBS

Introduction: Telling Fragments

This catalogue of 101 masterworks from the permanent collection of The University of Iowa Museum of Art is an attempt to put a museum between covers, so that its most important works of art become an occasion for examining the meaning of a masterwork in our culture and for understanding the role that significant art should play in museums in the future.

Because there are distinct limits to the art now available in private collections and on the market, museums need to rethink their role. No longer can relatively new institutions hope to form encyclopedic collections to demonstrate the course art has taken through the ages. The phrase "filling in the gaps in the collection," though it is still being used, is misdirected. An art museum is not a natural history museum, and it should not try to account for the equivalent of phylum, class, order, genus, species.

A work of art is a special revelation. It is an act of faith by someone who is trying to define the way reality feels at a specific moment. And a great work of art is an even more courageous act, because the artist is attempting not only to discern the felt tone of his or her time, but to heighten the reality of that time by projecting an intuitive feeling for what life can become and especially what it can feel like.

People have always laughed and cried, dreamed and fought and loved, but the manner in which they have done so changes over time. Early-twentieth-century jokes, for example, express a distinctly different orientation toward the world from our own. Humor can be ribald, slapstick, black, ironic, or deadpan. And even though each era manifests all types of humor to some degree, there is usually one kind of joke that best recreates the feeling of an entire time and place—and what is true for humor is also true for art. A great work of art is a telling fragment.

A telling fragment is a piece of history, taken out of time and placed on the walls of a museum where it can also be regarded as decorative and universally relevant. Such remnants can be merely beautiful, or they can become magical devices for making significant journeys. Every truly important work of art is capable of choreographing the action of its beholder in some specific way. A Schongauer print (p. 165) demands concentration and scrutiny of every detail; it makes looking a dedicated act. In contrast, Degas's etching of Mary Cassatt (p. 145), while seeming to require close examination, in fact provides the viewer with a carefully constructed casual glance and nothing more, thus placing the serious observer in the position of a disinterested spectator. Max Beckmann's *Karneval* (p. 55) forces the viewer to step back and consider its three panels as a modern-dress version of a religious scene. It plays on contradictory assumptions about art: art as sacred and formal, but also as secular and intimate.

The Irving Penn photograph (p. 137) also implies contradictory forms of orientation: the overall image is aggrandized and presented in the closed world of high fashion with which Penn is familiar, while the subject—a New Guinea tribesman—is extracted from another and entirely different closed world. Taken out of his natural environment, the New Guinea tribesman in Penn's photograph forces us to analyze how we see and how vision can be programmed. We look at another culture through the high-fashion lens of our own, and we experience discomfort as if something is not quite right. This forced examination of the social and cultural lens through which we see is an important aspect of art.

Looking at a work of art takes time. A few years ago the staff of The Metropolitan Museum of Art in New York City conducted a survey to find out exactly how much time people spent with a work of art. To their amazement they discovered that the average viewer took only three seconds for each piece, and part of that time was spent reading labels. Obviously, other art forms, such as music, theater, literature, and poetry, require more than a casual glance and an instant of recognition in order to reveal their contents. Works of art actually require far more time than most people are accustomed to spend with them.

Strangely enough, in the voluminous literature on art that has been published in the past few decades, there is little information about individual works of art except for the short-lived Art in Context series. Most information is what one might categorize as positivist: a description of what the viewer can already see, circumstantial evidence, and incidental biographical information. As a way of testing the amount of information available about individual works, I have assigned students the task of surveying the literature on one or another specific work of art. A student who examined Paul Gauguin's masterpiece *Nevermore* reported that she could find in the literature only a few paragraphs that dealt casually with the iconography of the work, and even that information was buttressed with anecdotes about Gauguin's search for a modern-day paradise. There was no mention of Edgar Allan Poe's poem *The Raven*, or of that poem's importance to the Symbolist movement in France, or of Baudelaire's and Mallarmé's fascination with Poe, or even of the strange details in the painting, which include a blackbird, a tapestry, background figures, and an anxious nude figure. Neither was there any analysis of the relationship of *Nevermore* to Gauguin's equally famous *Manao Tupapau* (The Spirit of the Dead Watches).

Art history has its place, but too many students of art history appear to be afraid of veering into criticism, and they remain content with pursuing verifiable information. It is also important, I think, to expand our knowledge of what art is, how it functions in the world, what systems of value it assumes, and how it coaxes us and at times maneuvers us so that we become a specific type of viewer—an intimate or a voyeur, a judge or sometimes an initiate into a new concept of reality.

It is not enough that museums now provide viewers with descriptive labels that recount the myths, biblical tales, and historic events that many works of art commemorate. Although that is a good beginning, such an approach can become absolutist because it assumes that looking at a work of art is merely a process of recognition and a confirmation of known facts and established perceptions. Such an approach provides little room for thought, for questioning the possible meanings of art.

Labels containing only a description of the art object are important as identifiers, but insofar as they seem to speak for the work of art they are also problematic. Of the three seconds that the average viewer spends looking at an individual work, the label takes at least one second and sometimes two. Speaking the high-tech language of information science, of cold type, and of unquestioned authority, the labels in our museums answer the most obvious questions and, just as important, help to forestall less obvious but more interesting ones.

To counteract this undisputed authority of museum labels, the Belgian artist Marcel Broodthaers created a work of art in the form of an exhibition that included images of eagles used in art from ancient times. In his *Museum*, which was exhibited at the Städtische Kunsthalle of Düsseldorf in 1972, Broodthaers's "Section des figures" was entitled *The Eagle from the Oligocene to the Present Day*. The label for each object stated in English, German, and French, "This is not a work of art," to indicate that art is part of a symbolic structure and not just an isolated object. The eagles were divided into obvious, logical categories, such as stuffed eagles, eagles on coats of arms, and eagles on labels of wine bottles or match boxes. Broodthaers's point was that a work of art can never truly be an isolated masterpiece; that it is always a telling fragment.

A work of art is an auto-focusing lens that alters one's way of seeing it. One may have to assume genius in order to find genius, to relax and let the work divulge its meaning. To look at the Jackson Pollock *Mural* (pp. 116–17), it is necessary to stand close to the painting and be surrounded by the apocalyptic environment it creates. To come to terms with Robert Michel's sensibility (p. 43) is to understand how people once needed to believe in the idea of technological progress. And to comprehend Motherwell's *Elegy* (pp. 106-7), one has to recognize that abstract tensions between yielding

organic forms and implacable verticals can become Rorschachs, emblematic of the unresolved tensions of the Cold War. Looking can be rational and analytic; it can also be discomforting and emotional.

Important works of art do not simply reflect life; they invent it. They contain within themselves deep understandings of reality and ways of dealing with conflict. Works of art often are capable of keeping contradictions in suspension, placing them on an ideal plane so that one can perceive conflict as a natural part of life. Hannah Höch's *Sperrende Kräfte* (p. 83) plays with contradictions between organic and machine-like forms, between real individuals and their personas, and between middle-class virtues and artistic license. Certainly alienation existed before the twentieth century, but in this painting Höch gives alienation a new meaning and force. She presents herself in the guise of a many-breasted Greek goddess whose hands become struggling thoughts, thoughts that take the form of blossoms attempting to free her from the domination of her lover and mentor Raoul Hausmann, and she presents their child as part toy and part human, a distinct individual and a new creation. Enslaved by her thoughts, Höch is alienated from her lover and cut off from her child.

Painted in 1929, when Germany was suffering from severe economic and political crises, *Sperrende Kräfte* creates a personal image that gives form to this bitter period. And since it is a painting by an artist who once rejected painting—the art of the bourgeoisie—in favor of photomontage, it is a surprising reversal and an acquiescence to the need for tradition and constancy in a world ruled by perpetual change.

A fragment from a particular moment in time, *Sperrende Kräfte* indicates the conflicts between tradition and the future, and in the process it personalizes the dilemma so that one can see how these tensions affected one sensitive person living at a specific time. Höch and Hausmann are symbolic of the painful game life can become, and in particular of the way genuine feelings can seem to be a series of mechanical acts performed by people who are reduced to being somehow less than fully human.

Just as some African masks serve the important function of providing dead ancestors an entry into the world, so Western art reveals aspects of our spiritual world to ourselves. Art is a mask that unveils reality; it is a conduit through which we can feel—if we are willing to take the chance—the way someone else has felt. It is a mask that we wear when we wish truly to understand what it is like to see as another sees.

Although art is always enriching, it is not always uplifting. To see with the eyes of Pollock, Degas, or Höch is to see profoundly, but also to see at times negatively and despondently. The beauty of these artists' work is to be found in their acceptance of humanity and their refusal to gloss over what they perceived as reality. What makes their art beautiful is the truth and perspicacity of their

vision rather than the richness of their colors and the harmony of their compositions. Their art functions as an emotional/intellectual thermometer of their time; it is useful as an instrument of truth, and its beauty depends on its faithfulness to a specific vision. Beauty is not the goal of art. It is only the captivating force that causes one to look, that entices one to understand and to come to terms with truth.

The most telling fragment is a masterwork. "Masterwork" is a more conservative term than "masterpiece." The former emphasizes technique, art as the embodiment of a craft; the latter emphasizes art as an object. Both terms derive from the medieval guild tradition in which a male child was apprenticed to a guild member and learned his craft in that member's workshop. After years of practical experience and increasing responsibility, the apprentice became a journeyman and then a master if he was able to create a "master's work," a piece of such consummate style, grace, and technique that guild members could accept it without question as exemplary of their trade. Since the late fifteenth century, when Leonardo da Vinci raised art to the level of other humanistic studies, "art" has connoted manual dexterity as well as artistic thought.

In this catalogue the traditional term "masterwork" signals an emphasis on outstanding quality and a masterly control of the techniques of making a work of art, including a command of the thought process that ensures a work of art's originality and its pertinence to a particular time.

It also conveys the continuity of quality through time, or more precisely the continuity of significant sensibilities. In its emphasis on masterworks as telling fragments The University of Iowa Museum of Art is more like a Great Books series than an encyclopedia, more an affirmation of quality in thought and technique than a simple grouping of artistic objects. The telling fragments in this Mu-

seum's collection contain in embryo the temper of distinct times and places, and they can communicate these felt qualities to people who take the time to look.

The brief essays accompanying the plates in this book are intended to provide a peripatetic view of The University of Iowa Museum of Art. Although the 101 works are grouped first by broad cultural areas, then by medium, and finally alphabetically by the artist's name for easy reference, this catalogue is intended to be savored at will, not read methodically from cover to cover. It is in the nature of an informal tour through the Museum's collection. The essays offer no absolute meanings, let alone theories, but rather suggest possible ways of approaching these particular works of art. They do not grant the artist total control over the work of art, including its meaning; rather they assume that creation involves both the conscious and the unconscious mind, that the work represents an act of faith rather than pure cognition, and that the meaning of imagery may not be consciously understood even by the artist at the outset. Artists create art, but society creates culture. And meaning is a collaborative effort that involves the artist but also involves development over time in a cultural context.

Although a work may allow for all kinds of possible interpretations, it is not a Rosetta Stone ready to be translated. Interpretation is a more creative endeavor than translation; it requires meditation on an artist's act of faith, on the meaning of the dream the artist has dreamed for us. Dreaming is an inventive process, as is the interpretation of dreams. In both endeavors one senses reality: feeling and thought are inextricably aligned. Yet interpretations are more questions than statements, more a plumbing of reality for meaning than an assertion of fact. Interpretation is culture made manifest; it is a significant aspect of the social contract or dialogue that constitutes the meaning of life.

In the catalogue that follows, dimensions are given in inches and centimeters (in parentheses); height precedes width and depth. Titles are in roman type; alternative titles in parentheses; and translations, descriptive titles, and original-language designations in brackets.

THE ANCIENT WORLD

Etruria

Persia

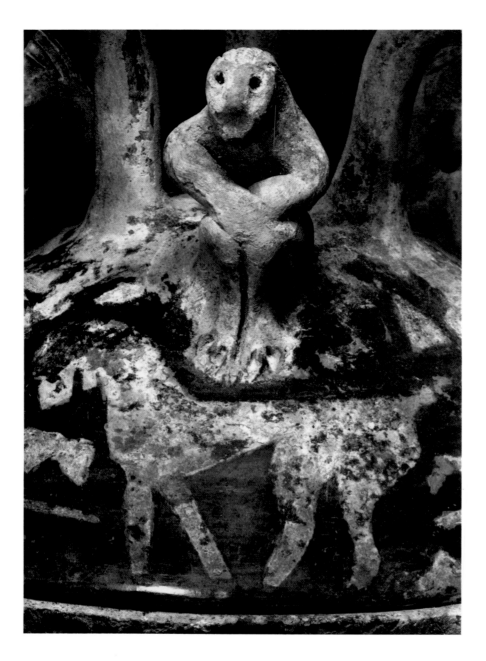

Etruria
Cerveteri

Vessel *7th century* B.C.
[*pyxis*]
*Impasto ceramic, 9⅜ × 7 diam. (23.8 × 17.8)
(with cover)*
Museum purchase, 1973.166a,b

It is likely that this *pyxis* was a tomb gift used to store food for the deceased. According to Professor Richard DePuma of the School of Art and Art History, there are only three extant examples similar to this compote: two in the Chiusi Museum (in the area from which this object probably came) and a lid in the Villa Giulia in Rome. The decoration of this piece is unusual in its use of sculpted human figures and in the way that the three handles are fashioned from loops of clay. The object was originally decorated with glued-on metal laminates, and the traces of mastic that remain reveal ghost images of meanders, chevrons, and horses.

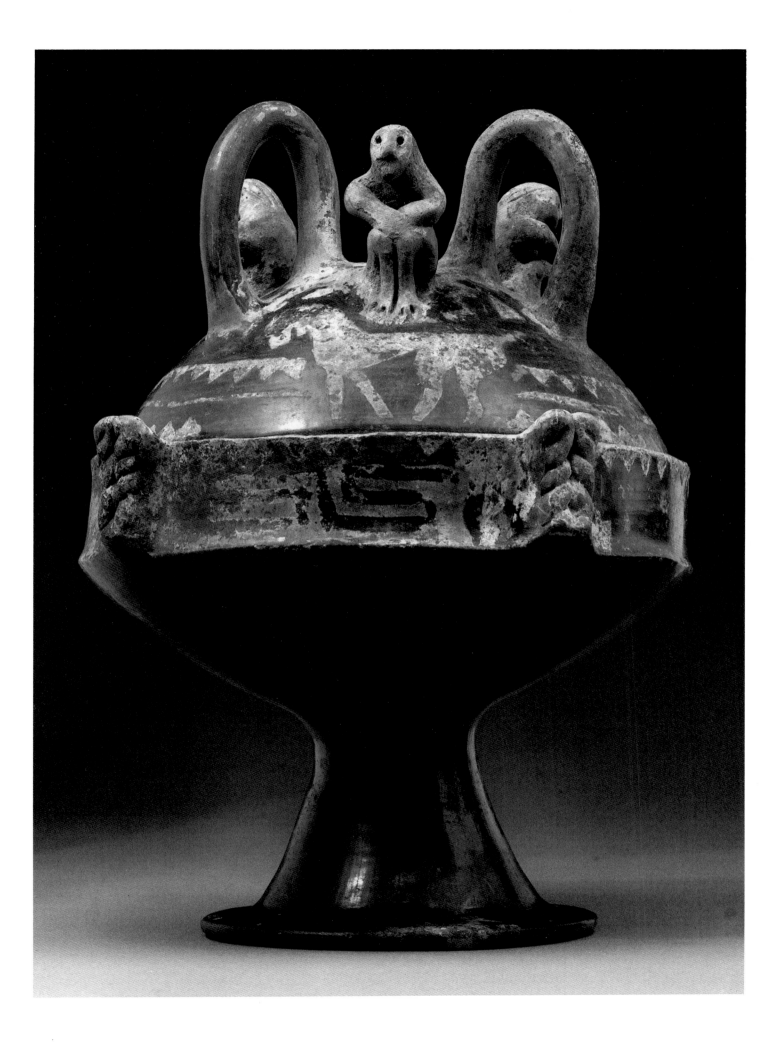

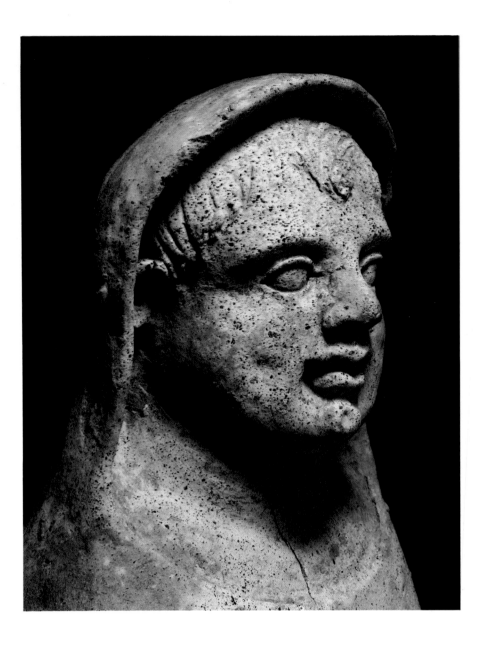

Etruria
Tarquinia

Votive offering 3rd–2nd century B.C.
[*bambino in fasce*]
Terra-cotta, 32⅜ × 9 3/16 (82.2 × 23.3)
Museum purchase, 1973.241

Believing that the gods intervene directly in the affairs of humankind, the Etruscans made offerings to their gods to thank them and to request their intervention. When votive offerings in the form of infants were deposited in temples, they generally represented a desire to bear children or a wish to have an infant safeguarded.

As Etruscan art developed, it became increasingly naturalistic. The Iowa *bambino* represents a late state of Etruscan votive art in which careful depiction of details such as dimples, fleshy cheeks, protruding ears, open mouth, and deep-set eyes became increasingly important. Although the physiognomy of this child is naturalistic, its original red coloring made it appear abstract. In Etruria the heads of male figures were painted red, those of female figures a creamy white.

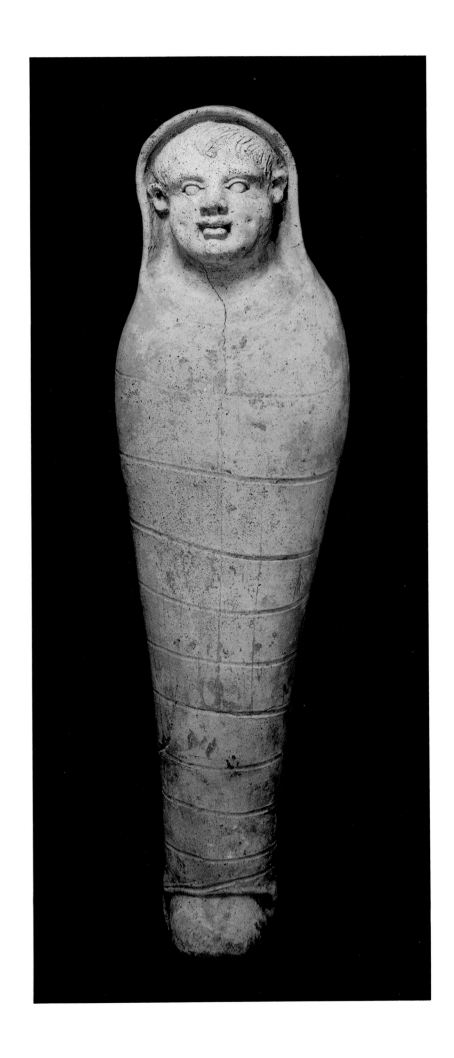

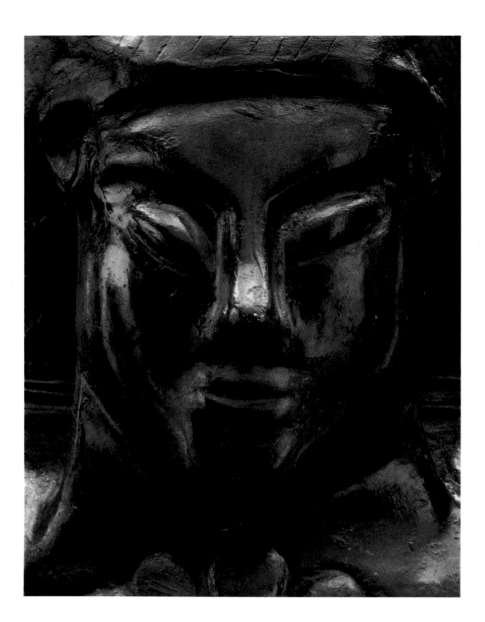

Etruria
Vulci

Vessel *6th century* B.C.
[Column krater]
Bucchero pesante ceramic,
15¾ × 17 diam. (40.0 × 43.2)
Museum purchase, 1970.57

This Etruscan column krater is modeled in high relief with depictions of two different masks alternating between the handles and supporting the rim in the manner of a column. This vessel would have been used to hold a mixture of wine and water at Etruscan drinking parties (*symposia*). One person would be appointed the overseer of the wine-water proportions: water was always mixed with wine, and the proportion determined the seriousness of the event.

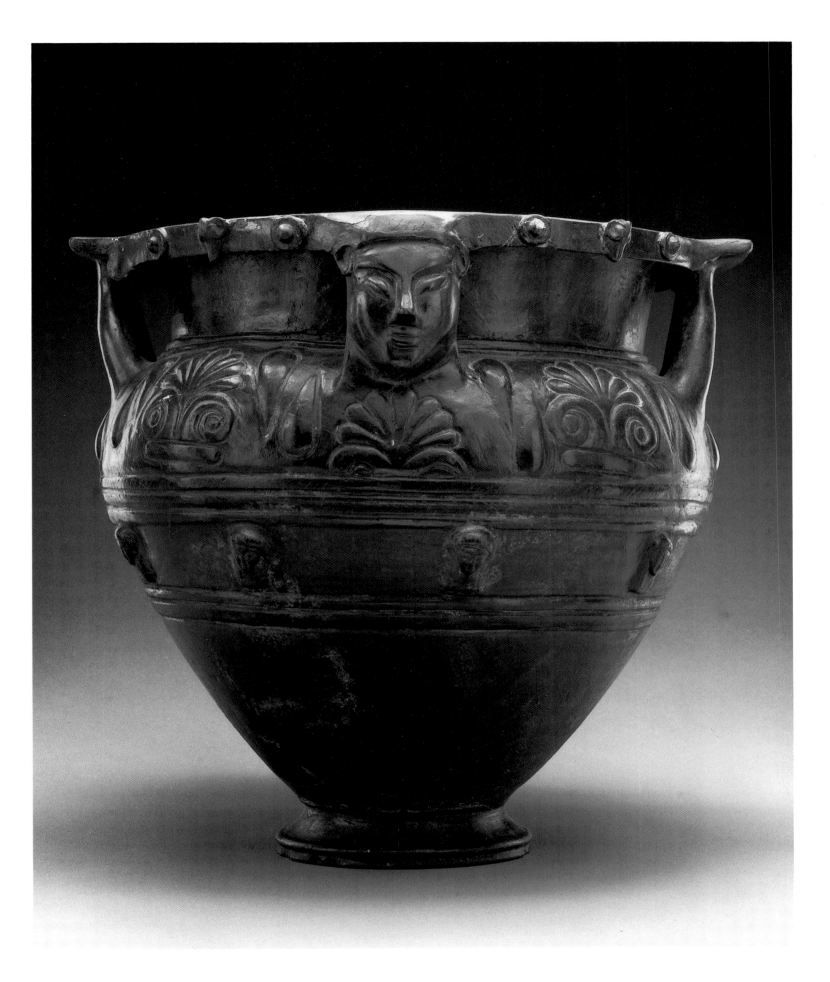

Persia

Bowl *c. 800–1025*
Reddish clay body, white engobe, underglaze in slips,
2½ × 8¼ (6.3 × 21.0)
Promised gift of Elizabeth Stanley

Although these Persian bowls with their spontaneously applied Kufic calligraphic inscriptions are now highly prized, especially in the West, they were once considered ordinary household items. The script, drawn by artisans who might be illiterate or semiliterate, is often difficult to translate, since important elements were frequently omitted. Usually the script communicated simple homilies: in these bowls the Kufic inscriptions bestow blessings on their owners. These rustic pottery bowls differed greatly from the highly cultivated, fastidiously decorated courtly wares that are more closely related to manuscript illumination.

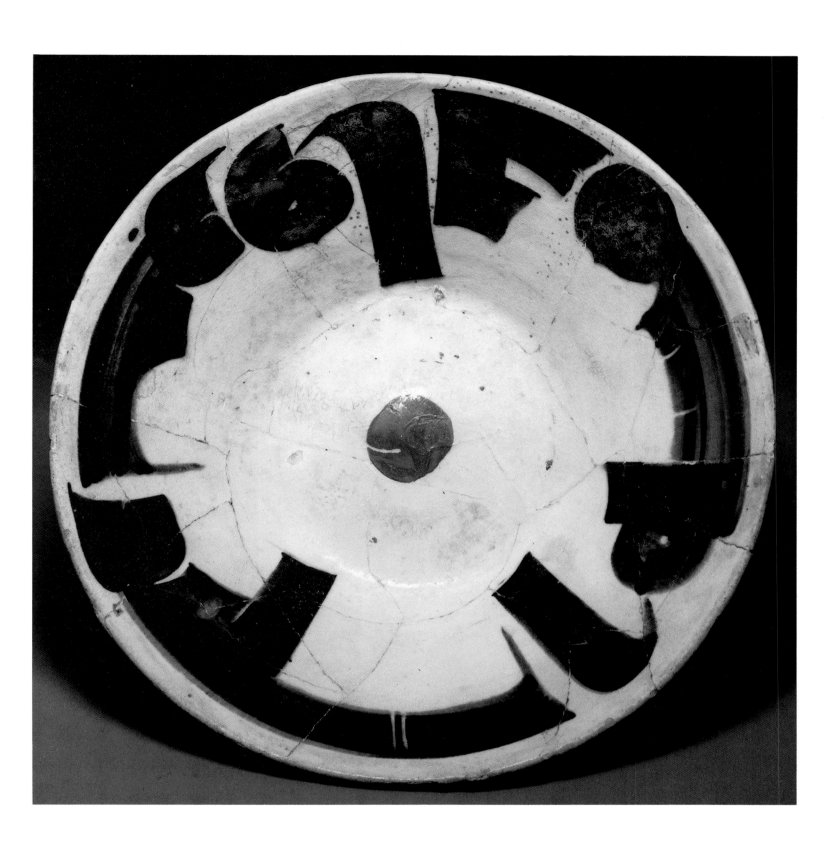

THE WESTERN WORLD

Ceramics

Drawings

Painting

Photography

Prints

Sculpture

Silver

Marc Chagall
French, born in Russia, 1887–1985

Plate *1951*
Glazed and painted ceramic,
10 × 16 × 1½ (25.4 × 40.6 × 3.8)
Gift of Owen and Leone Elliott, 1981.74

While postwar American artists reinvigorated painting and created new, monumental abstract works, an older generation of School of Paris artists that included Matisse, Picasso, and Chagall ventured at times into areas outside painting, ignoring the hierarchy that declared the fine arts superior to the decorative arts. Matisse made paper cutouts, and Picasso and Chagall worked in ceramics. While Picasso reviewed the history of ceramics from red-figured Greek vases to Renaissance Deruta ware and contemporary folk art, Chagall used the luscious glazes of highly fired ceramics to enrich his already established style, which combined aspects of naive art with the sophisticated saturated hues of French Fauvist art.

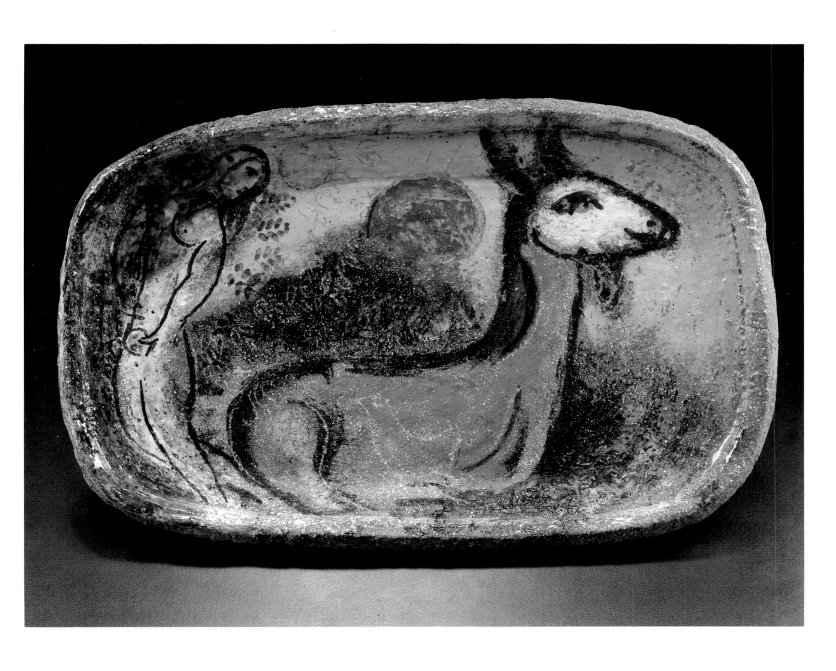

Richard DeVore
American, born 1933

Bowl *1977*
Wheel-thrown and altered stoneware,
4¾ × 10¼ × 10½ (12.1 × 26.0 × 26.7)
Promised gift of Joan Mannheimer

Purity of means is Richard DeVore's working premise and goal. A traditionalist who wishes to culminate the history of pottery with nonfunctional and consequently artistic forms that essentialize the meaning of a ceramic pot, DeVore has evolved a way of making two-layered pots, bowls within bowls, forms punctuated with a hole to reveal pottery's dark side, its ability to secrete and hide, to contain and embody internal space.

Unlike many of his contemporaries, DeVore does not wish to turn pottery into sculpture. His aims are both more ambitious and more conservative, for he wishes to assure everyone that pottery, in its essence, is a pure and distinct art form.

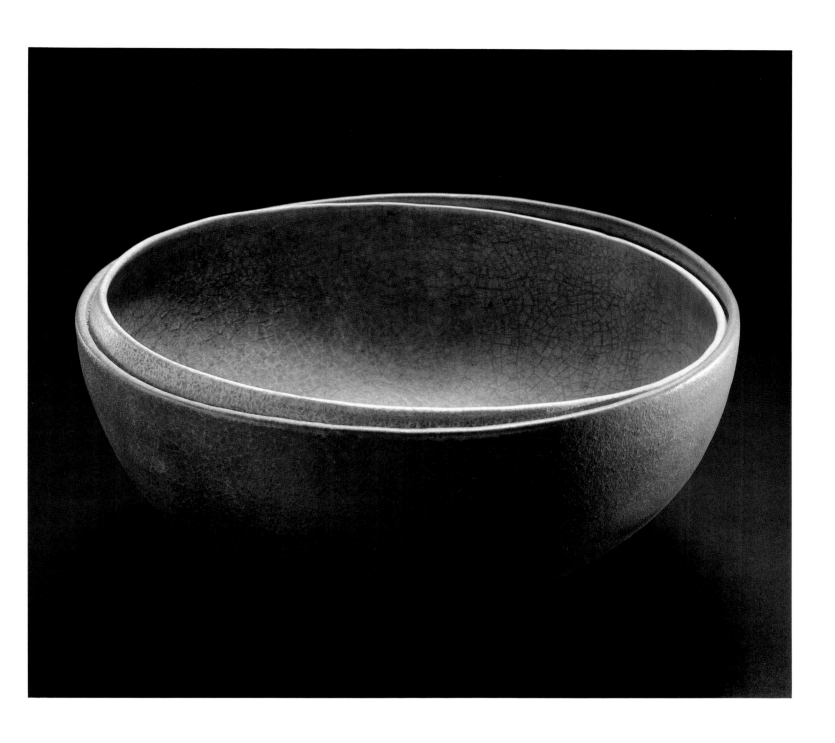

Viola Frey
American, born 1933

Pink Man on a Rooster *1976*
Slip-cast and assembled whiteware,
14 × 9¾ × 5¾ (35.6 × 24.8 × 14.6)
Promised gift of Joan Mannheimer

Viola Frey continues the grand ceramic tradition of the Bay Area of northern California, a tradition initiated by Peter Voulkos in the 1950s when he joined Japanese and American Abstract Expressionist aesthetics to create powerful ceramic sculpture. Although Frey certainly came under the influence of Japanese pottery, she has in recent years been more concerned with the Pop/Funk aesthetic of Robert Arneson and has found the dime-store "china" figurine an important source. In her art Frey takes a simple kitsch figurine and lavishes on it the kind of attention that only the finest ceramic sculptures have received in the past. She endows her humble forms with a vitality they never possessed in their dime-store guise, and in the process she reveals a sense of wry fantasy that has delighted the people who have collected these kitsch objects for decades.

Frey has explained that dime-store figurines "have a frozen presence far beyond their value. They become images from childhood, memories enlarged and scary. Amongst these artifacts are little animals—dogs, cats, roosters, birds—and their attendant human. . . ." Viola Frey in *Overglaze Imagery* (Fullerton: California State University at Fullerton, Art Gallery, 1977).

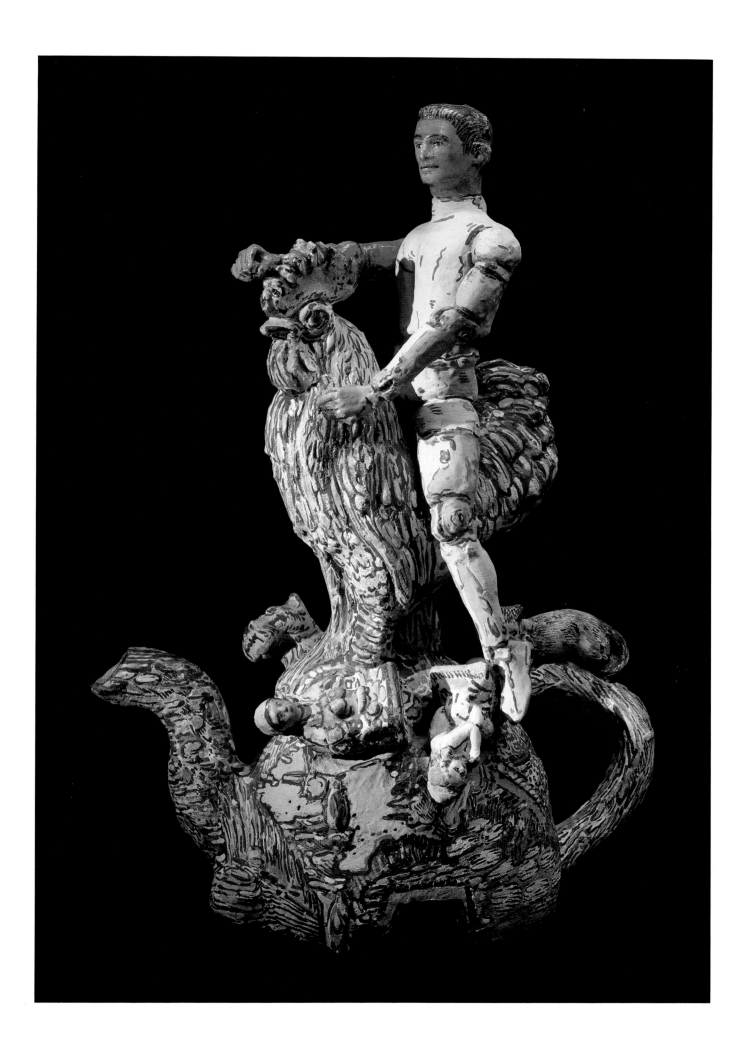

François Boucher
French, 1703–1770

Hagar and Ishmael in the Desert *n.d.*
Black chalk on buff paper, 11 11/16 × 8½ (29.7 × 21.6)
Purchase, Mark Ranney Memorial Fund, x1968.76

French Rococo art looks so light and charming, so filled with *joie de vivre*, so harmless and apolitical, that few have recognized the impact it had on French politics and the important role it played as a gentle form of coercion. Appearing early in the eighteenth century and continuing until the French Revolution, Rococo art became a life style that kept the nobility diverted by harmless but expensive flights of fancy and enabled the kings of France to wield absolute power.

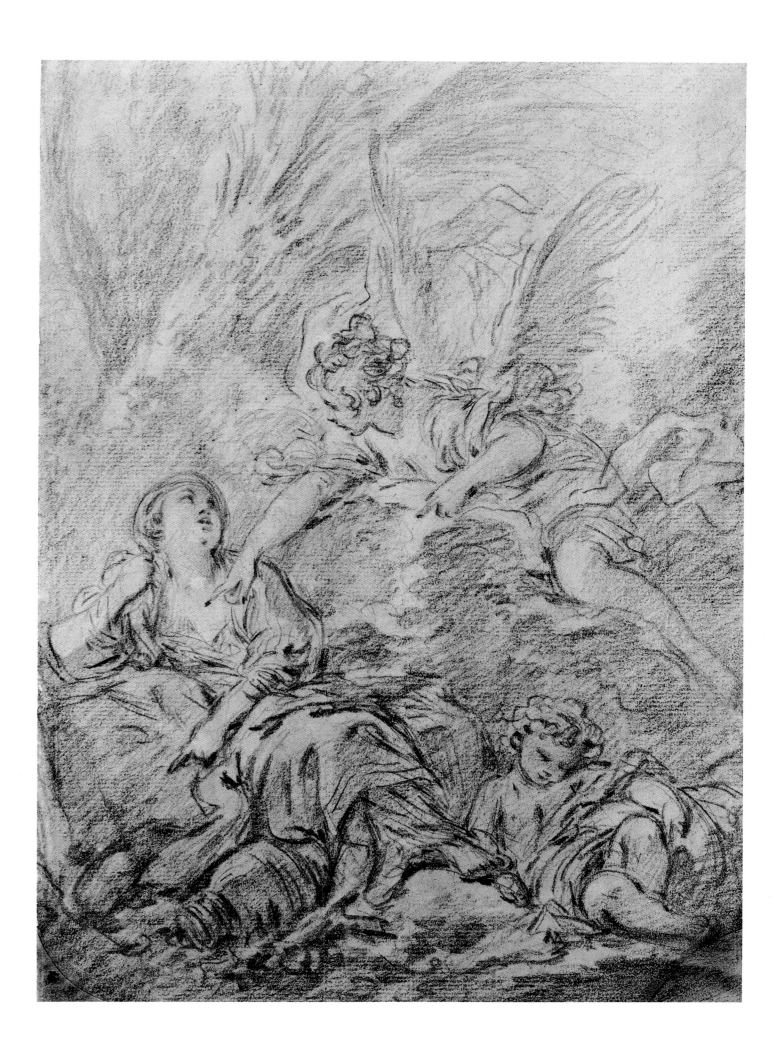

Arthur G. Dove

American, 1880–1946

Thunderstorm *1917–20*
Charcoal on paper, 21 × 17½ (53.3 × 44.4)
Purchase, Mark Ranney Memorial Fund, 1976.15

Dove's abstract art depends on essences. He
looks to the most characteristic shapes of light-
ning, thunderclouds, rain, and bending plant
forms, then he orchestrates them into a pattern
that indicates the spirit of thunderstorms. To be
truly effective, Dove's art must convey the force of
a specific storm at the same time that it describes
the underlying meaning of all thunderstorms: it
must be realistic and abstract at the same time.

George Grosz
American, born in Germany, 1893–1959

Stammtisch *1917*
[The regulars' table]
Quill pen and ink on paper,
11½ × 11⅞ (29.2 × 30.3)
Purchase, Mark Ranney Memorial Fund, x1968.144

Berlin artist George Grosz was known before World War I for the caricatures he published in *Ulk* and *Lustige Blätter*. After the war he turned to bitterly ironic Dadaist drawings of contemporary society that exposed the evils of the military and the hypocrisy of the capitalists. In the art he created just prior to the war, Grosz began to use the dislocation and abrupt sense of movement that characterized Cubism and Futurism; he joined this new type of line with his own insistent mode of caricature and his deep distrust of humanity. In the process he developed an art intended to undermine the brutal force of the modern world.

The year that Grosz drew *Stammtisch* (1917) he underwent changes that had a profound effect upon him. Although he had been discharged from military service because of "brain fever," he was drafted again in 1917. This time he suffered an emotional collapse and was placed in an asylum. In this drawing of a ribald and brutal group of regulars at a local bar, Grosz conveys his sensitive grasp of the harshness of existence. The letters "schult" may be intended to suggest the German word for "guilt" and the irony that none of these men are capable of feeling it.

It is fitting that The University of Iowa Museum of Art should have an important Grosz drawing from this crucial year in his life, for the Dada Archive and Research Center, including the Dada Literary Archive and the Dada Fine Arts Archive, is housed at the University.

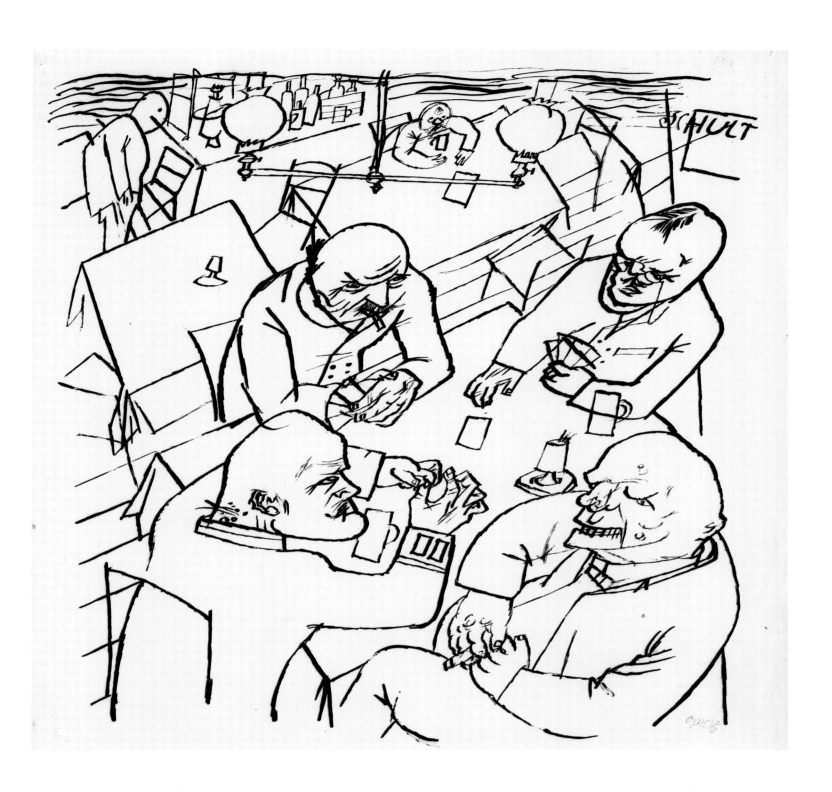

Guercino
(Giovanni Francesco Barbieri)
Italian, 1591–1666

St. Matthew and the Angel *c. 1640s*
Brown ink on paper, 9⁷⁄₁₆ × 8½ (24.0 × 21.6)
University purchase, x1968.67

Created approximately eighty years after the Council of Trent of 1563, at which time it was decided that art was to play a crucial role in the Counter Reformation, Iowa's *St. Matthew and the Angel* exhibits the faith, the artistic simplicity, and the directness of feeling that the Council strongly recommended. Such an emphasis on feeling encouraged artistic spontaneity. Together with the sixteenth-century Mannerist concern for a Master artist's distinctive style or peculiar manner, the ideals of the Council of Trent may well have helped to accelerate an interest in drawing. By the seventeenth century, collectors had come to regard drawing as an independent art form, and they begged artists for unique sketches.

St. Matthew and the Angel (the identification of the saint is still provisional) is representative of the second and more classical phase of the art of Giovanni Francesco Barbieri, who was known as Il Guercino ("the squinter"). Guercino's work is noted for its calligraphic impulsiveness and for the free play of webs that enmesh his figures and create a shallow space for them. Although highly respected for his sketches, Guercino is not known to have produced many finished drawings.

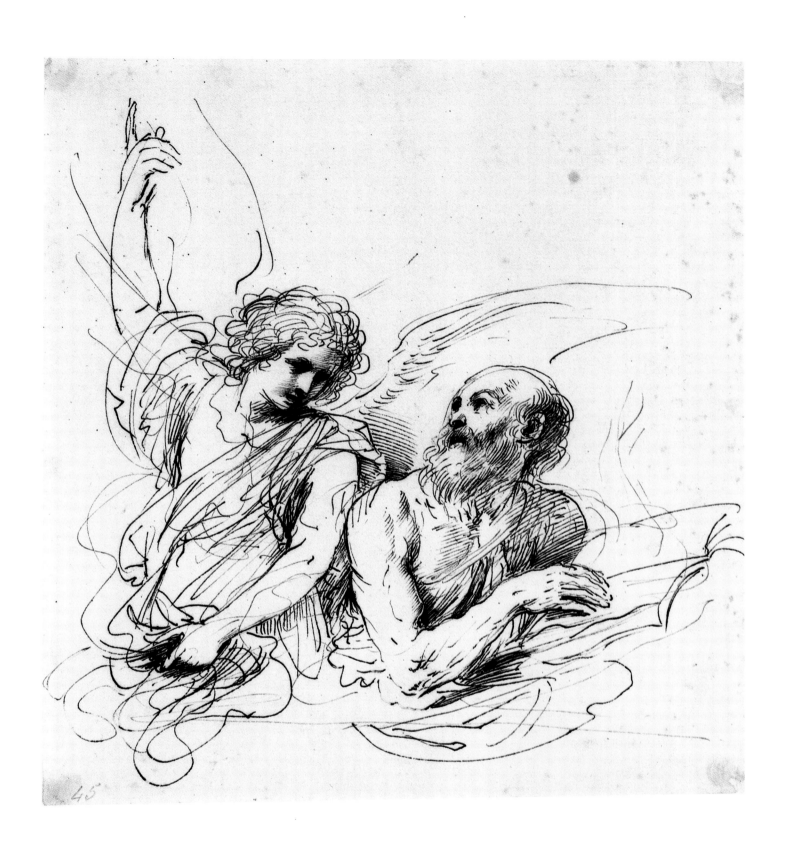

45

Yasuo Kuniyoshi
American, born in Japan, 1893–1953

Eggplant *n.d.*
Ink on paper, 14¾ × 10¹¹/₁₆ (37.5 × 27.8)
Museum purchase, 1981.9

Yasuo Kuniyoshi is among the post–World War I artists who should be regarded as minor masters. He and Reginald Marsh, Ben Shahn, Grant Wood, and the Soyers might be considered American equivalents of the Dutch seventeenth-century "little masters," notably Terborch, Van Ostade, and Van Goyen.

In his art Kuniyoshi combines elements of Cubism with the conservatism of the late Derain and the neoclassical Picasso. In *Eggplant* he draws on a refined Japanese sensibility and develops an abstract art of great subtlety and delicacy.

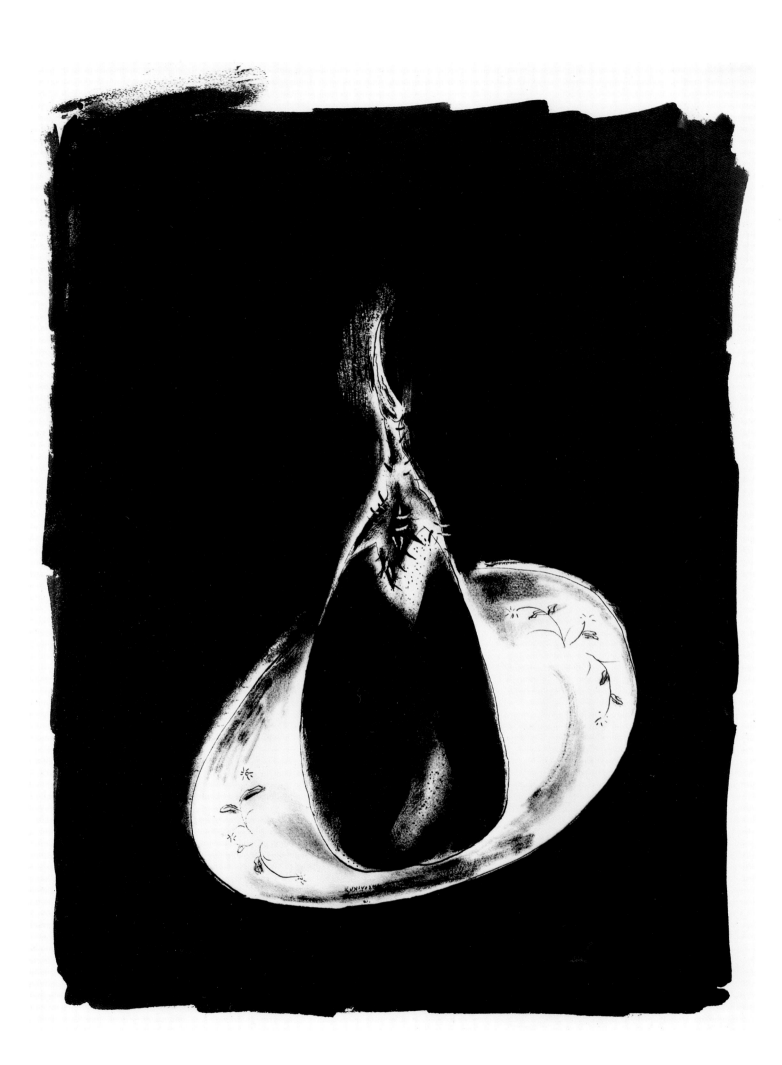

John Marin
American, 1870–1953

Off Flint Island, Maine Coast *1933*
Watercolor on paper, 15½ × 21⅞ (39.4 × 55.6)
Gift of Mr. and Mrs. James S. Schramm, 1969.525

Trained as an architect in the 1890s, John Marin was throughout his artistic life aware of the importance of thrusts and counterweights and the contrapuntal nature of the city, in which each building is affected by the others surrounding it. Marin developed a relaxed version of Cubism, which he joined with Orphism to create a distinctive style. He relied as much on color as on form, and his art pulsates with quivering shapes that suggest a new life force penetrating buildings, streets, and natural forms. This interdependence of natural and man-made forces is evident in *Off Flint Island, Maine Coast*, in which the boat looks almost like an aspect of the sea and the sea an extension of the boat. Marin's view of the world differs from that of the French Cubists, who dissected nature. One might say that whereas their universe resembles the traditional researches of a chemist in a laboratory, Marin's universe is ecological.

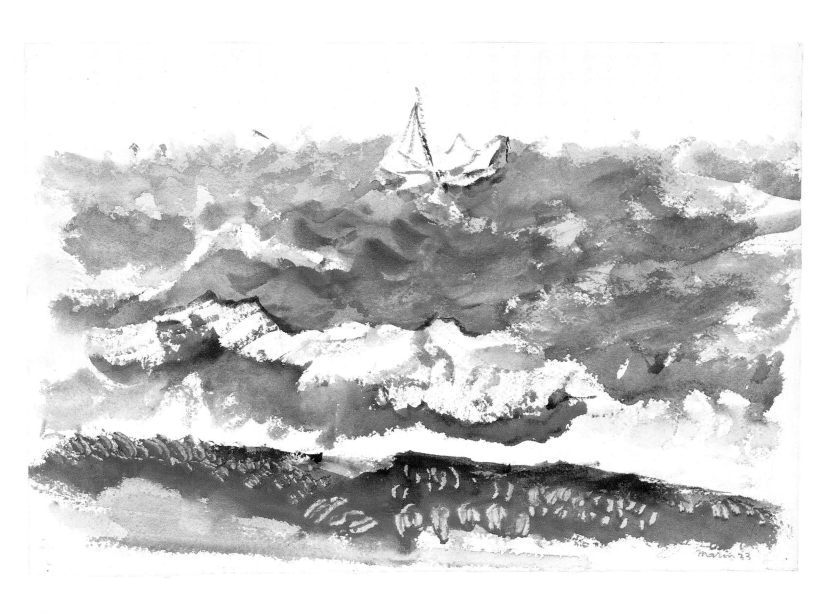

Robert Michel
German, 1897–1983

"Anti-Stilleben" O[riginal] Z[eichnung]
mit Stecknadeln *1922–23*
["Anti–still life" original drawing with pins]
Ink, wash, pencil, and assemblage collaged on card,
25½ × 26½ (64.8 × 67.3)
Purchase, Mark Ranney Memorial Fund, 1984.28

 Although they associated with Dadaists and
Bauhaus artists, Robert Michel and his wife, the
artist Ella Bergmann-Michel, remained indepen-
dent of group activities. Michel viewed machines
as symbols of a twentieth-century utopia, an ap-
proach certainly reinforced by the Bauhaus em-
phasis on beautiful utilitarian design but also
augmented by his own earlier experience as an en-
gineering apprentice and a pilot in World War I.
 Anti-Stilleben is, as the title indicates, a refuta-
tion of the traditional still life and its dependence
on nature. It is also an affirmation of the machine,
which is represented as a series of moving parts,
lovingly conceived, elegantly realized, and roman-
tically understood. The carefully engineered wood
frame, the subtly modulated, spray-painted mat,
and the stylized signature are integral to this work.

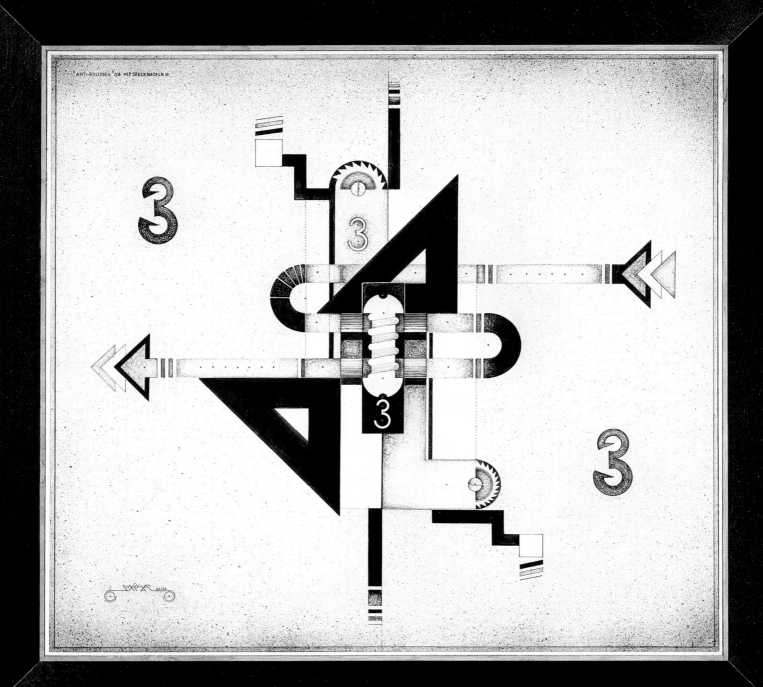

Maurice Prendergast
American, born in Canada, 1859–1924

Springtime *n.d.*
Watercolor on paper, 9½ × 10¼ (24.1 × 26.0)
Gift of Frank Eyerly, 1963.1

Like the French Impressionists who influenced him, Prendergast recognized that the changes in life produced by advances in technology and the consequent mass exodus from rural areas to cities called for changes in vision. Like the Impressionists, he wished to grasp in his art the vast moving panoply of modern life, to understand it in all its variety and complexity. Using a variant of the Impressionist style, he created works that represent the truth of the sweeping glance, the new type of perception that was elicited by these changes. In *Springtime* the glance is fully realized. Try as one might, one can never really focus on individual elements in this painting; all one can do is to look cursorily at the scene and lose oneself in the grand pageant of modern life.

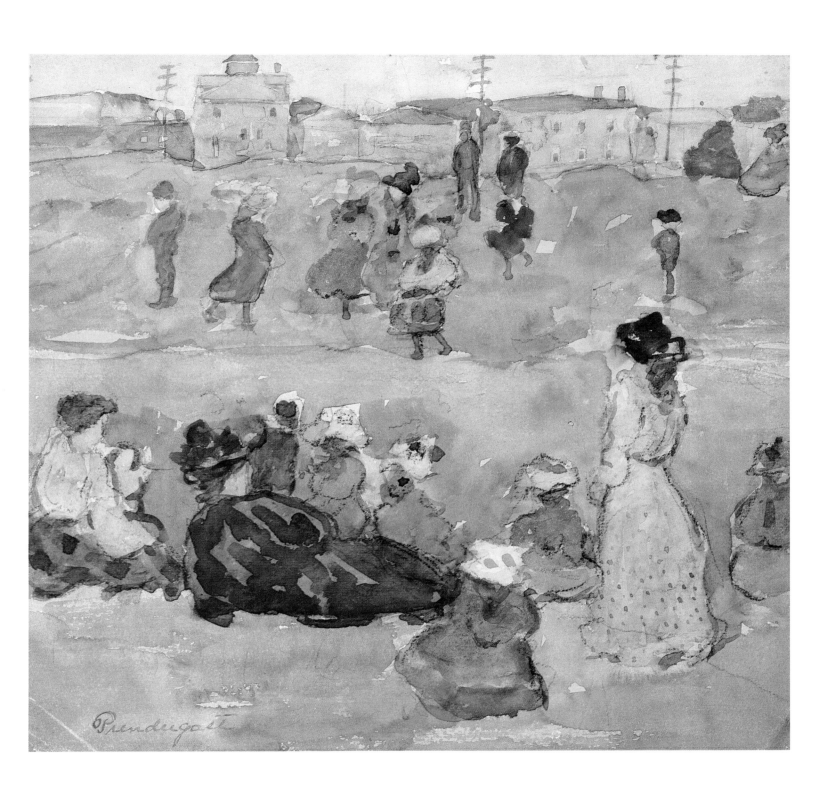

Odilon Redon

French, 1840–1916

Fleurs mystiques *n.d.*
[Mystical flowers]
Pastel and charcoal on paper mounted on cardboard,
25½ × 21⅛ (64.8 × 53.6)
Gift of Owen and Leone Elliott, 1968.40

 "The designation of my drawings by a title is
often, so to speak, superfluous. A title is justified
only when it is vague and even aims confusedly at
the equivocal. My drawings *inspire*, and are not to
be defined. They determine nothing. They place
us, as does music, in the ambiguous realm of the
undetermined. They are a kind of metaphor."
Odilon Redon in *Artists on Art, from the XIV
to the XX Century*, ed. Robert Goldwater and
Marco Treves (New York: Pantheon Books, 1947),
360–361.

Mark Rothko
American, born in Latvia, 1903–1970

Untitled *1944–46*
Watercolor and ink on paper,
21 15/16 × 21 1/4 (55.7 × 54.0)
Gift of The Mark Rothko Foundation, 1985.48

Much of Mark Rothko's art of the mid-1940s was conceived in watercolor. The medium was fluid and suggestive, and it allowed him to create generalized biomorphic shapes. These biomorphs called to mind a primordial world, tribal fetishes, and microscopic unicellular life without falling into the trap of a specific subject matter that would look like scientific or ethnographic illustration. Rothko wished to allude to a preconscious realm and to the significance of art as a way of coming to terms with preconscious or conscious intuitions.

When Rothko wrote "The Romantics Were Prompted" for publication in *Possibilities* in 1947, he was ending a period he later termed "Surrealist" and beginning to develop his art along more abstract lines, occasioned first by dropping mythic titles and later by creating multiforms. In this essay, which marks the shift between his earlier and later Abstract Expressionist styles, his attitude is generally retrospective. He uses a theatrical metaphor to explain why his art of the forties contained Surrealist hybrid forms that were part fetish and part human: "I think of my pictures as dramas; the shapes in the pictures are the performance." His references to the impossibility of realizing his drama in the everyday world rely heavily on Nietzsche's theories on the origin of tragedy: the emphasis on the chorus of satyrs is paralleled in Rothko's hybrids, and the effect of creating an atmosphere to break down individual differences and establish a primordial unity is crystallized in his term "transcendent experience."

Pierre Henri de Valenciennes
French, 1750–1819

Landscape with Figures *n.d.*
Black and white chalk and brown ink on gray-green laid paper, 11⅝ × 20⅜ (29.5 × 51.8)
Museum purchase in honor of Frank Seiberling, 1984.24

Valenciennes was one of the first French artists to go out of doors to make oil sketches. Although he remained a classical landscapist in the tradition of the seventeenth-century artist Poussin, he did help to elevate the category of landscape painting, which the French academy considered even in the early nineteenth century to be of little importance.

This finished drawing shows how Valenciennes's nature studies enriched his art and made him aware of the effects of atmosphere, rain, and wind. These studies also helped him to invigorate his traditional classical art with genre elements, such as the realistic cart with oxen. Valenciennes's interest in nature is most likely indebted to the writings of Jean Jacques Rousseau, who encouraged people to look at mountains, fields, streams, and skies and to be moved by them.

Grant Wood
American, 1891–1942

Sketch for The Birthplace of
Herbert Hoover *1931*
Charcoal, chalk, and pencil on paper,
29¼ × 39½ (74.3 × 100.3)
Gift of Edwin B. Green, 1985.92

One of the master orchestrators of the Depression temperament, Grant Wood served the strong need people then had for stability and continuity by reminding them of better times. Unable to find any optimistic vision of the future credible, these people did find Grant Wood's sentimentalized view of the past reassuring. In his sketch for *The Birthplace of Herbert Hoover*, Wood created an idealized world by utilizing the dreamlike bird's-eye view characteristic of the illustrations of many children's stories.

The saving grace of all this carefully manicured past is Grant Wood's sense of humor. The couple in *American Gothic* seem to know that they are posing; *Victorian Survival* with her exaggerated long neck seems to realize how ridiculous she really is; and George Washington, who in *Parson Weems' Fable* tells his father he cannot tell a lie, appears absurdly precocious with his childlike body connected to the familiar presidential face. Wood's Midwestern Regionalism is definitely tongue-in-cheek; it is carefully constructed and strangely complex.

Max Beckmann
German, 1884–1950

Karneval *1943*
(Carnival Triptych)
Oil on canvas, 75 × 116¾ (190.5 × 296.5) (overall)
Purchase, Mark Ranney Memorial Fund, 1946.1

One of Beckmann's nine completed triptychs, *Karneval* symbolizes the three ages of man and presents a morality play of Adam and Eve in modern dress. On the left stand a young, idealized man and woman, and on the right a middle-aged couple is being driven out of the Eden Hotel by an angel wearing a bird mask. The Eden Hotel actually existed in Berlin and was frequented by Beckmann. Its name appears on the hat of the bellboy, who also parallels the angel's stance by carrying a sword. In the center panel Beckmann may be reflecting on his own status at the time *Karneval* was painted: nearly sixty years of age, he was one of Hitler's "degenerate" artists, an outcast living in exile in Amsterdam. An old, disillusioned Adam, he dances with a much younger woman, perhaps a prostitute. An inscription on the megaphone, "DA Orient Sumat," may be a reference to Sumatra, but more likely it is an allusion to a bleak version of an exotic paradise in the form of a local bar. The letters ARNAVE AMST, a misspelled fragment of CARNAVAL AMSTERDAM, help support these interpretations.

Beckmann includes the letters EVAL AMSTERDA in the panel on the far left, suggesting that the Dutch Carnaval of the central panel might be presaged by the German Karneval, which is pictured in both the left and right panels and which represents the fall of humanity from grace. The large bust in the left panel refers to a form for rulers that has existed since the time of Constantine. Its features are strongly reminiscent of Hitler's, thus suggesting that the entire ensemble refers to the strange carnival of World War II and the Nazi occupation of the Netherlands. Carnival refers to the season of merrymaking before Lent; its use as a title for this painting underscores the solemnity of the circus figures who perform the tragic acts of life.

By using the triptych format, which has had almost exclusively religious associations since the Middle Ages, Beckmann underscores the disillusionment of a modern war-torn world that has lost its spiritual values.

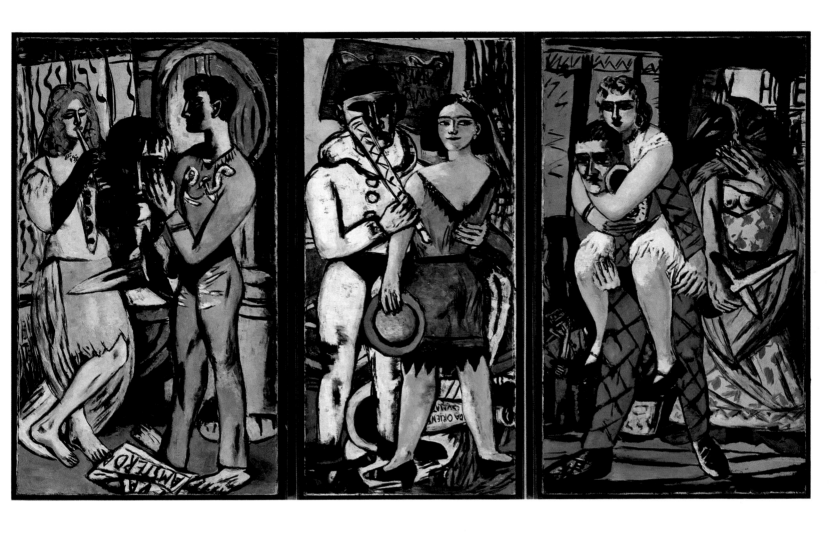

Georges Braque
French, 1882–1963

Still Life with Fruit *c. 1920–22*
(The Fruit Dish)
Oil with sand on canvas, 13¾ × 25½ (34.9 × 64.8)
Gift of Owen and Leone Elliott, 1968.2

A still life painting traditionally symbolizes the abundance of harvest and the good life: it also presents a visual feast of colors and shapes for the eye. In Braque's Cubist still life this feast is severely fragmented into constituent geometric forms to imply that art is more than a sensory banquet, that art, in fact, is a product of the mind and a form of representation deserving intellectual analysis. In Braque's still life the emphasis on art as idea is underscored in the low-key palette, the schematization of form, and the absence of seductive tricks using illusionistic lighting. In this painting the French term for still life, "nature morte" ("dead nature"), becomes a pun and also a working method for exposing a still life as a convention, a painted construct. It presents an embalming of illusionistic tricks and an affirmation by Braque that art, after all, is a visual thought.

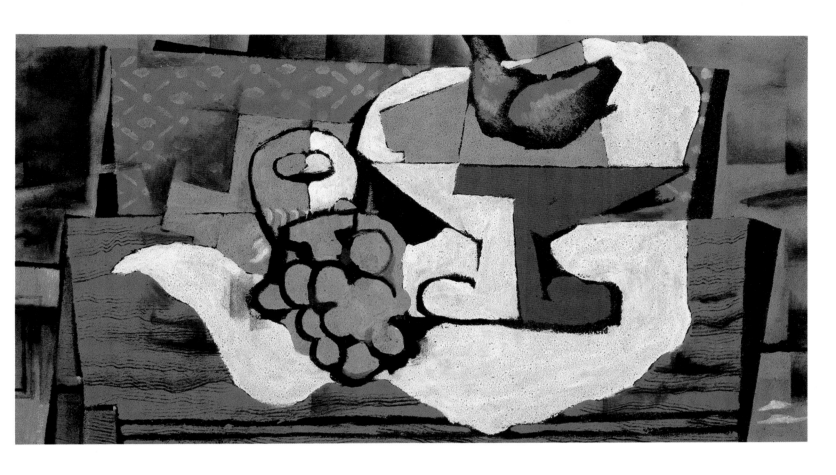

Joseph Cornell
American, 1903–1972

Untitled *c. 1965–68*
[Coffeepot], from the series "Puzzle of the
Reward," c. 1965–70
Collage and oil on Masonite,
11⅝ × 8⅜ (28.9 × 21.2)
Museum purchase, 1976.8

Reusing pictures from old magazines and junk
from secondhand shops, Joseph Cornell places im-
ages in unfamiliar contexts so that their poetic
evocativeness will be stirringly evident. Perhaps
the last real Surrealist and the only American truly
to deserve the label, Cornell is an alchemist who
transforms mundane elements into art. The steam-
ing blue coffeepot in this collage becomes almost
an apparition; seen in conjunction with an image
of the Big Dipper as it will appear in 50,000 years,
it suggests the vast differences in the ways time is
registered.

An admirer of French Symbolist poetry, Cornell
was struck by the idea that the meaning of a work
of art is always an enigma—a subtle and ingratiat-
ing question mark that delights even as it con-
tinues to puzzle and confound rational thought.

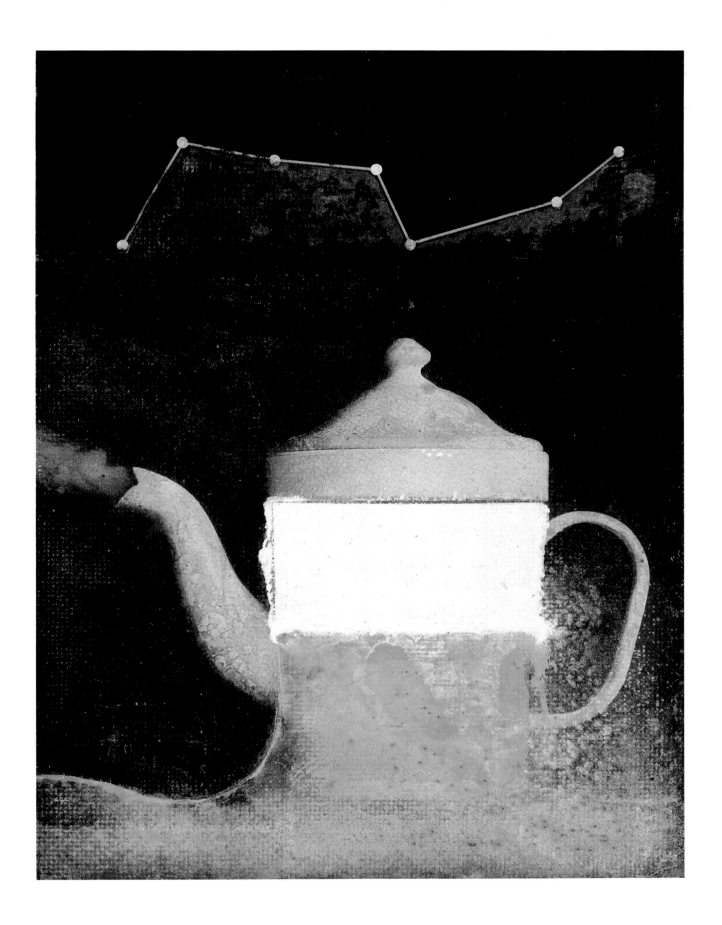

Stuart Davis
American, 1894–1964

New York–Paris, No. 1 *1931*
Oil on canvas,
39 × 51¾ (99.1 × 131.4)
University purchase, 1955.5

In his art Davis sought to synthesize French abstraction, the rhythm of American jazz, and the look of the billboard advertisements and neon lights of New York. In *New York–Paris No. 1* these various elements are incorporated and echoed. Memories form patterns that are painted with insistent rhythms, and letters, a leg, receipts, and the profile of the Chrysler Building lose their traditional hierarchical status to participate in a strange new reality. Only the intimate Paris sidewalk cafe seems to retain its proper scale and balance. "I liked Paris the minute I got there," Davis later reported. "Everything was humanized. The pressure of American anti-art was removed. You could starve to death quicker there but you had the notion that the artist was a human being and not just a bum." Quoted in Diane Kelder, *Stuart Davis* (New York: Praeger Publishers, 1971), 8.

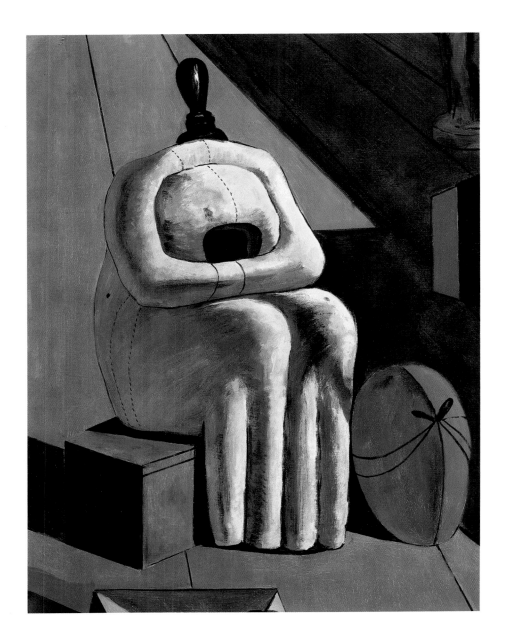

Giorgio De Chirico
Italian, 1888–1980

Le Muse inquietanti *1947?*
(The Disquieting Muses)
Oil on canvas, 38½ × 26⅛ (97.8 × 66.4)
Gift of Owen and Leone Elliott, 1968.12

Regarded by De Chirico as the finest of his three versions of *The Disquieting Muses*, this painting may be the latest. The earliest version was created in 1917, and the second, a loosely painted work, was made for the French poet Paul Eluard in 1924. Although dated 1918 on the canvas, the Iowa picture was dated c. 1947 by James Thrall Soby in his 1955 MoMA catalogue.

Ten years ago a late work by De Chirico would not have been regarded as a candidate for masterwork status even by Soby, who readily acknowledged the quality of the Iowa painting. But today some of the older man's copies of his earlier work seem remarkable recapitulations.

In this work the rational Renaissance muse who guided painters in their creation of coherent spaces has given way to an unfamiliar being who causes the artist to treat space as an artificial construct. The stage tips forward, the figures are alarming forms—part dressmaker's dummy and part classical sculpture—and some of the patterned shapes in the painting stick to the surface of the canvas instead of participating in the illusionistic game of perspective. This departure from tradition serves to break apart the entire illusory scheme and make rationality suspect.

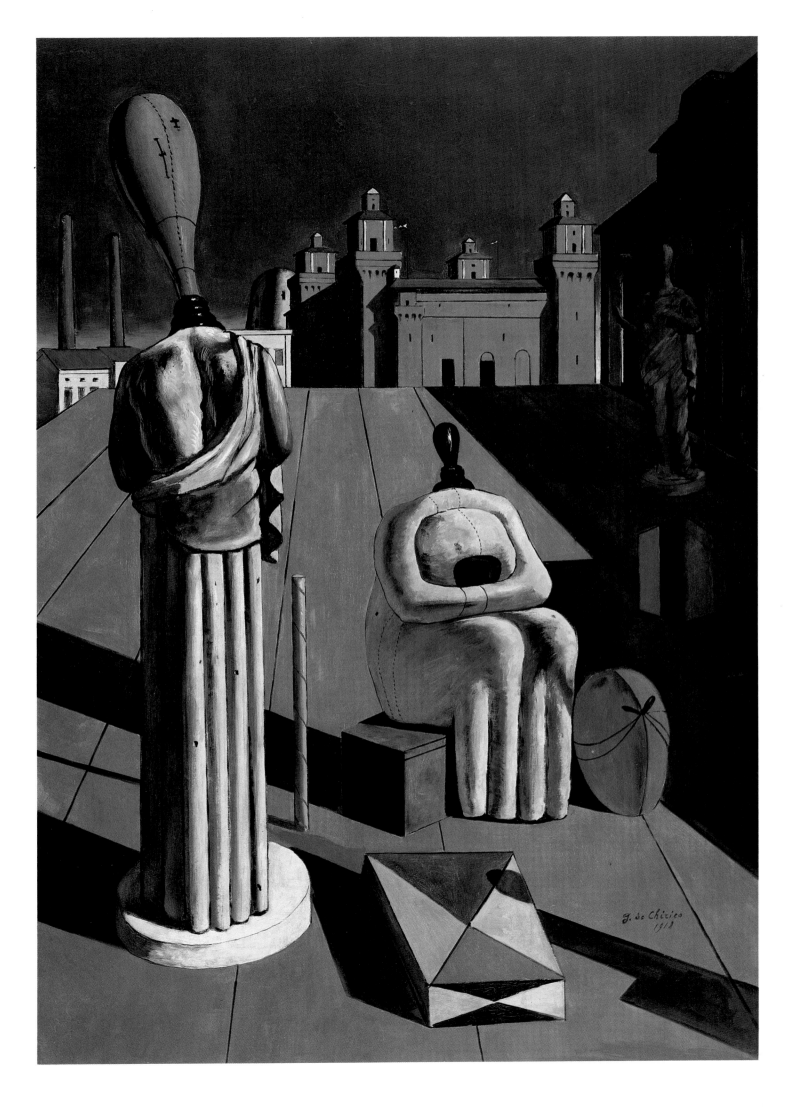

Gianni Dessì
Italian, born 1955

Figura d'intesa *1983*
[Figure of understanding]
Oil on canvas, 87 × 75 (221.0 × 190.5)
Promised gift of Antonio and Hanna Damasio

Dessì is one of seven Italian artists who have their studios in the same building in Via degli Ausoni, Rome. Like the others in this loosely constituted group, he is fascinated with art as a means for giving form to mystical and philosophical ideas without revealing their specific content. Dessì is concerned with art as an entry to great and profound mysteries, with art as a way of alluding to esoteric ideas that must always remain indecipherable to the uninitiated. Working in the time after the appearance of Arte Povera, European Minimalism of the 1960s and 1970s, which dealt with art as an objective and verifiable fact, Dessì wishes to invoke an earlier tradition of modern art and to return to the ideas of the American Abstract Expressionists, who believed painting to be capable of manifesting a culture's most profound concerns.

Dessì creates an art in which underpainting and mystical symbols are of paramount importance. Beneath the broad areas of color in his art are other colors that glimmer through lightly painted areas to suggest deeper levels of understanding and partially revealed truths. The underpainting endows the surface with great presence and subtlety. In *Figura d'intesa* there are warm and cool blacks and also matte and shiny blacks. A painted red diamond is overlaid with a rectangle of canvas on which the shape of a head is drawn in a viscous paint that resembles glue. In the center of the forehead, in the area traditionally referred to in Eastern mysticism as the third eye, two white arrows meet. Underneath these arrows the artist has painted whirling forms that resemble a series of galaxies. Slightly lower down, where a mouth might be located, he has suggested a ring of fire. In this painting the artist uses colors, painted and real squares, and signs to connote profound and mystical meanings, which are all partially veiled and suggested rather than directly described.

Richard Diebenkorn
American, born 1922

Ocean Park, No. 17 *1968*
Oil and charcoal on canvas,
80 × 71¾ (203.2 × 182.2)
Purchased with funds from the National Endowment
for the Arts and matching funds from The University
of Iowa Foundation, 1970.38

California artist Richard Diebenkorn has attempted to unite the Matisse of 1910 with the De Kooning of the 1940s. He has joined the openness, rationality, and hedonism of Matisse with the hesitations of an artist who was intent upon giving form to those images at the very threshold of the conscious mind. The result—in the more than 150 paintings of the *Ocean Park* series, named for a section of Santa Monica that overlooks the Pacific—is an art that is at the same time both open and closed. The paintings contain large passages of pale golden hues that reflect the light of southern California but also include subtle intimations of a specific scene. The series is both monumental and classical, both traditional and avant-garde. Like many European academic painters from the sixteenth century to the nineteenth, Diebenkorn intends to uphold tradition, but his tradition is that of the avant-garde. One might say that Diebenkorn is one of the first academic avant-garde painters, one of the first practitioners of Harold Rosenberg's "Tradition of the New."

Adolf Erbslöh

German, born in America, 1881–1947

Tennisplatz *1910*
[Tennis court]
Oil on canvas, 21½ × 26¼ (54.6 × 66.7)
Gift of Owen and Leone Elliott, 1968.66

Adolph Erbslöh was the only American-born
artist in the international Munich-based group
known as the Neue Künstlervereinigung. This
group served as the springboard for the Blauer
Reiter, which stressed inner feelings over external
reality. Painted in 1910 just prior to the formation
of the Blauer Reiter, *Tennisplatz* is a strange and
magical work, both lyrical and menacing, filled
with the gaiety of the game and yet imbued with
foreboding, with some of the same understanding
of approaching disaster that informs the pre–World
War I paintings of Kandinsky and Marc.

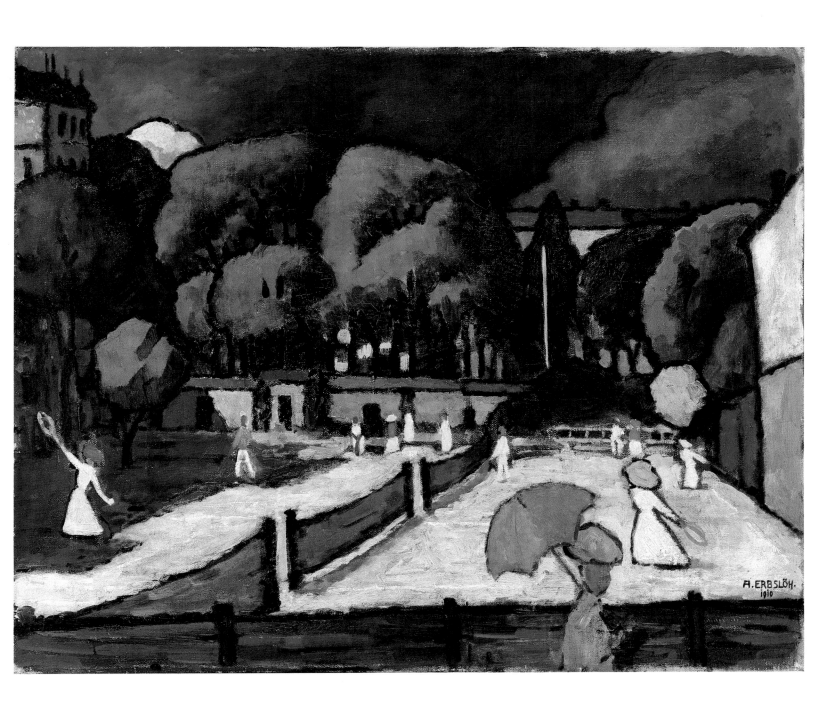

Lyonel Feininger
American, 1871–1956

In a Village Near Paris *1909*
(Street in Paris, Pink Sky)
Oil on canvas, 39¾ × 32 (101.0 × 81.3)
Gift of Owen and Leone Elliott, 1968.15

In a Village Near Paris depicts villagers rushing home while street lamps are being lit and the last light of the setting sun turns the sky a dazzling pink.

Three years before he created *In a Village Near Paris*, Feininger had concluded a career as an international cartoonist of note and begun to paint. He had created political cartoons for the German magazines *Lustige Blätter* and *Narrenschiff*, as well as the comic series "The Kin-der-kids" and "Wee Willie Winkie's World" for the *Chicago Tribune*. His first paintings naturally developed from his cartoons. His frequent visits to Paris beginning in the summer of 1906 put him in close contact with the Fauves, from whom he learned to experiment with saturated hues. Unlike the Fauves, however, he chose urban rather than Arcadian themes. Feininger considered in his early paintings the ways that modern life divides and depersonalizes people, turning them into types, into hurrying silhouettes, into cartoonlike characters.

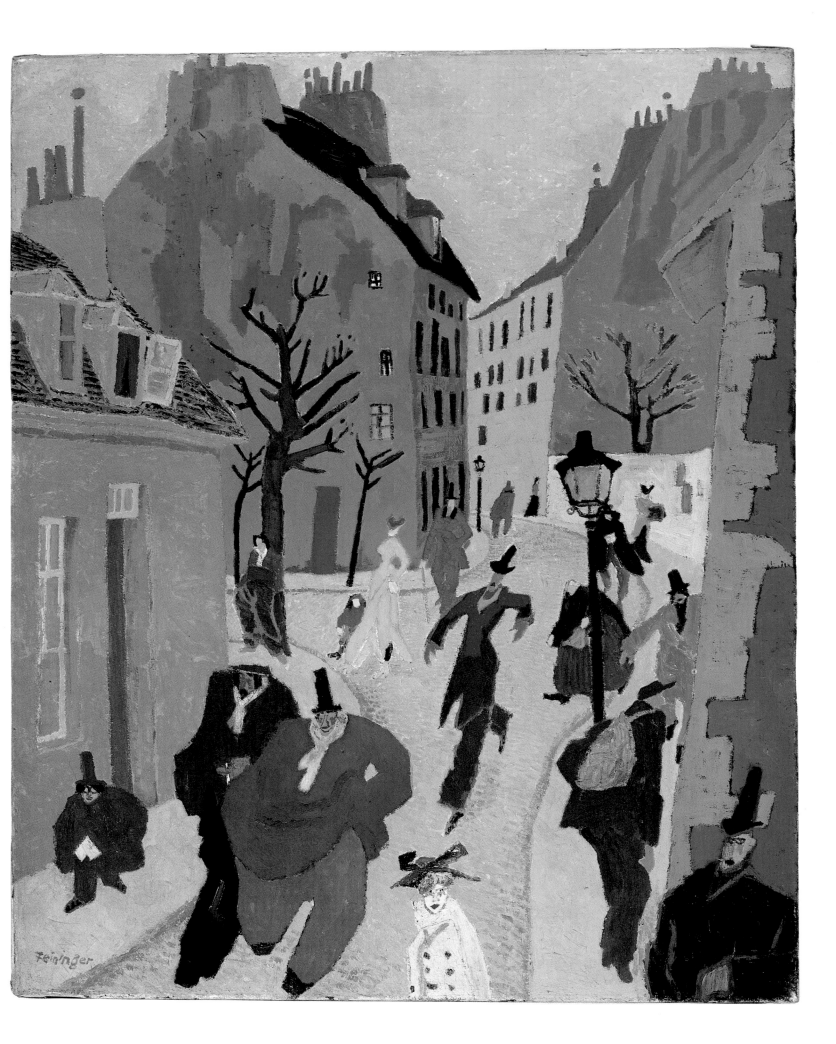

Juan Gris

(José Victoriano González)

Spanish, 1887–1927

La Guitare noire *1926*

(The Black Guitar)

Oil on canvas, 19¾ × 28⅝ (50.2 × 72.7)

Gift of Owen and Leone Elliott, 1968.20

In 1921, five years before painting *La Guitare noire*, Gris explained the premise of his tradition-bound Cubism:

"I work with the elements of the intellect, with the imagination. I try to make concrete that which is abstract. I proceed from the general to the particular, by which I mean that I start with an abstraction in order to arrive at a true fact. Mine is an art of synthesis, of deduction. . . .

"I consider that the architectural element in painting is mathematics, the abstract side; I want to humanize it. Cézanne turns a bottle into a cylinder, but I begin with a cylinder and create an individual of a special type: I make a bottle—a particular bottle—out of a cylinder. Cézanne tends toward architecture, I tend away from it. That is why I compose with abstractions (colours) and make my adjustments when these colours have assumed the form of objects."

Juan Gris in Mark Rosenthal, *Juan Gris* (New York: Abbeville Press, 1984), 159.

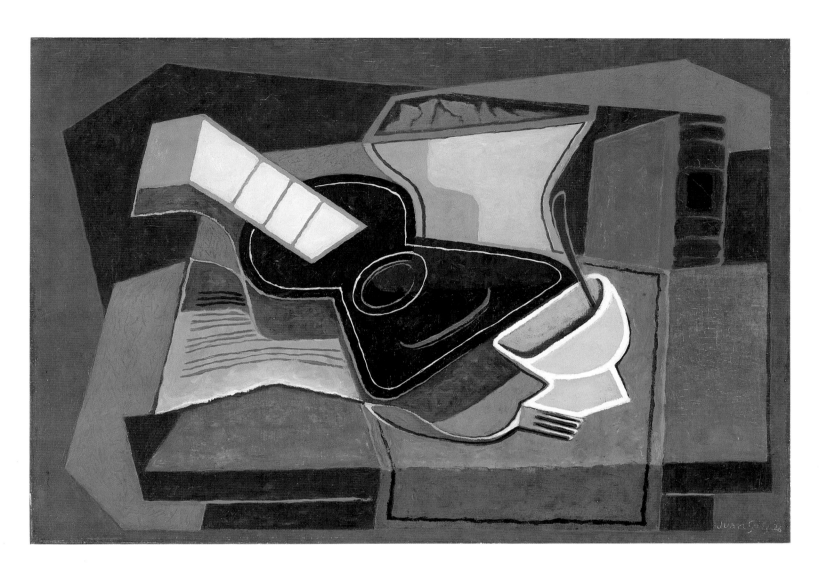

Philip Guston
American, born in Canada, 1913–1980

The Young Mother *1944*
Oil on canvas, 39⁷⁄₁₆ × 29½ (100.2 × 74.9)
Gift of Dr. Clarence Van Epps, 1947.24

In the fall of 1941, when he was 28 years old, Philip Guston came to The University of Iowa to teach. During the four years he remained in Iowa City, he created *The Young Mother*, a portrait of his wife Musa and their daughter, who was then known as Musette. In the background of this painting is the view that Guston would have seen from his studio window. (St. Mary's Church is on the right.) *The Young Mother* alludes to various styles that Guston was hoping to reconcile. He wanted to unite the geometry and light of the Renaissance master Piero della Francesca with the slightly abstract but still classical art of such twentieth-century artists as De Chirico, Picasso, Braque, and Léger. *The Young Mother* reflects Renaissance prototypes, particularly paintings of the Madonna and Christ Child, more than it does twentieth-century antecedents, although there are hints of Picasso's neoclassical figures in it.

The painting also reflects artistic currents then important in Iowa City, to which Guston came after making a conscious decision to leave New York and his avant-garde associates. He moved to the bastion of Midwestern Regionalism and became a friend of Grant Wood, even though he continued to be interested in the School of Paris. In Iowa City the School of Art and Art History was divided into two camps: the Midwestern Regionalists and the modernists. Led by Lester Longman, chairman of the department, the modernists sought to dispel the influence of Grant Wood and avidly collected and exhibited modern art. They were responsible for acquiring Miró's *Rosalie* and Beckmann's *Karneval*, two of the Museum's most important works. Their exhibitions elicited interest even in New York City, where they caused Peggy Guggenheim to think of The University of Iowa as the permanent home for two paintings by Jackson Pollock and several other works in her collection. Because he straddled both currents in the 1940s, Guston was well suited to the University; *The Young Mother* represents a merging of these trends in a style that is both modern and traditional, forward-moving and conservative.

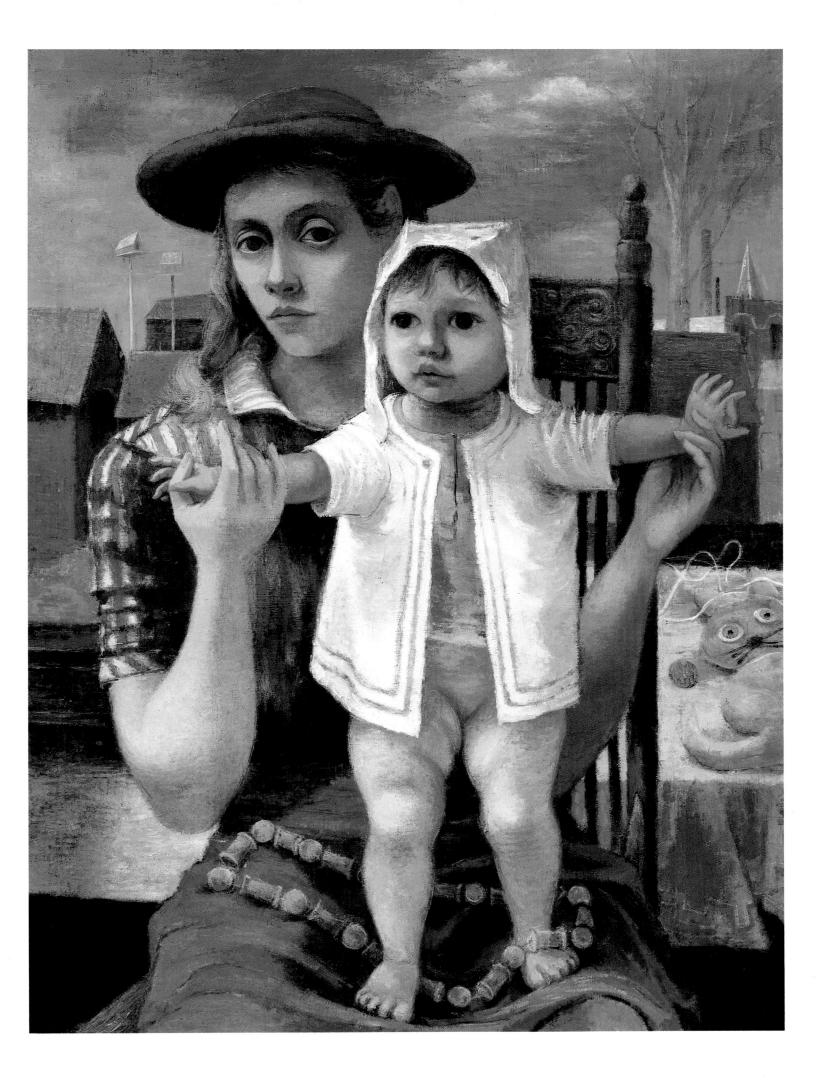

Philip Guston
American, born in Canada, 1913–1980

Edge *1960*
Oil on canvas, 68 × 76 (172.7 × 193.0)
*Purchased with funds from the National Endowment
for the Arts and a matching donation by Mrs. Oral
Sebelin, 1973.29*

In *Edge* Guston teeters between illusionism and
abstraction. He plays a disarming game, suggest-
ing a still life complete with a bottle in a holder,
and then he begins to mask his forms. Surround-
ing what might be a table are a group of abstracted
masks. Are they masks of people, or are they sim-
ply masks whose purpose is to cover rather than to
disclose and to demonstrate that art is about its
own painterly reality even when it hints at other
meanings? In *Edge* Guston creates an inversion of
the traditional realistic still life and presents an ab-
stract painting that hints at a substratum of repre-
sentational still life. The clue to this painting's play
with reality and abstraction is the orange in the
center, which may be a fruit—or it may be simply
a colored abstract shape. Guston allowed the left
and lower margins to remain white and blank to
suggest that painting is an ongoing process of
playing with forms and shapes and not a com-
pleted enterprise. The work is seen by the viewer
in much the same way that it is regarded by the
artist. Both create the work imaginatively, both
attempt to complete it by deciding if its reality is
paint, or if it is a reflection of a reality beyond the
canvas.

Philip Guston
American, born in Canada, 1913–1980

Ramp *1979*
Oil on canvas, 60 × 48 (152.4 × 121.9)
Promised gift of Musa Guston and Musa Mayer

By the end of the 1960s Guston had evolved a third style, one that united his Abstract Expressionist work with his earlier interest in cartoons and social realist art. The new art shocked many critics, who were upset with the way it seemed to span comedy and tragedy, at times oscillating between the two without differentiating one as "low art" and the other as "high art." Critics and viewers felt uncomfortable because they did not know how to react; the art forced them to examine their own assumptions about art's meaning and its status.

Ramp (1979) is representative of this brilliant culminating style. Conceived in deliberately sweet and soft colors, harshly applied, the painting pictures an attempted but futile ascension into heaven. In the tradition of depictions of the Assumption of the Virgin and the Ascension of Christ, the painting shows symbols such as knives and clubs trying to move to a higher spiritual realm but unable to get beyond their own negativity. In this group the words on the book are ironically riveted down, as are the mountings on the garbage can lids (which, years earlier, had served as shields in Guston's paintings of children fighting with makeshift toys). The keyhole and key in this grouping of objects should provide a means of exit, but they are just as mundane and weighted down as the rest of the implements. The keyhole and key do, however, provide a clue to Guston's own relationship to the painting, for they refer to his heart problem: he had a pacemaker, which he felt wound him up like a child's toy.

Ramp ironically pictures symbols of negativity, misunderstanding, and resistance to change (the rivets) that are all attempting a grand take-off, an Assumption. Stuck on the top of the ramp, they become profound and troubling metaphors of human inability to comprehend the meaning of transcendence and the sacrifice it entails.

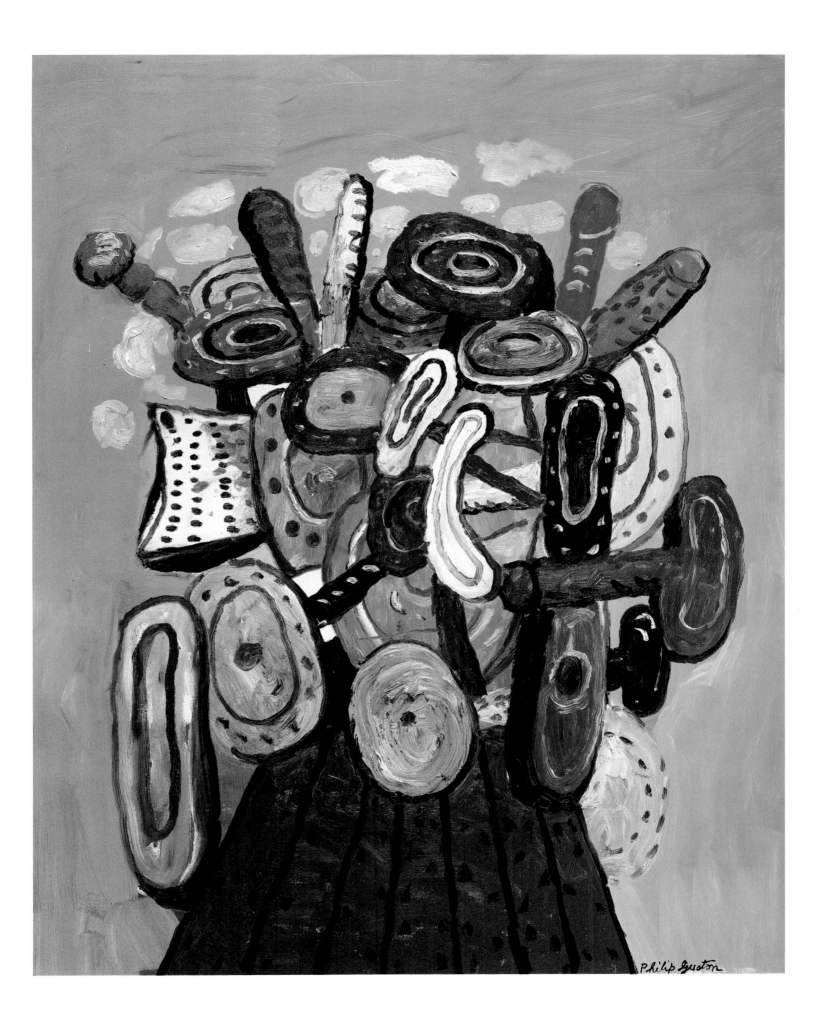

Marsden Hartley
American, 1877–1943

E *1915*
Oil on canvas, 47⅛ × 47¼ (119.7 × 120.0)
Purchase, Mark Ranney Memorial Fund, 1958.1

In a letter of the early 1940s to Duncan Phillips, Arnold Rönnebeck described the special iconography of Marsden Hartley's *Portrait of a German Officer* and pointed to the meaning of other works in the series, including *E*:

"There is a very personal and emotional connection between this picture and myself, because I am partly symbolized in it. I am one half of the Prussian officer. The other half is a cousin of mine. . . . Rather dominating is the Iron Cross. My cousin was killed in action in France on the 24th of October, 1914. (24). He was an active officer in the 4th regiment of the Kaiser's guards (center) 4 on blue ground (of shoulder straps). He received the Iron Cross a day before his death. Next to the 4 is an E and I am certain that it is in red on yellow ground which stands for Queen Elizabeth of Greece or the patroness of the third regiment of the grand-grenadiers in which I then served. The E appears again in the lower middle right on my 'full-dress epaulettes' and the long tassles next to 24 represent the heavy silver-wire tassles I wore as an aide-de-camp in the guards. In the lower left corner we distinguish the initials K.V.F. My cousin's name was Karl Von Freyberg. The triangle symbolized the friendship and the understanding between the three men: Hartley, Karl Freyberg and myself. During the winter of 1914/15 I was hospitalized, wounded and battered in Berlin, but the Iron Cross had already been awarded to me. Hartley admired its beautiful shape, designed by the great German architect Schinckel in 1813, and asked me to leave it on his palette-table as something of a silent friend who had left us. . . . Karl loved to play chess which explains the black and and white squares." The Alfred Stieglitz Archives, Collection of American Literature, Beinicke Rare Book and Manuscript Library, Yale University, quoted in Gail Levin, "Hidden Symbolism in Marsden Hartley's Military Pictures," *Arts*, 54: 2 (October 1979), 155–56.

Fully aware of the possible reaction of New Yorkers to his paintings and their militaristic connotations, Hartley limited the range of meanings of the *German Officer* paintings. He explained in 1916, when forty of these works were exhibited:

"The forms are only those which I have observed casually from day to day. There is no hidden symbolism whatsoever in them; there is no slight intention of that anywhere. Things under observation; just pictures of any day, any hour. I have expressed only what I have seen. They are merely consultations of the eye . . . my notion of the purely pictorial." Marsden Hartley, artist's statement in exhibition catalogue, reprinted in "Hartley's Exhibition," *Camera Work*, no. 48 (October 1916) 12, quoted in Levin, 154.

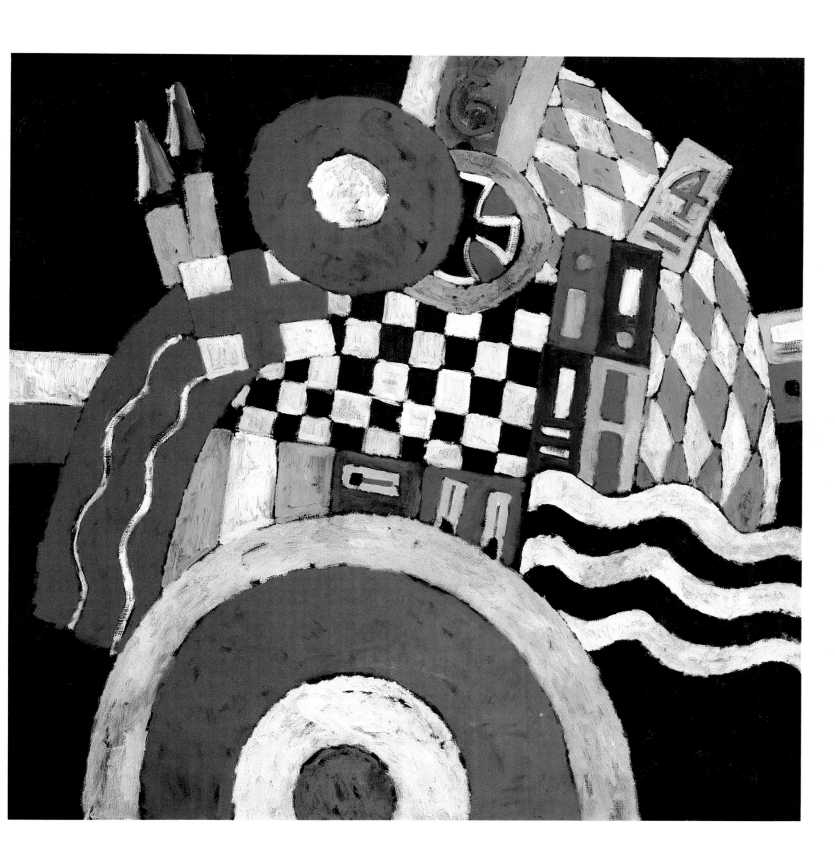

Hannah Höch

German, 1889–1978

Sperrende Kräfte *1929*
[Locking powers]

Oil on canvas, 38⅛ × 38⅛ (96.8 × 96.8)
Museum purchase, 1985.52

Höch is one of the three major Berlin Dadaists, together with John Heartfield and Raoul Hausmann. Although she first became known for her collages, she continued painting throughout her life. Incorporating sections of photographs, her collages, known as photomontages, reinforce the Dadaist claim that painting was a bourgeois art form; they also reflect Höch's work as a pattern designer for major European firms. Her photomontages, unlike those of Heartfield and Hausmann, tended to be autobiographical rather than political.

In 1922 Höch's personal relationship with her mentor and lover Hausmann was terminated, and although she continued to make photomontages, painting came to assume increasing importance for her. In her paintings Höch hoped to make of Dadaism a clear statement of the absurdity and meaninglessness of existence. In turning to painting, she used an art form regarded by the Dadaists as bourgeois in order to mount a critique of the last lingering trace of idealism in Dada: its belief in a future world populated with mechanical forms controlled by precisionist techniques.

In *Sperrende Kräfte* Höch reflects on her relationship with Hausmann, which she pictures as both meaningful and absurd. She views herself and Hausmann as complex toys, Cubist masks, carved facsimiles of plants, and the parents of an unnatural, toylike infant. Hausmann clings to Höch, who struggles to be free. Appearing as Artemis, a many-breasted Greek goddess, Höch cannot free herself because her hands are imprisoned by her thoughts. Rising from the center of her forehead, a point commonly regarded by mystics as the seat of consciousness, one of these thoughts is firmly planted within a ring of the same blue used for Hausmann, suggesting that he has surrounded her both physically and spiritually.

The two figures rest on an insubstantial paper stage; beside them are sections of pipe, a reference to the mechanical forms important to the Dadaists but viewed by Höch as incidental pieces of plumbing. In the background the interaction between Höch and Hausmann is depicted symbolically by a blue accordion plant, which looks as if it is carved out of wood and appears to be sucking power from the pink blossom of a sea anemone. That the blossom symbolizes Höch's creation, the child, is indicated by its reddish pink color, which also is used in a heart firmly planted on the child's head. The small platform beneath the child is the same shade of blue used to color Hausmann, thus connecting the figures and indicating some of the struggles involved when Höch conceived their child. The use of red and pink to symbolize Höch and blue to indicate Hausmann is not unique to this work. As early as 1920 Höch created a painting in which she appears in red and Hausmann in blue.

In *Sperrende Kräfte* Höch uses painting as a means for examining Dada; she also uses it to condemn both herself and Hausmann to a bourgeois purgatory. The resulting work of art is a deeply ironic, even bitter picture of human beings as toys, masks, wooden plants, and actors on a flimsy paper stage. The entire ensemble looks like a table decoration, an insult that Höch uses to emphasize the absurdity of human existence. The protagonists of this painting undergo the emotional and intellectual conflicts that assail many people who believe they must either react to life like mechanical toys or remain true to their nature and grow freely like distinct species of plants. But there is no real choice, since the plants are as wooden as the toylike figures of Höch and Hausmann: both attitudes, Höch implies, are clichés.

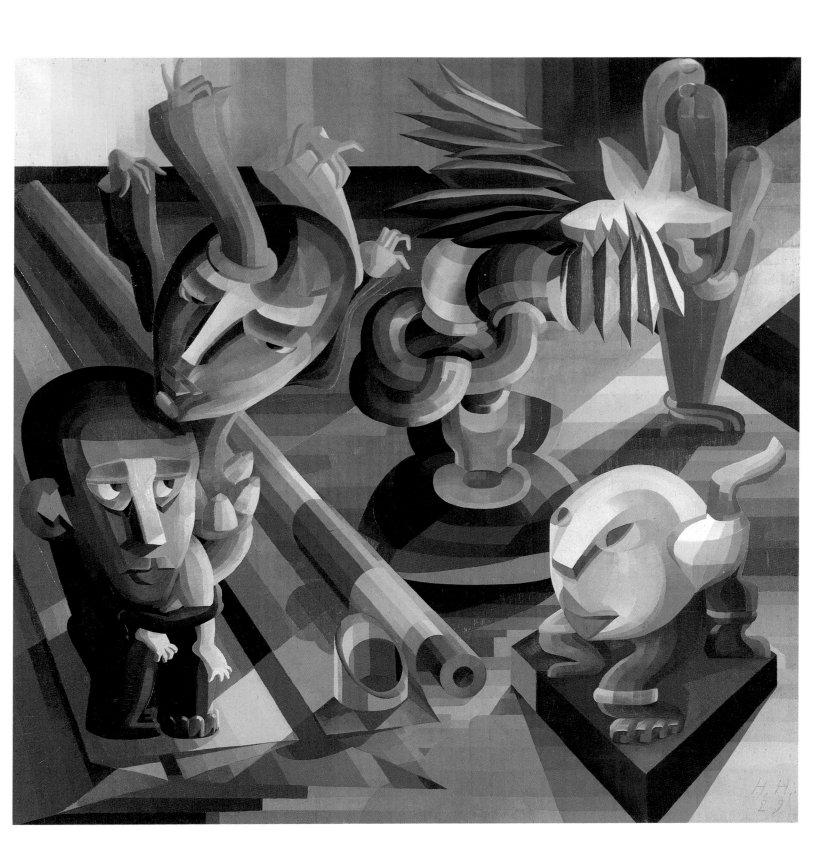

Hans Hofmann
American, born in Bavaria, 1880–1966

The Red Cap *1953*
Oil on canvas, 60 × 48 (152.4 × 121.9)
Promised gift of Dorothy Schramm

Unlike most other Abstract Expressionists, Hans Hofmann never lost touch with his studies of nature. He was older than most of the painters of this group; and he had the advantage of having personally known many School of Paris artists, including Matisse, Delaunay, Braque, and Picasso. Hofmann never lost sight of the fact that, even though he was working from a subject, he was also creating a picture of colors and shapes. He looked for painterly equivalents for objects in nature so that he could transform a painting of them into a spiritual, action-filled creation. In *The Red Cap* Hofmann takes a studio still life as the source for his painting, but the prosaic subject matter has in the end little to do with this largely abstract work in which the color blue seems to have been invented afresh.

Hofmann wished to create "the spiritual third"; he wanted to "impregnate physical limitation from within": "The relative meaning of two physical facts in an emotionally controlled relation always creates the phenomenon of a third fact of a higher order, just as two musical sounds, heard simultaneously, create the phenomenon of a third, fourth, or fifth. The nature of this higher third is nonphysical. In a sense it is magic. Each such phenomenon always overshadows the material qualities and limited meaning of the basic factors from which it has sprung. For this reason art expresses the highest quality of the spirit when it is surreal in nature; or, in terms of the visual arts, when it is of a surreal plastic nature." Hans Hofmann in William C. Seitz, *Hans Hofmann* (New York: The Museum of Modern Art), 53.

Or, putting it differently, Hofmann has written, "A work of art is finished from the point of view of the artist when feeling and perception have resulted in a spiritual synthesis." E. de Kooning, "Hans Hofmann Paints a Picture," *Art News*, 48: 10 (February 1950), 59.

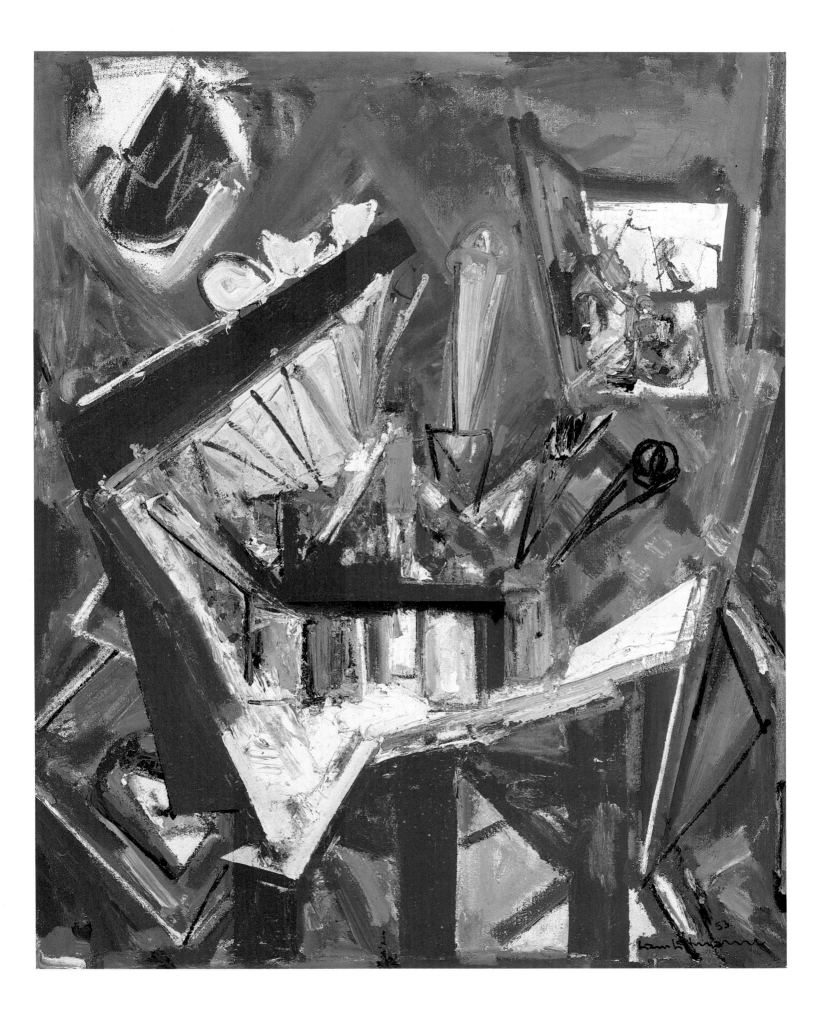

Alexej von Jawlensky
German, born in Russia, 1864–1941

Spanierin *1910*
[Spanish woman] (Spanish Woman with Mantilla)
Oil on canvas board, 38½ × 25½ (97.2 × 64.8)
Gift of Owen and Leone Elliott, 1968.57

Painted in Munich by an expatriate Russian artist strongly influenced by both the new French art and folk art, *Spanierin* testifies to the internationalism of the early-twentieth-century avant-garde. The painting is a portrait of Helene Nesnakomoff, whom the artist married in 1922; it remained in her collection until it was sold in 1965 to the Elliotts, who donated it two years later to the Museum of Art.

Less an outpouring of feeling than a general stocktaking of avant-garde painting, *Spanierin* reflects what Jawlensky had learned from his friend and teacher Henri Matisse about the liberal use of highly saturated hues of related value. The subject matter of this painting looks back to Edouard Manet's paintings of Spanish subjects and recalls the esteem with which mid-nineteenth-century French artists regarded Spanish painting, which seemed to them exotic and bold and not at all European. Although *Spanierin* is as much a formal investigation as it is a portrait, it is also an expression of romantic feelings about exotic cultures. In the early twentieth century, artists experimented with ways of communicating forcefully within the limits of their medium. Jawlensky found Spanish costumes, French-inspired color, and the uninhibited direct painting of Bavarian folk art important sources for his stolid and forceful *Spanierin*.

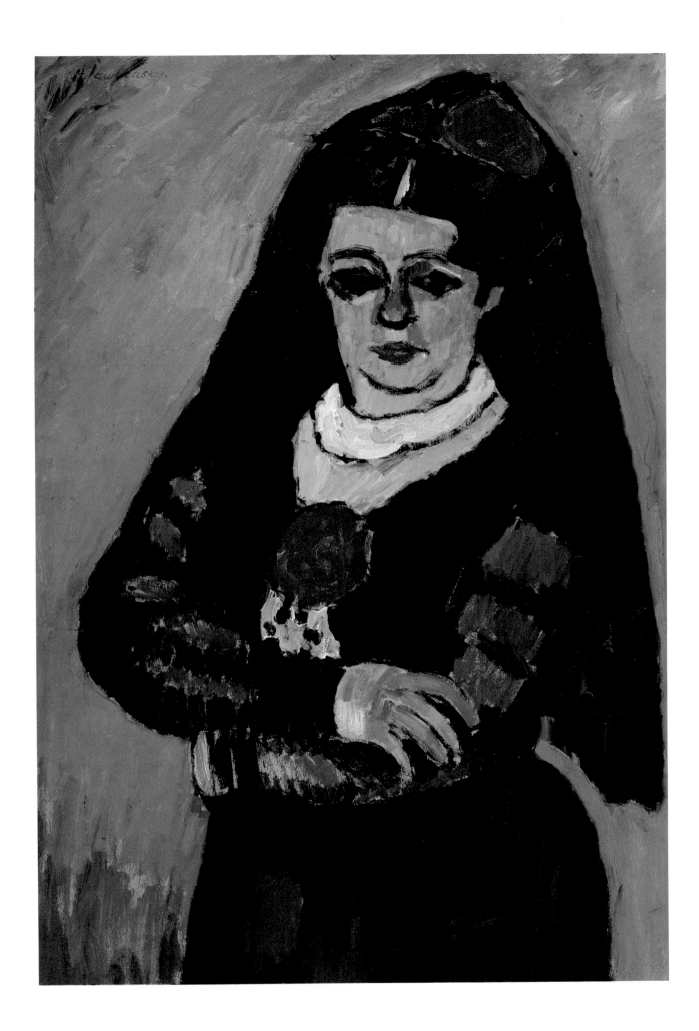

Wassily Kandinsky
Russian, 1866–1944

Verdichtung *1929*
[Compression]
Oil on canvas, 39½ × 31½ (100.3 × 80.0)
Gift of Owen and Leone Elliott, 1968.26

Concerned with the overwhelming material-
ism left in the wake of the Industrial Revolution,
Kandinsky sought a new abstract art capable of
evoking spiritual vibrations, an art made of its
own inherent elements—simple geometric forms
and pure colors, an art that no longer needed to
represent prosaic reality. Kandinsky felt that the
new art would manifest new spiritual freedoms.
Early in his career, he had become attuned to the
Theosophic belief in the energy field of thought
and the colored auras produced by feeling. In his
art he sought to evoke these thought forms. Less
than a decade after creating his first abstract work,
Kandinsky returned to his native Russia because of
World War I, and he later participated in the Bol-
shevik victory. At that time he became convinced
of the power of pure geometric forms and the ways
that art can envision a utopia. He later synthesized
these spiritual and idealistic concepts; in *Verdich-
tung*, painted in Paris, he unites pure geometric
form with ambient areas reflecting unseen but in-
tuited feelings.

One of the great originators of the century,
Kandinsky is credited with being the first artist to
create abstract or nonobjective art. A more useful
assessment of his accomplishment would be that
he was the first to create a cogent theory that
took into consideration the spiritual need for an
abstract art.

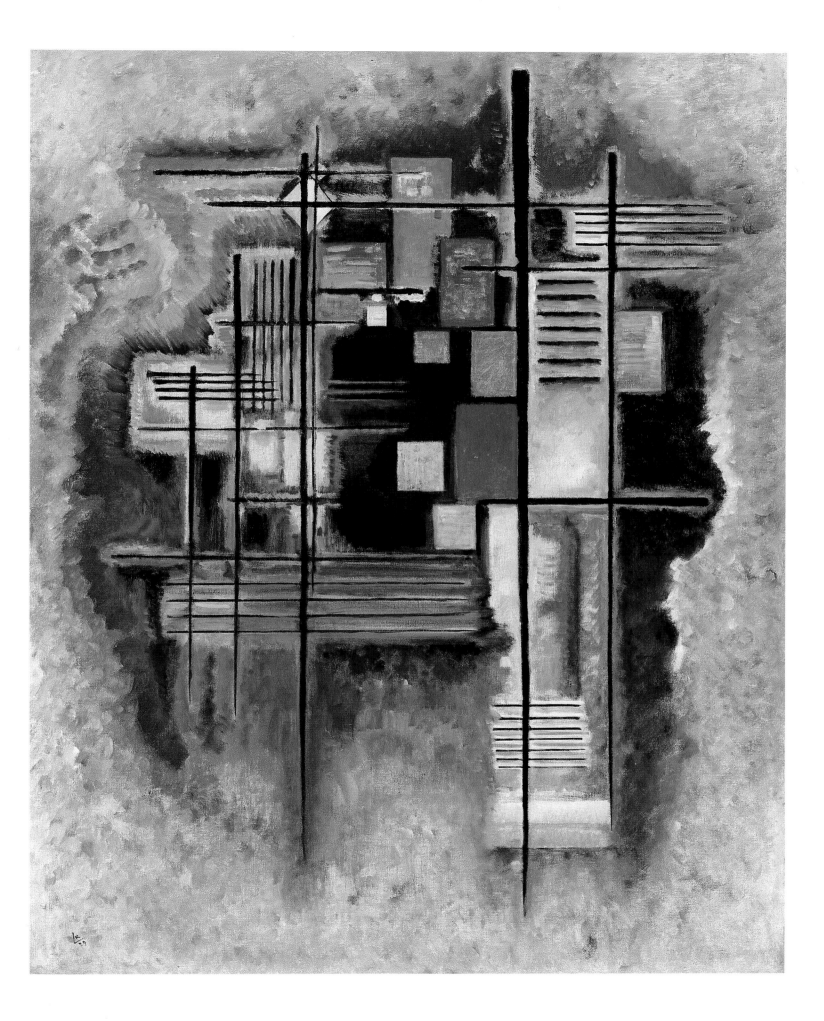

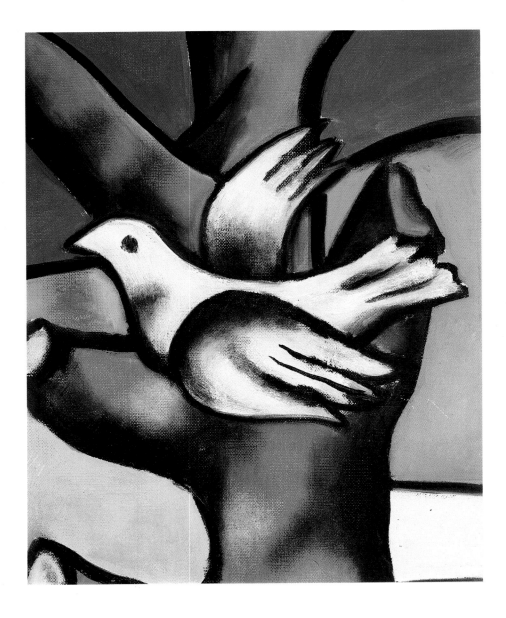

Fernand Léger
French, 1881–1955

Un Chapeau noir sur une
chaise jaune *1952*
(Black Hat on a Yellow Chair)
Oil on canvas, 36 × 25½ (91.4 × 64.8)
Gift of Owen and Leone Elliott, 1968.29

"A foot in a shoe, under a table, projected and
magnified ten times, becomes a surprising fact that
you have never noticed before. It takes on a reality,
a new reality that does not exist when you look at
the back of your leg unconsciously while you are
walking or sitting. . . .

"One then understands that everything is of
equal interest, that the human face or the human
body is of no weightier plastic interest than a tree,
a piece of rock, or a pile of rope. It is enough to
compare a picture with true objects, being careful
to choose those that may best create a composi-
tion. It is a question of choice on the artist's part.
An example: if I compare a picture and use as an
object a piece of tree bark, a fragment of a butter-
fly's wing, and also a purely imaginary form, it is
likely that you will not recognize the tree bark or
the butterfly wing, and you will ask 'What does
that represent?' Is it an abstract picture? No, it is a
representational picture. What we call an abstract
picture does not exist. There is neither an abstract
picture nor a concrete one. There is a beautiful pic-
ture and a bad picture. There is the picture that
moves you and the one that leaves you indifferent.
A picture can never be judged *in comparison* to
more or less natural elements. A picture has a
value in itself, like a musical score, like a poem."

Fernand Léger, "The New Realism," in his *Func-
tions of Painting*, trans. Alexandra Anderson and ed.
Edward F. Fry, The Documents of Twentieth-
Century Art (New York: Viking Press, 1973), 111.

Even though Léger rejects a narrative reading of
his art, he does create new dislocated images that
symbolize the abrupt changes and consequent dis-
junction of modern life. Putting familiar items
such as a chair, a hat, and a dove in a new environ-
ment, he creates startling, evocative images.

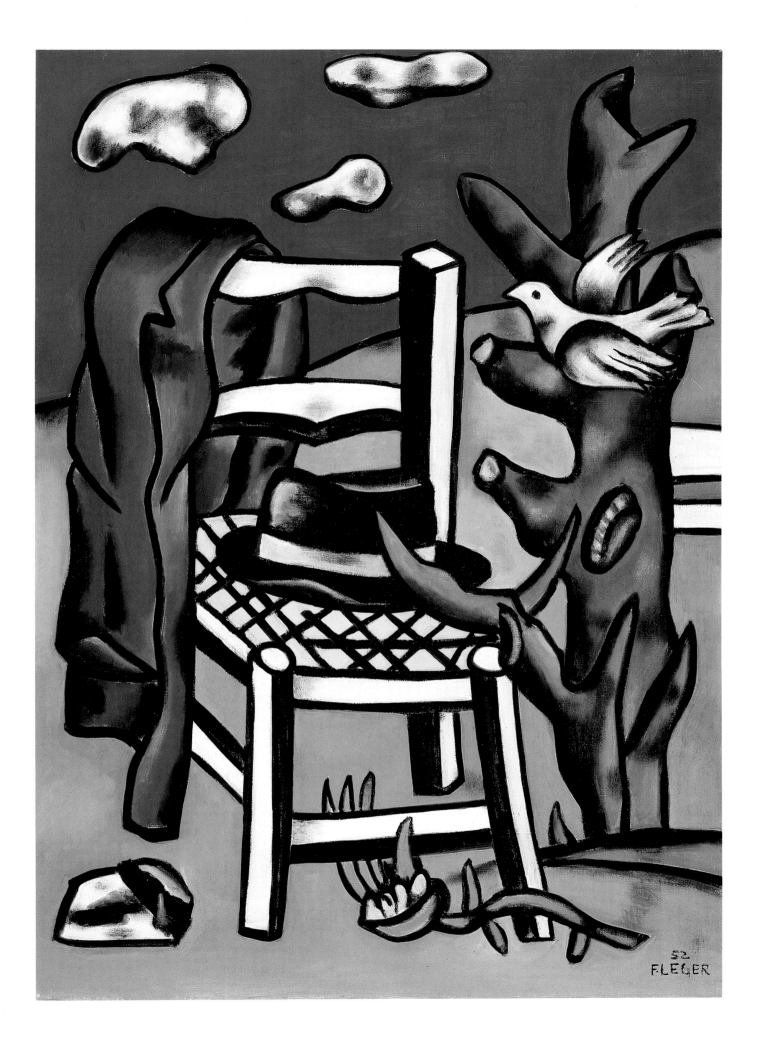

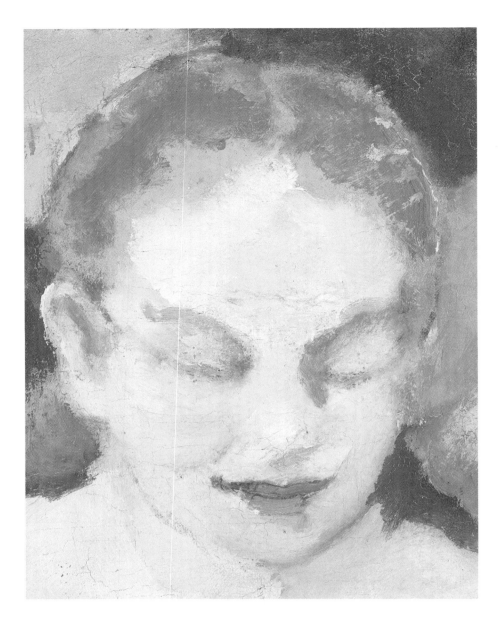

Franz Marc
German, 1880–1916

Akte auf Zinnober *1910*
[Nudes on vermilion]
Oil on canvas, 31¾ × 23¾ (80.6 × 60.3)
Gift of Owen and Leone Elliott, 1968.64

Deeply religious, Franz Marc believed that art had an important spiritual function in modern life. He felt that art communicated on two levels: the level of subject matter, which cued viewers into the meaning of the work, and the level of color, which set off a series of spiritual vibrations and awakened in viewers new sensations of being. His color symbolism was influenced by the art of Van Gogh and Gauguin, but it was also felt personally and became an intense and elemental force throughout his work. His *Nudes on Vermilion* incorporates some of his ideas. Presenting two robust nudes in the landscape, Marc indicates a new paradise available for all who are willing to remove the clothing of civilization and merge with nature.

In a letter of 12 December 1910 Marc described his interest in color symbolism to his friend August Macke and made reference to *Nudes on Vermilion*: "Blue is the masculine principle, robust and spiritual. Yellow is the feminine principle, gentle, serene, sensual. Red is nature, brutal and heavy." He has said that he created his female nudes in a "minor key" by using "blond" colors. Painted primarily in yellow, the nudes in this painting serve as "the feminine principle," while the background of red indicates matter, or nature. Accents of violet and green balance the warm colors and create an overall harmony in the composition.

As much a manifestation of Marc's ideas about color symbolism as it is a representation of women, *Nudes on Vermilion* anticipates Marc's later work, which is concerned with animism, the indwelling spirit in nature, and its opposite, alienation, which he viewed as the tragedy of modern life.

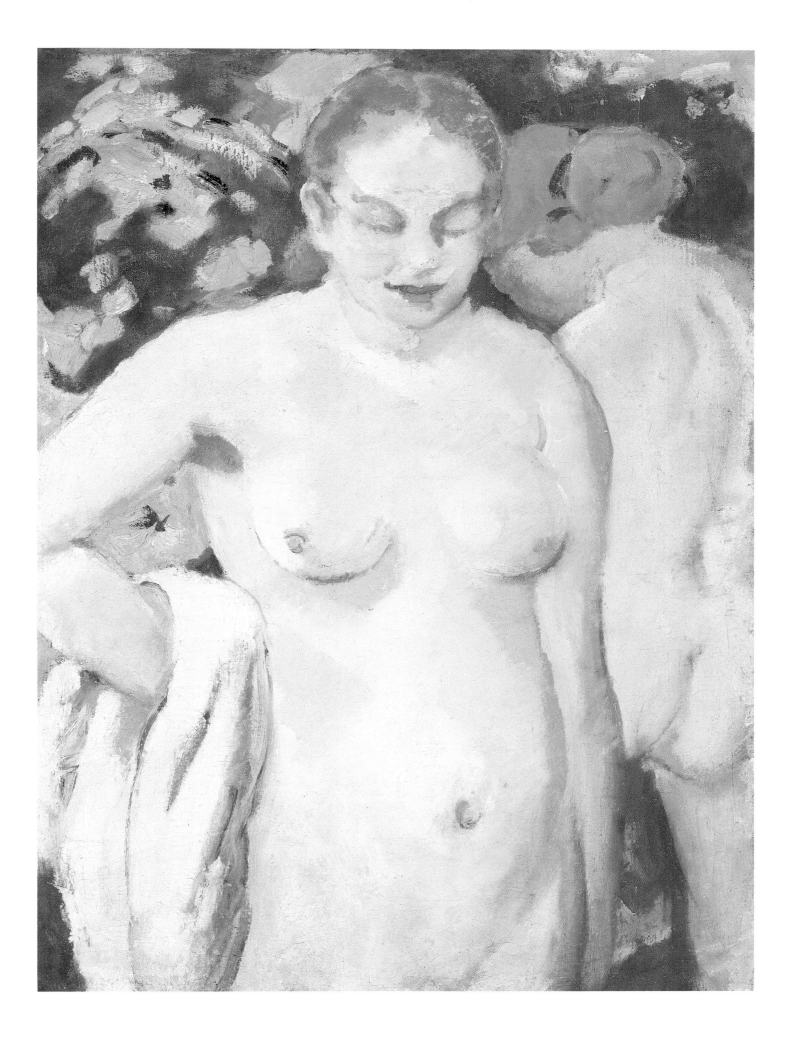

Henri Matisse
French, 1869–1954

Blue Interior with Two Girls *1947*
Oil on canvas, 25¾ × 21¼ (65.4 × 54.0)
Gift of Owen and Leone Elliott, 1968.38

Trained as a lawyer, Matisse reckoned with his art in a most logical fashion. Viewing painting as an opening into a fictive realm, he underscored art's function by frequently creating images of windows or doors within an interior. After carefully working out his composition, he often quickly painted a second version that would appear fresh, spontaneous, and sometimes even offhand.

Blue Interior with Two Girls depicts a partly opened window. The painting's ability to suggest and allude is underscored by the plant on the table, which partially obscures one of the girls. The plant rhymes visually with nature outside the window and the realm of realistic appearances that is just beyond the real confines of painting.

Matisse rejected the naturalism of his predecessors, the Impressionists, and opted for the realism of the artist's medium. After all, he reasoned, a painting is first and foremost a series of colors and shapes on a two-dimensional surface. In his art Matisse stresses the fact that a picture is a convention realized in paint on canvas. The image depicted reinforces the feeling evoked by the saturated colors and the abstract shapes; the reverse is true in traditional art. As a consequence the two girls and the interior are subservient to the realization of an abstract harmony, which is the artist's aim.

Matisse seems to follow the example of the French Symbolist poet Stéphane Mallarmé, who first made a statement to the artist Edgar Degas that he later recorded in *Divagations*: "It isn't with ideas but with words that one makes a poem." (Cited in Anna Balakian, *The Symbolist Movement: A Critical Appraisal* [New York: New York University Press, 1977], 87.) Similarly, it is not with ideas or narrative but with paint and canvas that one makes a painting.

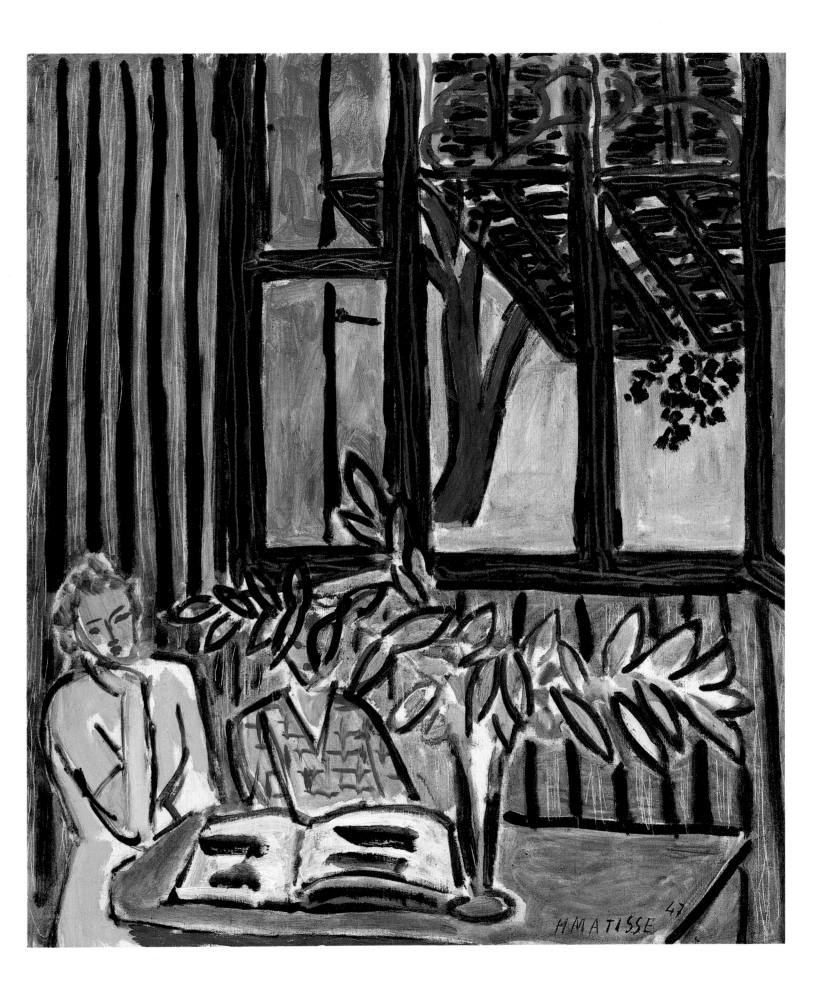

Matta
(Roberto Sebastián Antonio Matta Echaúrren)
French, born in Chile in 1911

Like Me, Like X *1942*
Oil on canvas, 28 × 36 (71.1 × 91.4)
Gift of Peggy Guggenheim, 1955.4

Trained as an architect in his native Chile, then employed as a designer in Le Corbusier's office in Paris, Matta joined forces with the Surrealists, becoming one of their youngest converts in the late 1930s. His interest in rational architectural spaces quickly changed to an interest in nonrational, psychic spaces, capable of infinite expansion as well as total contraction into claustrophobic voids. Spaces in his art are no longer landscapes but are instead inscapes, spaces responsive to human emotions.

In an essay entitled "Sensitive Mathematics—Architecture of Time," he described these spaces: "The question is to discover the way to pass between the rages that move in tender parallels, in soft and thick angles, or under hairy undulations through which many fears are clinging. Man regrets the dark thrusts of his origins, which wrapped him in wet walls where blood was beating near the eye with the sound of the mother. . . . We must have walls like wet sheets that get out of shape and fit our psychological fears. . . . Find for each of these umbilical cords linking us with other suns objects of total liberty which would be like plastic psychoanalytical mirrors." *Minotaur*, no. 11, May 1938, quoted in *The Autobiography of Surrealism*, ed. Marcel Jean (New York: Viking Press, 1980), 338.

Jean Metzinger
French, 1883–1956

Two Nudes in a Garden *c. 1906*
Oil on canvas, 36 × 25⅛ (91.4 × 63.8)
Gift of Owen and Leone Elliott, 1968.33

This Neo-Impressionist painting reflects Metzinger's formal researches into color. It also anticipates his interest in Cubist structure, but, most important, it manifests a definite interest in an ideal realm. The subject matter of this painting was also used by some of Metzinger's contemporaries: Matisse created images of Arcadia, and Derain reflections of the Golden Age. Early in the twentieth century, several of these artists transformed Neo-Impressionism, a pseudo-scientific method of research into the way color functions, into a mosaic-like format that uses tiny blocks of color like those of Roman and early Christian mosaics. In the hands of these artists, Neo-Impressionism became an archaizing tool, a lens for viewing Arcadia distantly and nostalgically.

Joan Miró
Spanish, born 1893

A Drop of Dew Falling from the Wing of a Bird Awakens Rosalie Asleep in the Shade of a Cobweb *1939*

[Une goutte de rosée tombant de l'aile d'un oiseau réveille Rosalie endormie à l'ombre d'une toile d'araignée]

Oil on basketweave fabric, 25¾ × 36⅛ (65.4 × 91.8)
Purchase, Mark Ranney Memorial Fund, 1948.3

When Francis Lee, an American soldier, had an opportunity to interview the painter Joan Miró soon after World War II, he asked questions that seemed at the time naive but that produced special insights into the artist's schedule, his way of working, and his attitudes toward art. After Lee questioned Miró about his daily routine, his preferences in literature and music, and his interest in painting on Sunday (in other words, was he a Sunday painter?), he asked, "What do you think is the direction that painting ought to take?" And Miró's response was, "To rediscover the sources of human feeling." Then Lee wondered why art sometimes seems so far removed from life. Miró reflected and answered, "We live in a period of transition. It is necessary to make a revision of everything that has been done." *Possibilities: An Occasional Review*, no. 1 (Winter 1947–48), ed. Robert Motherwell, Harold Rosenberg, Pierre Chareau, and John Cage (New York: Wittenborn, Schultz, 1947), 66–67.

Certainly in *Rosalie*, created nine years before his conversation with Lee, Miró attempted to ground art in feeling and to change the common assumption that significant painting has to deal with serious subject matter. In *Rosalie*, as in most of his art, Miró uses human feeling as a guide. The result is that the scale of an object becomes a reflection of the importance of that object to him and has little to do with its relative scale in the world. Miró's changes of scale have comic results as well as profound implications about the consequences of using feeling as a measure of importance: in *Rosalie* a spider is as large as a bird's head, a drop of dew is the size of an eye, and the hair in Rosalie's nostrils, on her breasts, and under her arms is more important than the hair on her head. With her arms stretching upward, Rosalie dominates the painting. About her head fly several birds. In the upper left a star appears in the sky, balanced on the lower right by the cobweb mentioned in the title. *Rosalie* is both whimsical and nonsensical; it has the nonsense of a children's story that ingratiates as it teaches important truths about the way an accurate depiction of one's feelings can totally change the appearance of the world.

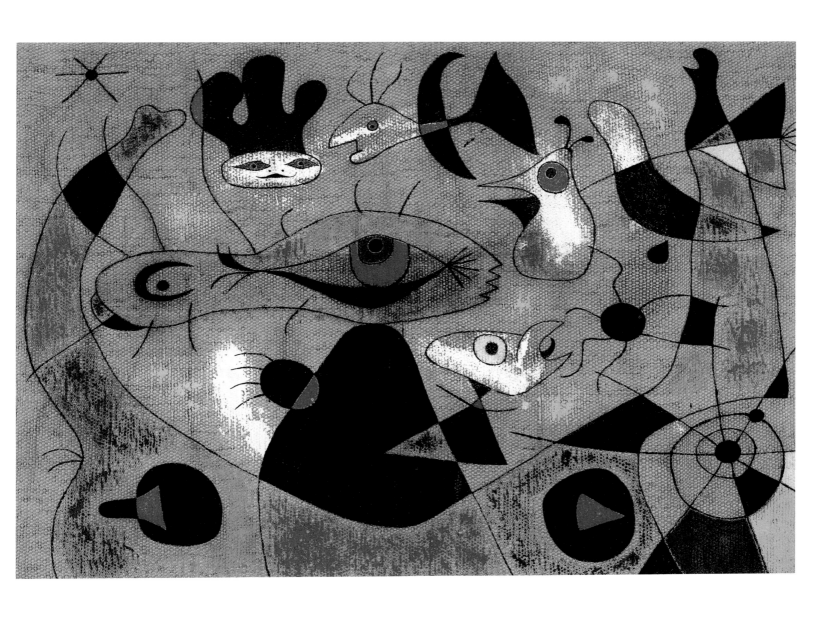

Joan Mitchell
American, born 1926

Red Painting No. 2 *1954*
Oil on canvas, 66 × 72 (167.6 × 182.9)
Gift of Frederick King Shaw, 1973.34

Unlike the "first-generation" New York School painters who were intent upon creating inscapes—visions of the unconscious—Mitchell and the so-called second-generation artists sought to create abstracted landscapes. They were influenced by the grand traditions of modern art, beginning with Cubism and extending through German Expressionism and postwar European painting. Mitchell's is a lyrical art, spontaneously conceived and elaborated with cascading brushstrokes, rich color, and diaphanous atmospheric effects.

Giorgio Morandi
Italian, 1890–1964

Natura morta *c. 1957*
(Still Life)
Oil on canvas, 10 × 16 (25.4 × 40.6)
Gift of Owen and Leone Elliott, 1968.36

 "Everything is mystery, ourselves, and all things both simple and humble." Giorgio Morandi, as quoted in *Painters' Painters*, exhibition catalogue, Hoyt L. Sherman Gallery, March–April 1984 (Columbus, Ohio: University Gallery, Ohio State University, 1984), 15.

Robert Motherwell
American, born 1915

Elegy to the Spanish Republic,
No. 126 *1965–75*
Acrylic on canvas, 77¾ × 200¼ (1.98 × 5.09 m)
*Purchased with funds from the National Endowment for
the Arts and matching donations, and gift of the artist,
1973.289*

Elegy to the Spanish Republic, No. 126 is an en-
largement of a 1965 drawing that Ulfert Wilke,
then director of the Museum of Art, saw in Mother-
well's studio. Originally the painting that was to
be developed from the drawing was to be sixteen
feet high and twenty feet wide. Because canvas
could not be found in the United States in this
size, the *Elegy* was created in its present dimen-
sions. The work was made to be hung opposite
Pollock's *Mural.* Motherwell wished to create a
powerful, cadenced work that culminated the aims
of all the Abstract Expressionists, who hoped to
symbolize their own intuitive understandings of
the unconscious in monumental and universal
works of art.

Elegy to the Spanish Republic, No. 126 attempts
to deal with the abstractness of modern life and
with its tensions, which are symbolized by ovoids
caught between implacable verticals. The *Elegy* se-
ries is concerned with the loss of idealism; the title
recalls the demise of the Spanish Republic, the en-
suing civil war in Spain, and the enormous con-
flicts of the world war that followed. Motherwell
believes that the Spanish Civil War was a rehearsal
for World War II, and he pays homage to this tragic
rehearsal in the *Elegies.*

Gabriele Münter
German, 1877–1962

Schnee und Sonne *1911*
(Snow and Sun)
Oil on cardboard, 20 × 27½ (50.8 × 69.8)
Gift of Owen and Leone Elliott, 1968.63

Gabriele Münter created *Snow and Sun* the same year that she joined Kandinsky, Marc, and Kubin in establishing the group called the Blauer Reiter. *Snow and Sun* reflects some of the interests she shared with members of this German Expressionist group, which espoused no single style even though all its members appreciated the advances made by the French Fauvists and the enduring strengths of naive, folk, tribal, and children's art. Dividing her time between Munich and her home in the nearby Alpine village of Murnau, Münter assimilated the sophisticated, forceful art of the Fauves, which emphasized pure color directly applied, and combined this approach with the schematic shapes of regional folk art, particularly Bavarian *Hinterglasmalerei*, "painting behind glass." In her art she sought color equivalents for both feelings and forms in nature, and she attempted to weld these two elements into an art that was true to both feeling and visual perception. Her experiments parallel those of other twentieth-century artists who believed modern culture to have become too mechanized, too detached from real feeling and a true understanding of existence. These artists, who often relied upon folk or tribal art, parallel thinkers like Leo Tolstoy, who looked to the life of the Russian peasant as a model for a clearly defined, satisfying existence.

Recalling her experience of learning to paint quickly and forcefully in the first decade of the century, Münter told Edward Roditi in the 1950s: "Later, of course, here in Murnau, I learned to handle brushes too, but I managed this by following Kandinsky's example, first with a palette knife, then with brushes. My main difficulty was that I could not paint fast enough. My pictures are all moments of my life, I mean instantaneous visual experience, generally noted very rapidly and spontaneously. When I begin to paint, it's like leaping suddenly into deep waters, and I never know beforehand whether I will be able to swim. Well, it was Kandinsky who taught me the technique of swimming. I mean that he taught me to work fast enough, and with enough self-assurance, to be able to achieve this kind of rapid and spontaneous recording of moments of life." Edward Roditi, *Dialogues on Art* (Santa Barbara: Row-Erickson, 1980), 151–152.

Ben Nicholson

English, born 1894

(May 1965) Carnac *1965*
Relief: oil on carved Masonite,
40⅛ × 46 (101.9 × 116.8)
Gift of Owen and Leone Elliott, 1968.60

"A great deal of painting and sculpture today is concerned with the imitation of life, with the imitation of a man, a tree or a flower instead of using colour and form to create its *equivalent*; no one will ask what a tree is supposed to represent and yet, with the most innocent expression in the world, they will ask what a painting or a sculpture or a construction in space is supposed to represent. This equivalent must be conceived within the terms of the medium, it must be pure painting and sculptural expression, since the introduction of anything extraneous means that the conception is adulterated and therefore that it can no longer have a complete application to other forms of life.

"One of the main differences between a representational and an abstract painting is that the forms can transport you to Greece by a representation of blue skies and seas, olive trees and marble columns, but in order that you may take part in this you will have to concentrate on the painting, whereas the abstract version by its free use of form and colour will be able to give you the actual quality of Greece itself, and this will become a part of the light and space and life in the room—there is no need to concentrate, *it becomes a part of living.* . . .

"The geometrical forms often used by abstract artists do not indicate, as has been thought, a conscious and intellectual mathematical approach—a square or a circle in art are nothing in themselves and are alive only in the instinctive and inspirational use an artist can make of them in expressing a poetic idea. If you take a large ultramarine blue and a small cadmium red square and place them on a cool white surface along with a pencilled circle, you can create a most exciting tension between these forces, and if at any time their tension becomes too exciting you can easily, by the smallest mark made by a compass in the centre, transfix the circle like a butterfly!"

Ben Nicholson, "Notes on 'Abstract Art,'" in *Ben Nicholson* (London: Studio International, 1969), 33–34.

I. Rice Pereira
American, 1907–1971

Eight Oblongs *1943*
Encaustic on parchment, 19 × 25 (48.3 × 63.5)
Gift of Peggy Guggenheim, 1947.41

Although I. Rice Pereira shares the attitude of
many twentieth-century nonobjective painters
who idealized geometry and science, viewing
them romantically and mystically, she is unique
in her emphasis on transparent and translucent
surfaces that suspend and reflect light, making it
a real and indispensable element of art. In 1939
Pereira began painting on glass; two years later she
turned to parchment. *Eight Oblongs* unifies her
complex, modernistic geometric forms with trans-
lucent parchment, a writing material used for legal
documents for centuries, to create an image of art
as a universal outside the constraints of time.

Jackson Pollock

American, 1912–1956

Mural *1943*

Oil on canvas, 8' 1¼" × 19' 10" (2.47 × 6.05 m)
Gift of Peggy Guggenheim, 1959.6

In the late 1930s and early 1940s, Pollock attempted to control his alcoholism by going to a Jungian psychiatrist. He was encouraged by Jung's method to analyze his chaotic drawings picturing demons, Picassoid heads, El Greco figures, and African masks, and he was still fighting his way to self-knowledge when he painted the Iowa *Mural* in 1943. He had read nineteenth-century U.S. Bureau of Ethnology reports and was taken with the idea that Navajo Indians made sand paintings to heal people by uniting them with their environment, by surrounding them with symbolic pictures that seem to compensate for their inadequacies and make them feel whole and complete. Painted for the foyer of Peggy Guggenheim's New York townhouse, Pollock's *Mural* was important in bringing psychiatry out of the back room and placing it in the reception hall.

The *Mural* is art made useful, reinvigorated with some of its primitive magic, art made during the middle of World War II when Planet Earth itself seemed to be undergoing severe neurosis. Pollock had grandiose ideas: he felt the need to heal himself, and he felt that since Paris, the former world art center, had been overtaken by the Nazis, he had to go back to the beginnings of art—to Navajo sand paintings, Jung's archetypes, and a layering of images that suggested the primordial chaos at the basis of life and thought. Forceful and aggressive, the painting demonstrates how Pollock reacted to his own personal problems and to the war. It also demonstrates the acceptance that his imagery found with Peggy Guggenheim, a prominent collector of modern art who was then running an art gallery assertively titled "Art of This Century." Guggenheim was married to Max Ernst, a leading Surrealist painter who, like Pollock, held American Indian art in great esteem and found psychiatry a most convincing approach to explaining human behavior.

Hemmed in by the ceiling and walls of the townhouse, Pollock's *Mural* originally was intended to be apocalyptic wallpaper. The great rhythmic striding figures recall the personages of Miró's paintings and the Yei figures of Navajo sand painting. Although the paint in *Mural* is not poured as in Pollock's later drip paintings, but splashed and splattered, this work does anticipate the large scale of his later works. The work was supposedly painted in one session, and its emphasis on spontaneity and bravura helped give rise to the 1950s term "action painting." *Mural* boldly announces Pollock's interest in a portentous subject matter that is similar to myth and magic in not being easily understood by the conscious mind.

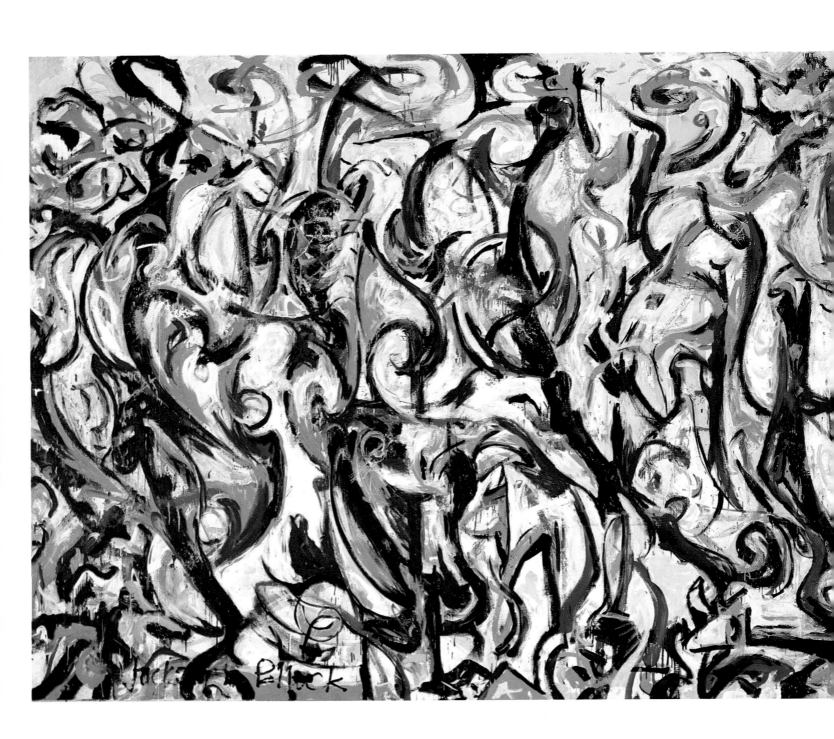

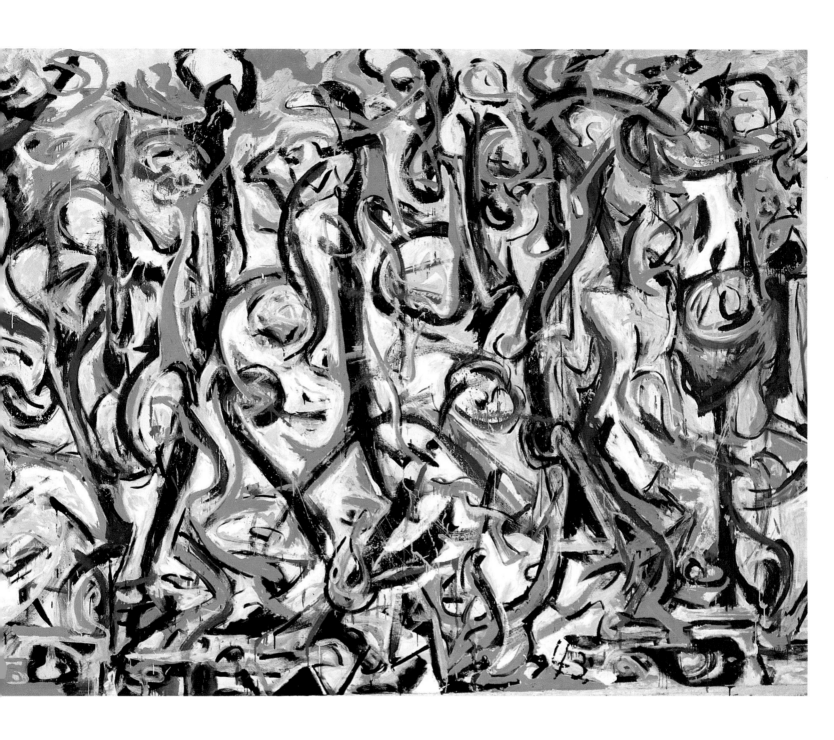

Jackson Pollock
American, 1912–1956

Portrait of H.M. *1945*
Oil on canvas, 36 × 43 (91.4 × 109.2)
Gift of Peggy Guggenheim, 1947.39

 H.M. could refer to the French artist Henri Matisse, to Pollock's friend Helen Marot, who helped him seek the aid of a Jungian analyst, to Herbert Matter, another friend, or to Herman Melville, author of *Moby Dick*. Melville is the most logical referent, for the coruscations of paint in this work resemble a maelstrom, and the central form appears to be a ship at sea. For American artists working in the 1940s, Melville's *Moby Dick* seemed to be the American analogue to James Joyce's *Ulysses*. It was a symbolic and psychological journey into the inner recesses of the mind, the dim pathways filled with little-understood passions and yearnings. Consequently, the Pollock painting is filled with spontaneously applied paint and with strange overlying strokes that indicate strong feelings caught up in waves of turmoil.

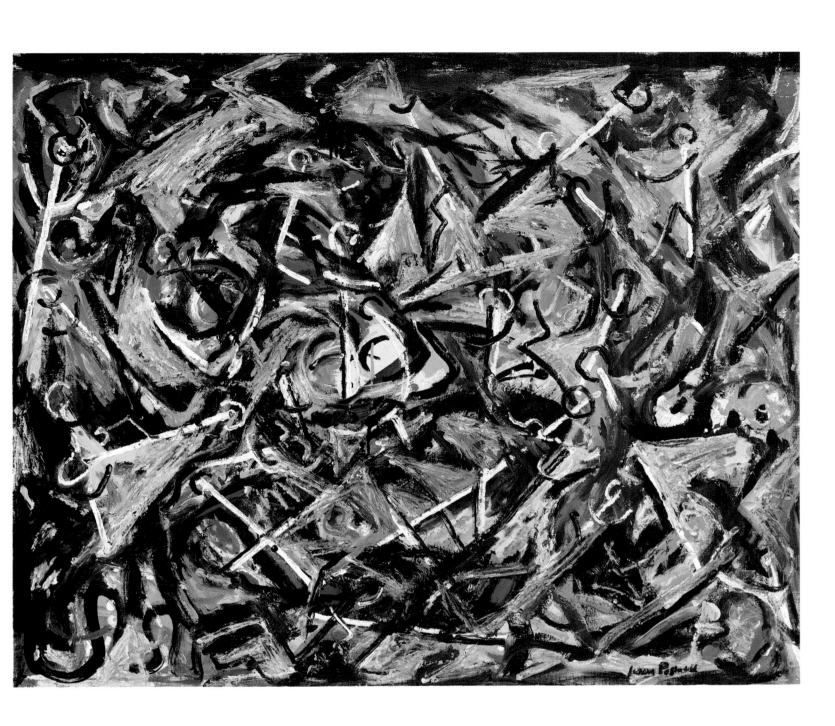

Severin Roesen

American, born in Cologne, c. 1815/17–c. 1871

Nature's Bounty *c. 1855*

Oil on canvas, 29½ × 43½ (74.9 × 110.5)
Gift of Robert P. Coggins, 1980.188

Little is known about the early life of Severin Roesen except that he was born in Cologne, was known as a porcelain and enamel painter, and exhibited a flower painting there in 1847. After coming to the United States, he quickly established a reputation in New York City for his monumental still lifes, in part because they seemed more impressive than the few austere still lifes created earlier by members of the Peale family.

Roesen brought to America the recently renewed European interest in Dutch seventeenth-century still life painting. His style was especially appropriate to the art then being created in the United States. By the 1840s many Hudson River School landscape painters, including Thomas Cole and Jasper Francis Cropsey, had already turned from paintings emphasizing the wildness and force of nature to generous open landscapes reflecting the lushness and richness of a promised land that had been pioneered and peacefully inhabited. To viewers enjoying the first fruits of newly settled upper New York State and the opening of the Ohio Valley, a lush still life that spared them traditional warnings about the transitoriness of life must have seemed particularly satisfying.

Mark Rothko
American, born in Latvia, 1903–1970

Untitled *1968*
Acrylic on paper mounted on Masonite panel,
39¼ × 25⅛ (99.7 × 63.8)
Gift of The Mark Rothko Foundation, 1985.47

Mark Rothko's mature Abstract Expressionist works of the 1950s and 1960s never become abstracted landscapes. Always they oscillate between being ingratiating and being difficult; they seem to allow entry, but in actual fact they become soft, misty barriers. They act as veils that defy trespassers, and they appear spiritual because they suggest the ineffable and provide no conscious way of attaining it.

Forms always float in these paintings, and they are always surrounded by margins that mark off the edge at the same time that they protect the soft, hovering shapes in the center. These works choreograph their viewers, who often find that they experience sensations of floating when they are looking at them. The floating sensation may be an accurate physiological account of one's experience of looking at a Rothko, since the works emphasize peripheral scanning and provide viewers few elements on which they can focus their attention. Since peripheral viewing is unfocused and largely unconscious, it may serve as a perceptual equivalent to the unconscious or preconscious mind. In this way Rothko may have found for himself what the Abstract Expressionists sought, the route to a meaningful content that eludes the conscious mind and communicates its intuited meanings directly to the unconscious.

Lucas Samaras
American, born in Greece in 1936

Reconstruction No. 69 *1979*
Sewn fabrics, 61 × 65 (154.9 × 165.1)
Purchased with funds from the National Endowment for the Arts and matching donations from Mr. and Mrs. Herbert Lyman and Elizabeth A. Hale, 1980.3

In *Reconstruction No. 69* Samaras creates a crazy quilt of high-fashion fabrics that makes fun of many attitudes common to the New York School in particular and to modernist art in general. Playing on the overall appearance of Jackson Pollock's famous drip paintings, Samaras chooses a black and white material that looks as if it has been spattered with paint; this fabric helps to form a Pollock-like composition without a central focus. Parodying Pollock's drips, the fabric suggests that a similar effect can be obtained with yard goods, that a painting is nothing more than a piece of decorated material.

In the mid-seventies, while Samaras was creating his crazy quilts, artists on the East and West Coasts proclaimed a new style known as Pattern Painting. Important proponents of this style, in addition to Samaras, included Robert Krushner, Kim McConnell, Miriam Schapiro, and Robert Zakanitch. These artists thought of painting as an outworn convention with little metaphysical power but plenty of decorative potential; they used decorative elements with a vengeance to create a certain edge, to intensify their compositions with cacophonous combinations. They seemed to accept the merely decorative elements that Abstract Expressionists feared the most.

Abstract Expressionists like Philip Guston, Mark Rothko, Robert Motherwell, and Jackson Pollock had at first been afraid of creating abstract art because they feared that abstract works would be meaningless and pretty. They wanted to create new meanings that were profoundly moving and at the same time indicative of their own personal traumas and intuitively perceived truths, meanings that would appeal to viewers on an unconscious level. The Pattern Painters saw depth of this sort as unattainable. They caricatured modernist painting as an outworn decorative sensibility that included modernist-inspired fabrics of the forties and fifties, not to mention tasteless wallpaper designs that appear to have originated in the nineteenth century and continued into the present. Pattern Painting is a critique of the radical vanguard art that has frequently ended up as decoration for the rich: it is also a rejection of the monotony of the Minimalism and Conceptualism that dominated the art world for most of the sixties and seventies.

Chaim Soutine
French, born in Russia, 1894–1943

Femme au chien *1917*
(Woman with Dog)
Oil on canvas, 25½ × 19⅝ (64.8 × 49.8)
Gift of Owen and Leone Elliott, 1968.42

Together with Marc Chagall and Jacques Lipchitz, Chaim Soutine represented the first generation of Jewish artists to reject the proscription against idolatrous images and make art. Perhaps because he was one of eleven children of a Lithuanian tailor, really only a mender, who was at the bottom of the social hierarchy of the shtetl, Soutine suffered from the prejudice against images more than other contemporary Jewish artists. He later recalled being tormented by his brothers and severely beaten by his neighbors for making images.

The enormity of his breach with tradition may be a factor in the frenetic style he later developed. A willed force and an inner turbulence activate his paintings, invigorating even the backgrounds with a restless energy. In *Femme au chien* he appears to be countering the proscriptions against imagery and against dogs, for in the shtetl dogs were feared as violent and unpredictable animals. In this painting the dog has been turned into a pet and the idolatrous female into a distinct individual. *Femme au chien* thus represents a temporary period of repose when Soutine was able to challenge successfully prejudices from his childhood, to calm the freneticism for which he became known, and to attune his technique to the job of rendering a specific likeness.

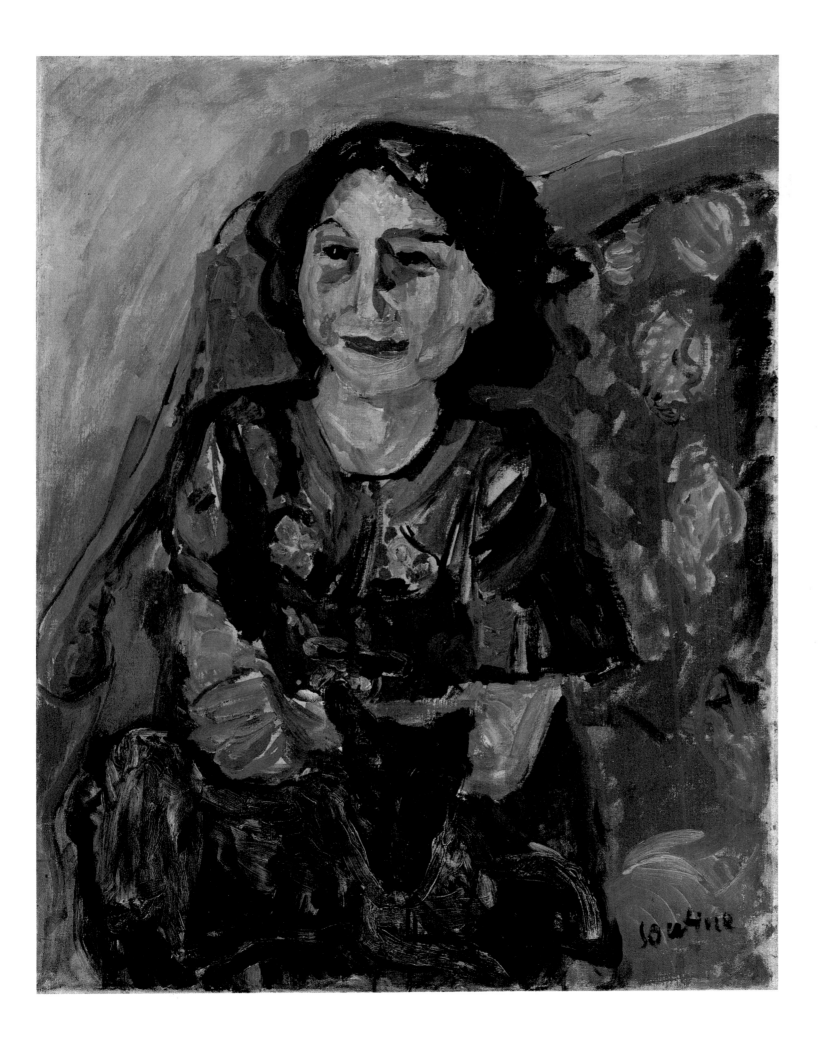

Mark Tobey
American, 1890–1976

Autumnal Light *1965*
Tempera on board, 57 × 30¼ (144.8 × 76.8)
Gift of Owen and Leone Elliott, 1970.19

"Over the past 15 years, my approach to painting has varied, sometimes being dependent on brush-work, sometimes on lines, dynamic white strokes in geometric space. I have tried to pursue a particular style in my work. For me, the road has been a zig-zag into and out of old civilizations, seeking new horizons through meditation and contemplation. My sources of inspiration have gone from those of my native Middle West to those of microscopic worlds. I have discovered many a universe on paving stones and tree barks. I know very little about what is generally called 'abstract' painting. Pure abstraction would mean a type of painting completely unrelated to life, which is unacceptable to me. I have sought to make my painting 'whole' but to attain this I have used a whirling mass. I take up no definite position. Maybe this explains someone's remark while looking at one of my paintings: 'Where is the centre?'"

Mark Tobey in *Tobey*, exhibition catalogue, Galerie Beyeler, January–March, 1966 (Basel: Galerie Beyeler, 1966), unp.

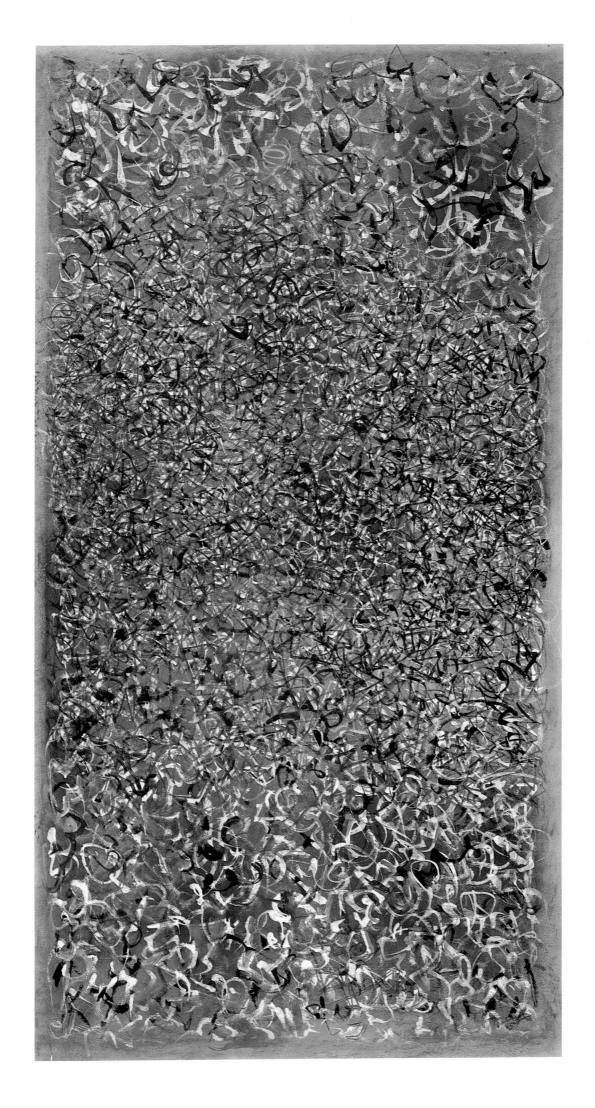

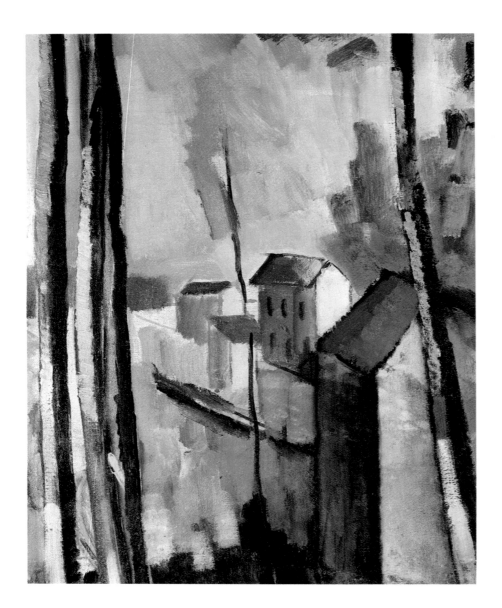

Maurice de Vlaminck
French, 1876–1958

A travers les arbres *1911–12*
[Through the trees]
Oil on canvas, 28¾ × 36¼ (73.0 × 92.1)
Gift of Owen and Leone Elliott, 1968.45

By 1910 Vlaminck had already left the exploitation of pure color of his Fauvist period and entrenched himself in the grand tradition of modernism. *A travers les arbres* pays homage to Cézanne, who wanted to reform Impressionism by understanding classicism; and it is also a tipping of the hat to Braque and Picasso, who were then inventing Analytical Cubism. This painting is typical of the branch of early modernism that became known as School of Paris painting: it is a knowing and self-assured art that is casually handled without becoming superficial. *A travers les arbres* documents a time when Vlaminck was still able to create masterly paintings, a time when he had not yet succumbed to the replications of his own art that he produced over so many years.

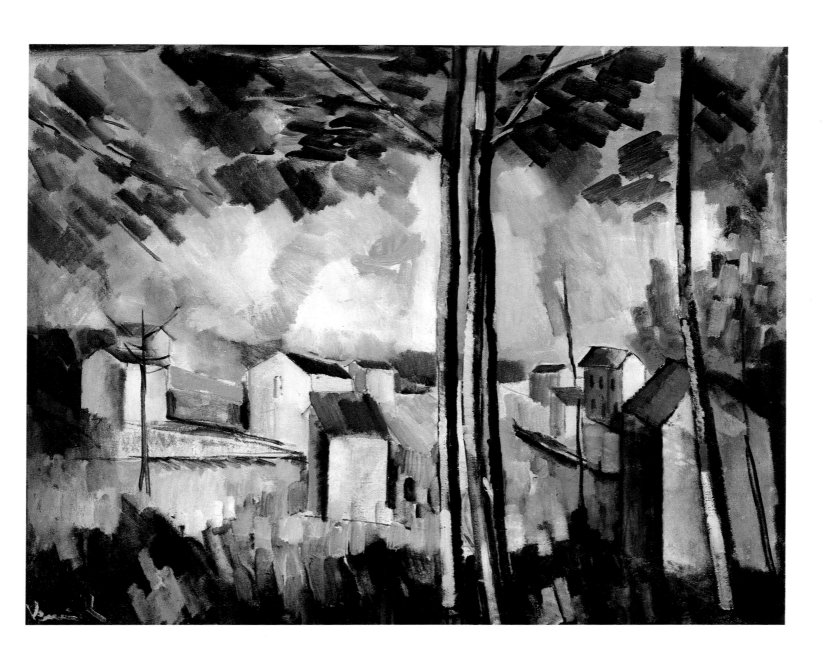

Grant Wood
American, 1891–1942

Plaid Sweater *1931*
Oil on Masonite, 29½ × 24⅛ (74.9 × 61.3)
Gift of Melvin R. and Carole Blumberg and Edwin B.
Green through The University of Iowa Foundation,
1984.56

Although *Plaid Sweater* is a portrait of Mel
Blumberg of Clinton, Iowa, it clearly is part of
Grant Wood's mature work, which turns people
into types, into embodiments of the Midwestern
landscape. Just as the couple in *American Gothic*
represents endurance and stability, and *Daughters
of the American Revolution* continuity and false
pride, so *Plaid Sweater* symbolizes the oncoming
generation in the form of a young football player.
In *Plaid Sweater* Mel Blumberg is posed high on
a hill with an autumnal landscape in the back-
ground. Blumberg belongs to the rolling hills of
Iowa, a fact Wood underscores when he pictures
the boy in colors that echo the landscape.

Ansel Adams

American, 1902–1984

The Tetons and the Snake River, Grand Teton National Park, Wyoming *1942*

Silver print, 15 ½ × 19 ¼ (39.4 × 48.9)
Museum purchase, 1984.75

Ansel Adams found photographic equivalents for the grand panoramic nineteenth-century vision created by the Hudson River School painters Albert Bierstadt and George Frederick Church. He made their Manifest Destiny a believable image of manifested destiny, and in the process he gave a country at war a positive, credible image of itself. Produced in 1942, just after the American entrance into World War II, *The Tetons and the Snake River, Grand Teton National Park, Wyoming* is a long retrospective view of America that looks past the war and the recent Depression to find the serenity and peace of the West that appealed to early-nineteenth-century explorers. It is an image of amazing precision and hope, as if renewed belief had been brought sharply into focus.

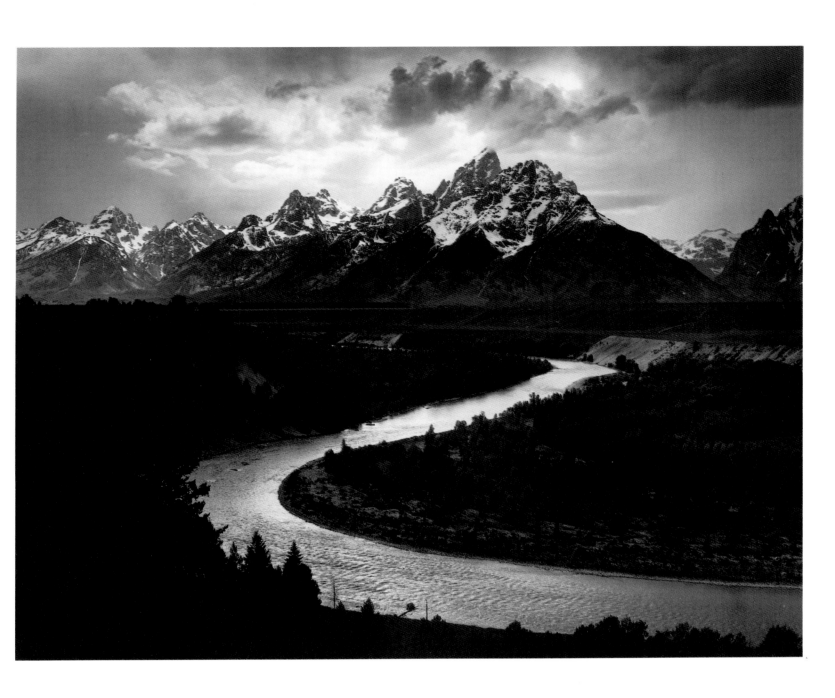

Irving Penn
American, born 1917

Sitting Man with Pink Face
(New Guinea)
From the series "Worlds in a Small Room"; negative 1970, print 1979
Platinum and palladium print on Rives BFK, 20⅝ × 19⅜ (52.3 × 49.3)
Gift of Charles Randall Tosh in memory of Rubye Joyner, and purchase, Mark Ranney Memorial Fund, 1985.34

When New York fashion photographer Irving Penn took this picture of a masked New Guinean, he established strange contradictions between glamour and reality, and between advertisement and documentation. Rather than settling these contradictions, Penn's photograph suspends them, leaving viewers with the dilemma of being either prospective consumers or serious students of ethnology.

Speaking of his photographs of New Guinea tribespeople in his book *Worlds in a Small Room*, Penn unwittingly emphasizes the alienating effect his portable studio has on these people, who find themselves for a few moments appearing on the austere, almost clinical stage that has become a commonplace for Western commercial photography: "In 1970 I went to the New Guinea highlands for *Vogue*, with our portable studio. . . . I wanted to get past the purely costume part of the tribal dressing-up and see what I could of the people underneath. The result was successful to an extent, because the experience of posing in a studio actually set up in their villages became for the highlanders a serious, somber, and revealing occasion." Irving Penn, *Worlds in a Small Room* (New York: Viking Press, 1974), 64, 66.

Placed in the portable studio, these people were shaken out of their daily routine. The studio stripped them of their usual defenses and revealed their curiosity and wariness. Though the man in this photograph is partially protected by his mask, he still cautiously watches himself being transformed into an image that belongs to an alien system. Even though the ostensible purpose of this photograph is to capture his likeness, it really supports a Western world view and a Western way of representing New Guinea tribespeople.

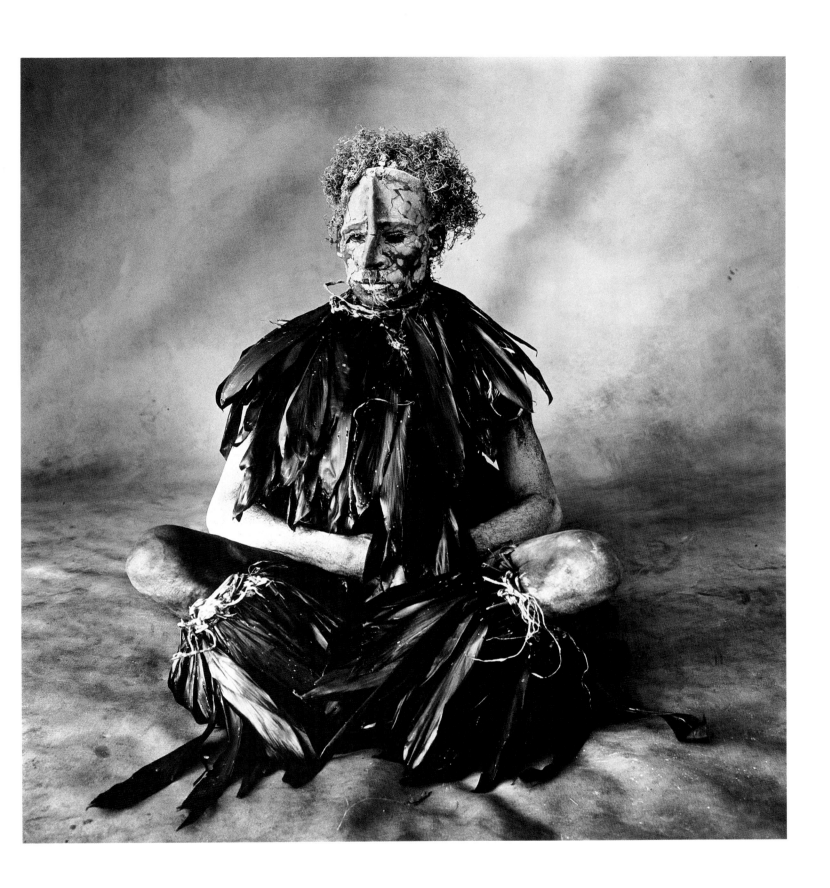

Francesco Clemente
Italian, born 1952

Untitled 1984
Lithograph, 19¾ × 16 (50.2 × 40.6)
Museum purchase, 1984.29

Some contemporary artists manage to evade the designations "formalist" and "postmodernist" and to create an individual style that draws on tradition and reconciles that tradition with the psychological reality of the present day. Such an artist is Clemente, who imaginatively propels an image of himself into a number of different circumstances, testing them for feeling, becoming deeply involved in their humor, tragedy, and perversity. In this untitled print of 1984 the artist has reinvented Picasso's Negro period and joined it with the psychological pressures that made Edvard Munch's work so profound. Wearing a variation of an African mask, the artist looks out in terror as his raised knee becomes a symbolic phallus and an archway for a dreamlike black woman.

Clemente frequently changes his style from work to work. In his art, style becomes an important part of the subject matter. The African-inspired Cubist mask, for example, alludes to twentieth-century attempts to reinvigorate art by drawing on tribal sources. In other works Clemente indicates the necessity for spiritual renewal by using the style of Indian miniatures, and in still others he uses fresco to indicate timelessness and universal human concerns. In Clemente's work there is a knowing wit, a gentle irony, and sometimes a definite interest in shocking people by using sex to underscore the various masks reality assumes.

"You know people say my work is violent," Clemente has stated. "But this I do not understand. They say it is perverse. They have no sense of humor. I don't want people to think I am gloomy or preoccupied by sex. There is no more sex in my work than there is in anyone's life during 12 hours of a day. If people find the work scandalous, it is because they want to know about the artist and his personal life. You are expected today to publicly explain who you are, what you are—and then remain in that cage. But life is about flow, feeling and change. We change from moment to moment." Francesco Clemente in Paul Gardner, "Gargoyles, Goddesses and Faces in the Crowd," *Art News*, 85: 3(March 1983), 56.

Chuck Close

American, born 1940

Keith V *1982*
Paper pulp on handmade paper,
24¾ × 19 (62.9 × 48.3)
Purchased with funds from the National Endowment
for the Arts and donations to The University of Iowa
Foundation, 1982.24

Chuck Close is a Minimalist/Conceptualist artist posing as a realist. Although *Keith V* is an image of a specific person, Close is concerned with the information attainable from a snapshot and not with revealing a personality through the media of painting and printmaking. Close looks analytically at the snapshot: he blows it up and divides it into small squares, which he then translates into a different medium. The new medium—the handmade paper and paper pulp of the print *Keith V*—provides a vantage point for assessing the truth of the photograph and for understanding its limits and conventions.

Chuck Close's art calls to mind a story of Picasso and an American G.I. When the G.I. looked at one of Picasso's portraits, he exclaimed that no one could possibly look like that! Picasso then asked the G.I. if he had a picture of his girlfriend. When the soldier pulled out a snapshot, Picasso remarked that she was very pretty even though she was exceedingly small.

13/40 "Phil" Close 199_

Honoré Daumier
French, 1808–1879

Rue Transnonain,
le 15 avril 1834 *July 1834*
Lithograph, 11⅜ × 17½ (29.0 × 44.5)
Gift of Owen and Leone Elliott, 1967.50

In 1832 the magazine and print publisher Charles Philipon created L'Association Mensuelle, which offered a large lithograph to its subscribers each month. Artists working for the magazine *Caricature* created the prints, which were all political and intended to help Philipon in his fight against King Louis Philippe. For this series Daumier created four prints, including *Le Ventre législatif, Liberté de la presse*, and *Rue Transnonain.* This last print became famous overnight because it documented a massacre on the evening of 14 April 1834, when the king's 35th Battalion, reacting to a sniper shot, broke into the house at 12 Rue Transnonain and slaughtered entire families. The killings occurred at a time when the labor unions, then functioning as secret societies, were fighting for improved wages and working conditions. The situation was exacerbated by the Assembly, which extended a vote of thanks and a reward to the gendarmes who had killed the citizens. Daumier's lithograph was released three months after the event, and immediately the lithographic stone and all available copies of the print were seized by government agents, thus making extant copies of the lithograph extremely rare.

Philipon's comments on the release of the print indicate the outrage felt at the event, as well as his respect for the quality of Daumier's art: "This lithograph is shocking to see, frightful as the ghastly scene which it relates. Here lie an old man slaughtered, a woman murdered, the corpse of a man who, riddled with wounds, fell on the body of a poor child which lies under him, with its skull crushed. This indeed is not a caricature; it is not a *charge*; it is a page of our modern history bespattered with blood, a page drawn with a powerful hand and dictated by a noble anger. In creating this drawing, Daumier raised himself to a high eminence. He made a picture which, though executed in black on a sheet of paper, will not be the less enduring. The murders of Rue Transonain will be a permanent blot of shame on all who allowed them to happen. This lithograph which we cite will be the medal struck at the time to perpetuate the recollection of the victory won over fourteen old men, women, and children." Howard P. Vincent, *Daumier and His World* (Evanston: Northwestern University Press, 1968), 59.

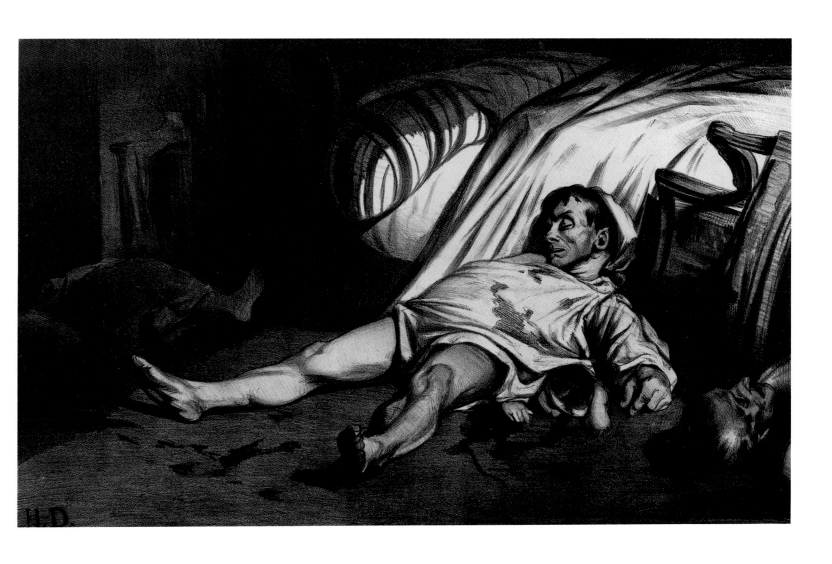

Edgar Degas
French, 1834–1917

Au Louvre: La Peinture
[Mary Cassatt] *1879*
(Mary Cassatt at the Louvre: The Paintings
Gallery; At the Louvre: The Painter Mary Cassatt)
Etching, softground etching, and drypoint,
11⅞ × 4¹⁵⁄₁₆ (30.2 × 12.5)
Gift of Owen and Leone Elliott, 1966.6

Influenced by the woodblock prints that came to
France after Japan opened its ports to Western trade
in 1853, Degas created an art that reflected chang-
ing fashions and concerns and also embodied some
of the shifting points of view he had come to ex-
pect in Japanese art. Mary Cassatt, the Impression-
ist artist from Philadelphia, is the standing figure
in this print; the seated woman looking at a book
is probably her sister Lydia.

Although the two women are prominently lo-
cated in the foreground, Degas has so placed them
that their appearance seems almost accidental. The
real focus of the scene is not on the two women at
all; rather it is on a new mode of perception, the
casual glance. This scene choreographs all viewers
so that they become accidental eavesdroppers who
have stumbled on two women who are looking at
pictures. If one begins to examine the structure of
this accidental glance, one will find that Lydia's
foot and Mary Cassatt's hand and back become
important foci, and that the floor takes on an un-
expected significance.

In this way Degas upsets the traditional hierar-
chy of art, making it an occasion for a particular
way of seeing rather than a set of important sub-
jects that must be seen and recognized as specific
individuals. He thus creates an image of everyday
life that appeals to the sweeping, cursory glance
that has become more and more a distinct way of
dealing with a great amount of information in the
modern world. Though *Mary Cassatt at the Louvre*
appears to be about the traditional, academic art
contained in the Louvre, it is in fact about the
special new types of perception that art is capable
of revealing.

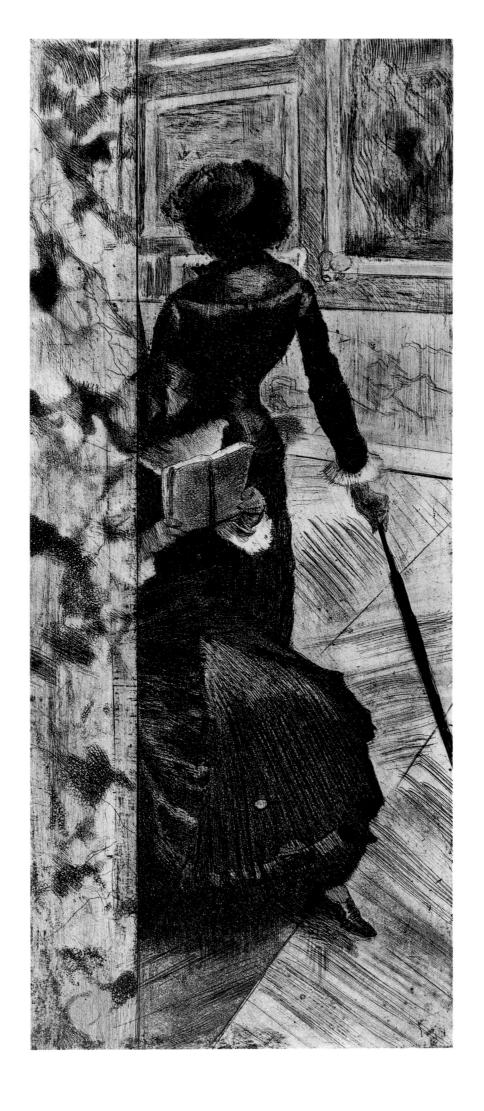

Albrecht Dürer

German, 1471–1528

The Temptation of the Idler *c. 1498*
(The Dream of the Doctor)
Engraving, 7⁷/₁₆ × 4¹¹/₁₆ (18.9 × 11.9)
Gift of Owen and Leone Elliott, 1967.437

A man asleep beside a tile stove is the focus for the Devil's bellows and for the temptations of the luxurious life, symbolized here by Venus and Cupid. The sleeper is the idler or slothful one, and the proverbs "Idle hands are the Devil's workshop" and "Idling is the pillow of the Devil" are the verbal equivalent of the visual moral of this print.

According to Erwin Panofsky, the ring on Venus's hand has an additional meaning: "She beckons to the sinner with her right hand, and on her left she wears a ring—a most unusual attribute. . . . This attribute, in combination with the smallish sphere on the ground, would call to the mind of every well-read beholder a legend which, in different versions, was told and retold from the twelfth century up to the time of Heinrich Heine and Prosper Mérimée. According to the German version, some fashionable Roman youngsters, not yet converted to Christianity, were playing ball, or rather *boccia*, when one of them threw the ball out of bounds. Rolling along, it led the youth to a dilapidated pagan temple, where he beheld a statue of Venus so inconceivably beautiful that he was at once bewitched. But none other than the Devil was hidden in the image; it beckoned to the youth and induced him to put his ring on its finger, thereby concluding a formal engagement. The sequel is more or less obvious: the young man begins to worry about his extraordinary commitment, tries to retrieve his ring in vain, falls severely ill, and is finally saved by a Christian priest who forces the Devil to restore the ring and to leave the statue. The youth adopts the Christian faith while the statue is consecrated by the Pope and placed on top of the Castel Sant'Angelo. Thus the correct title of the 'Dream of the Doctor' should be *The Temptation of the Idler.*" Panofsky, *The Life and Art of Albrecht Dürer* (Princeton: Princeton University Press, 1955), 72.

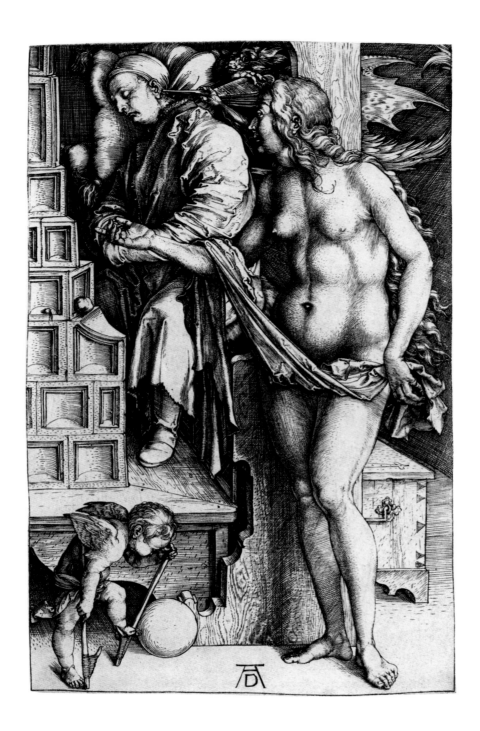

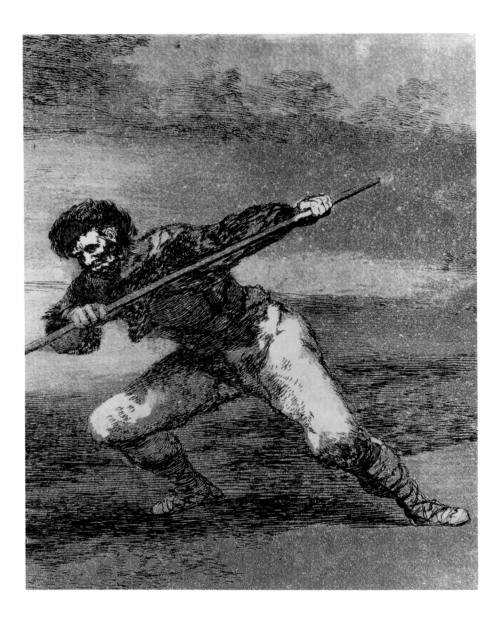

Francisco Goya
Spanish, 1746–1828

Otro modo de cazar á pie

[Another way of hunting on foot], plate 2 from
La Tauromaquia, first published 1816
Etching, burnished aquatint, drypoint, and engraving,
9%16 × 13⅞ (24.3 × 35.2)
Gift of Owen and Leone Elliott, 1968.96

First advertised for sale in October and December 1816, the thirty-three prints making up the *Tauromaquia* represent the history of bullfighting from the time the Moors initiated the sport, through the period when Christian princes and noblemen undertook to perfect it, to the eighteenth and early nineteenth centuries, when bullfighting became the game of the people.

An unflinching realist, Goya has represented the cruelty, brutality, heroism, and humor of bullfighting so convincingly that it is difficult to ascertain his own specific reaction to this sport. He may have joined some of his more modern friends who regarded the game as indicative of a brutal and vicious spirit in Spanish society; he may have used it as a way of symbolizing the still untamed force of Spain itself; or he may simply have viewed it as an amazing ritual of ancient origin that allowed the free play of a variety of emotions from pity to fear to awe and even on occasion laughter.

Plate 2 of *Tauromaquia*, entitled "Another way of hunting on foot," shows Spaniards of an earlier time spearing a bull. This impression is from the first edition. It shows the Rococo subtlety that formed the backdrop for Goya's realistic subject matter and helped, in fact, to emphasize the bullfight's brutality.

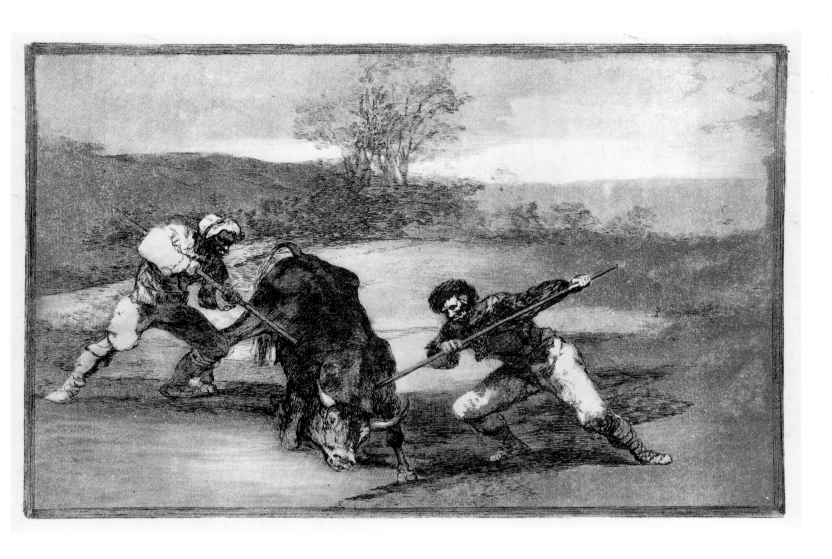

Edward Hopper
American, 1882–1967

Night Shadows *1921*
Etching on wove paper, 6⅞ × 8⅛ (17.5 × 20.6)
Gift of The Print and Drawing Study Club, 1984.69

Part of the power of Hopper's art stems from his manner of stripping bare the forced gaiety in the illustrations that he made for C. C. Phillips & Company to expose an unrelenting core of desperation and loneliness, which many have since viewed as a fundamental part of American life. Although his interest in unusual points of view and startling artificial lights derives to some extent from the French Impressionists, Hopper differs radically from their view of life as fundamentally comfortable, engaging, and filled with group activities. In *Night Shadows* he unflinchingly studies the isolated persons who inhabit American cities.

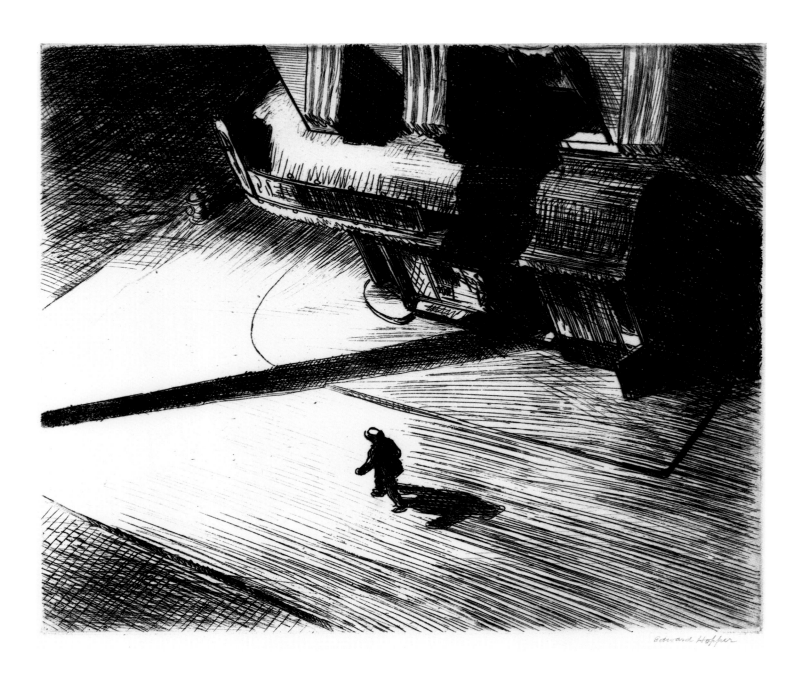

Edward Hopper

Robert Motherwell
American, born 1915

TOP: "Red" 8–11
BOTTOM: *Endpage*
From *A la pintura* [To painting], 1968–72
Color intaglio with letterpress,
25½ × 38 (64.8 × 96.5)
Museum purchase, 1972.186, 193

Motherwell made his unbound illustrated print cycle *A la pintura* in homage to another medium, painting. As his text he used the cycle of poems by Rafael Alberti; the poems are printed in English and the original Spanish, accompanied by Motherwell's intaglio prints. The pages of the cycle emphasize concretely the importance of color, to which Alberti suggestively alludes in the poem. The poem becomes a psalm praising this very specific and sensuous aspect of art:

A la pintura: "Black"

4
Spanish black: the five senses
blackened:
black sight
and black sound,
black smell
and black taste; and the painter's black,
black to the touch.
5
Black of the burial cloths:
the sleep of my woven eternity
will not outlive
the yellowing horn of the bones.
11
Most purely of all,
intact and entire like the white of a wall,
I answer Juan Gris and Picasso and Braque.

A la pintura: "Red"

6
The rose in the front of Velázquez.
7
I descend to the rose of Picasso.
8
Carnation explosions, erect
in the ivory round of the tightening nipple.
9
The poppy in fugitive cochineal.

The Spanish poet's feeling for color bears a striking similarity to that of Motherwell. "The pure red of which certain abstractionists speak," Motherwell wrote in 1946, "does not exist, no matter how one shifts its physical contexts. Any red is rooted in blood, glass, wine, hunter's caps, and a thousand other concrete phenomena. Otherwise we should have no feeling toward red or its relations, and it would be useless as an artistic element." Robert Motherwell, "Beyond the Aesthetic," *Design*, 47: 8 (1946), 14–15.

8
Carnation explosions, erect
in the ivory round of the tightening nipple.

Como el clavel que estalla en los ceñidos
marfiles de unos senos apretados.

9
The poppy in fugitive cochineal.

Como el grana fugaz de una amapola.

10
Think how I dwindle away
in the least of the violets.

Pensad que ando perdido en la más mínima,
humilde violeta.

11
Brueghel's and Bosch's inferno:
the night-hag that stares
from the eyes of insomniac children.

Soy el infierno—Brueghel,
Bosch—y el nocturno espanto
en los ojos insomnes de los niños.

A la pintura

the end

fin

Edvard Munch
Norwegian, 1863–1944

Vampire *1894*
Drypoint, 11⅝ × 8¹⁵⁄₁₆ (29.5 × 22.6)
Gift of Mr. and Mrs. George Rickey, 1975.100

According to the guidelines provided by Gustav Schiefler in his 1907 book, the *Vampire* belonging to the Museum of Art is a rare impression of the third state. Schiefler describes the differences between the second and third states, notably the horizontal line across the navel, the lines added to the three horizontal lines above the navel, and the lines underneath the vampire's left breast. All these additions are so subtle that they can easily be missed without the aid of a magnifying glass. Schiefler also adds that the one known third-state impression, which was in the artist's own collection and which has smaller margins than the Iowa impression, is signed "E. Munch," as is the one belonging to the Museum of Art. The single most readily discernible feature separating the early states from the fourth state is the mutton-chop-shaped beard on the figure on the lower left in the fourth state, and the heavier shading on the vampire's left wing.

The vampire who consumes men in the process of loving them is an important theme in Munch's work. This early imaging of the theme portrays three males: a vanquished, emaciated man beneath the vampire; an old man at the lower left, who is perhaps a sage and is safe from the vampire since he has a head but no body; and, presumably, the artist himself, depicted in the background as a victim: a skeleton, who is drawing.

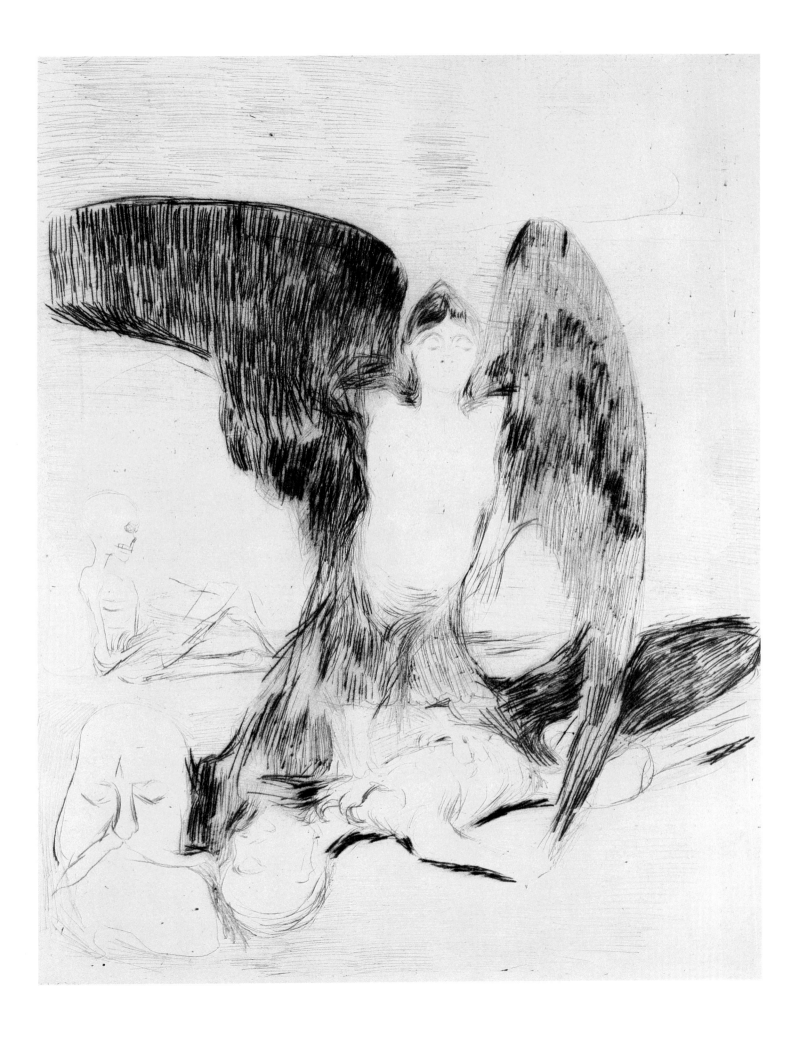

Pablo Picasso

Spanish, 1881–1973

Blind Minotaur Led by Girl with Fluttering Dove III *c. 1934*

Plate 95 of *The Vollard Suite, 1930–37*
Etching and engraving, 8⅞ × 12¼ (22.5 × 31.1)
Gift of John and Cindy McEnroe and museum purchase, 1975.71

Picasso began his series of Minotaurs in 1933, the same year the Surrealists commenced publication of their journal *Minotaure*. The Minotaur is a mythological figure, half beast and half human, the offspring of the wife of King Minos of Crete, Pasiphaë, who consorted with a bull. It is an apt symbol for the Surrealists' journal and for Picasso's Surrealist prints, which, following Freud, are concerned with picturing through Greek myths the subconscious of modern humanity. The Minotaur is lodged in the labyrinth, which symbolizes the inner pathways of the brain, the subconscious or the unconscious, which can never be known directly. The Minotaur may be a concrete symbol of the animal nature of the id, which can frequently dominate the seemingly more human superego.

Picasso's meditations on the Minotaur, like much Surrealist art, do not permit clear explanations. The Minotaur is a complex symbol for representing the subconscious or unconscious mind and perhaps even the artist. The blind Minotaur guided by a girl (a likeness of Picasso's mistress Marie-Thérèse) suggests that the artist must rely on instinct (the Minotaur animal head), childlike faith (Marie-Thérèse), and spiritual values (the white dove). The girl also represents Ariadne of the Greek myth; the young man seated on the right, Theseus; and the fishermen pulling in their nets and setting their sail, voyagers to this strange land. Even though the various personages of this print can be identified, their relationship is unclear. Where is the girl leading the Minotaur? Why is Theseus only contemplating this scene and not actively fighting the Minotaur as in the Greek myth?

One wonders if the fishermen provide a clue to the complex meaning of this work, since they appear to be realistic analogues for Picasso, the artist, who sails on mythic journeys and casts his net into the unconscious to retrieve glimmers of old myths. The concept of artistic creation as a journey has a tradition going back at least to the nineteenth-century poets Baudelaire, who wrote of creation as a journey to the new, and Rimbaud, who found creation a new form of drunken exultation.

The blind Minotaur led by Ariadne may also refer to the Greek myth concerning the aged, blind Oedipus, who is led by his daughter Antigone. Young Oedipus blinded himself to his destiny, and after he learned the horror of his crime—his murder of his father and his marriage to his mother—he put out his own eyes and thus again blinded himself. Conflating the Minotaur myth with that of Oedipus, Picasso may be saying that instinct is sometimes the only route available to the artist, who must close his eyes to tradition and create anew the same eternal psychological dramas that have plagued all humankind.

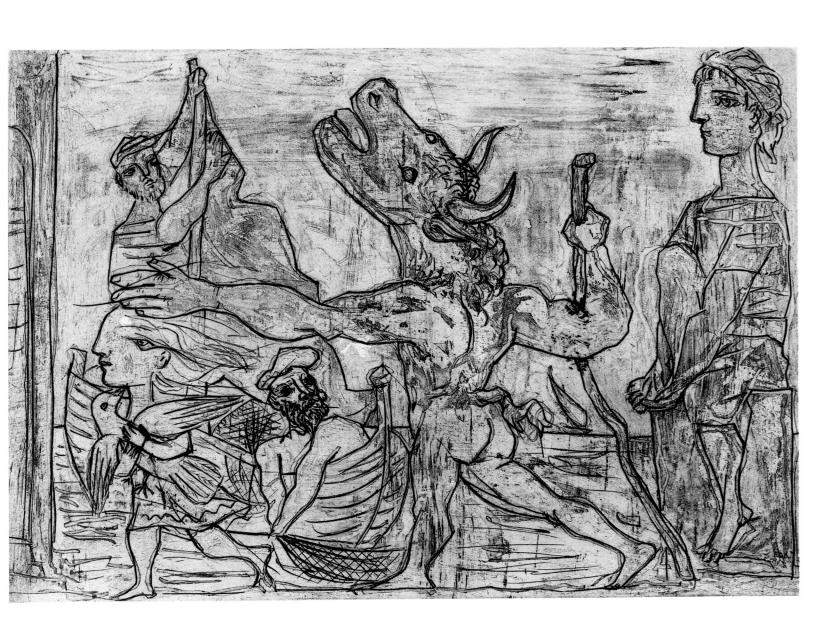

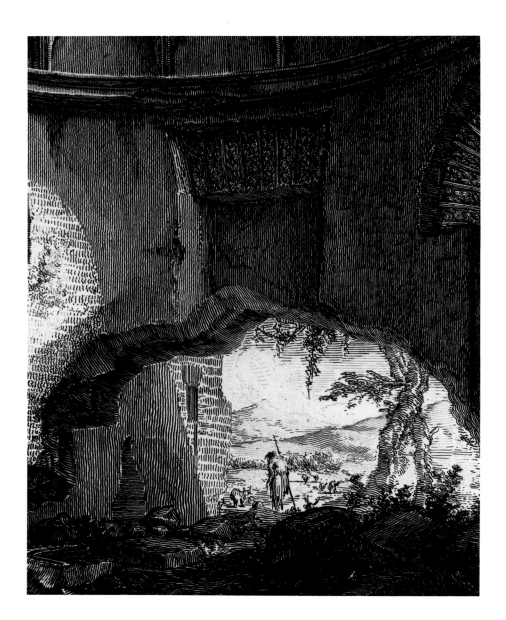

Giovanni Battista Piranesi
Italian, 1720–1778

Veduta degli Avanzi di Fabbrica magnifica sepolcrale co' sue Rovine, la quale si vede vicina a Torre de' Schiavi un miglio e mezzo in circa fuori di Porta Maggiore
[View of the remains of a magnificent mausoleum with its ruins, which can be seen near the Tower of Slaves, about a mile and a half outside the Porta Maggiore], vol. 2, plate 60, of *Le Antichità Romane* [Roman antiquities], c. 1784
Bound volume in folio, 16⅝ × 12⁵⁄₁₆ (42.3 × 31.4)
Gift of Owen and Leone Elliott, 1969.346b

In the most successful of his views of ancient ruins, Piranesi plays games with scale. He enlarges the scale of the actual viewer of the print by presenting him with a Lilliputian world of figures who are dwarfed by imposing ancient ruins. In this way Piranesi's art reaffirms a contemporary, optimistic view that the ancient world in all its grandeur could not compare with the accomplishments of the eighteenth century. The ancient scene is mysterious and grand, but its grandeur is held in check and placed in a subservient position to Piranesi's time. It is no wonder that these views were avidly collected by Englishmen, who returned home from Rome feeling comfortable about their nation's accomplishments relative to those of the ancient world.

VEDUTA *degli Avanzi di Fabbrica magnifica sepolcrale co' sue Rovine, la quale si vede vicina a Torre de' Schiavi un miglio e mezzo in circa fuori di Porta Maggiore*

Piranesi Archit. dis. et inc.

Rembrandt van Rijn

Dutch, 1606–1669

Christ Preaching *c. 1652*
(La Petite Tombe)
Etching, engraving, and drypoint,
6⅛ × 8⅛ (15.5 × 20.6)
Gift of Owen and Leone Elliott, 1968.87

Better known during his lifetime for his etchings than his paintings, Rembrandt created a way of inking the plate and only partially rubbing off the ink so that the print would exhibit velvety blacks and warm greys that would enhance its atmospheric quality. In this manner he connected his etchings with his paintings and produced printed images bathed in light and suffused with shadow.

Christ Preaching has also been known as "La Petite Tombe" ("The Little Tomb"), possibly because of a misunderstanding in 1751 by the French print dealer Gesaint of a description in the inventory of the Dutch print dealer Clement de Jonghe. That description, "La tombisch plaatjens" ("The Tomb[e] picture"), may actually refer to the Tombe family, with whom Rembrandt is known to have had business connections. Art historians and cataloguers of Rembrandt's work have speculated for two centuries on he meaning of the "tombisch" description.

Rembrandt's art is influenced by the art of the Italian Michelangelo Caravaggio, who had responded to the new ideals of Counter Reformation Rome by attempting to reinvigorate religious art with simplicity, faith, and feeling. Although a Protestant, Rembrandt approved of Caravaggio's use of simple peasants as models for religious figures and chose in *Christ Preaching* to emphasize some of his friends as well as contemporary Dutch peasants, beggars, and merchants. His image of Christ preaching to people in contemporary dress gave the Gospels new relevancy and dignified the daily problems and needs of his contemporaries.

Georges Rouault
French, 1871–1958

Le Christ en croix *1936*
[Christ on the cross]
Color aquatint and sugar lift aquatint,
25 ¼ × 19 ¾ (64.1 × 50.2)
Gift of Owen and Leone Elliott, 1968.286

 Although he was closely associated with Matisse and the Fauves early in the twentieth century, Rouault's art affirms many of the nineteenth-century ideas of his teacher Gustave Moreau, who wished art to represent distant times and places as well as to serve as a vehicle of the imagination. About 1904 Rouault met the Catholic novelist Léon Bloy, who encouraged him to devote his art to religious themes. In many works Rouault devoted himself to picturing the stupidity and bestiality of humanity. He found the heavy black leading in stained glass a worthwhile metaphor for religion, and he used it in pictures of clowns and prostitutes and in traditional religious scenes, of which *Le Christ en croix* is an example. The black outlines surrounding the figure heighten the blocks of color in this print and transform them into radiating abstract elements. These black lines and radiant hues in turn reinforce the iconic quality of the religious subject matter: the abstract spirituality thus affirms the orthodox subject matter.

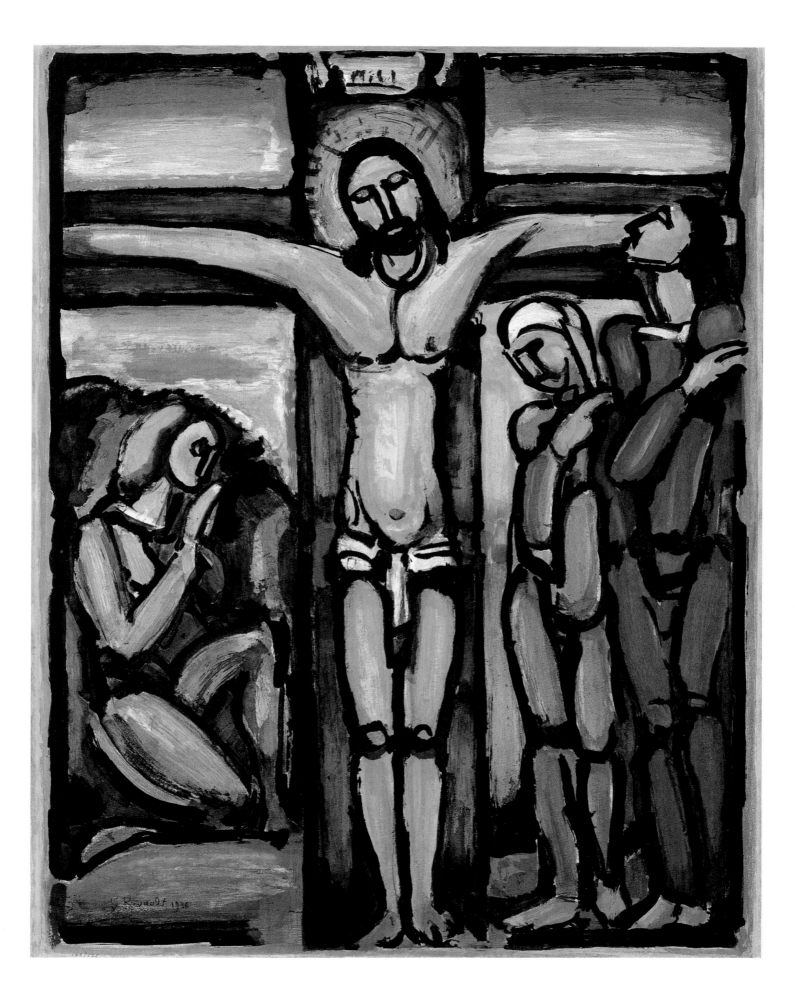

Martin Schongauer
German, c. 1430/50–1491

Ecce Homo *c. 1480*
From the series "The Passion"
Engraving, 6¼ × 4⁵⁄₁₆ (15.9 × 10.9)
Gift of Owen and Leone Elliott, 1967.436

In the mid-fifteenth century German goldsmiths discovered that ink could be rubbed into designs incised on metal surfaces and then impressed on paper. Their discovery gave rise to the new art of engraving.

The son of a goldsmith, Martin Schongauer was the most accomplished engraver of the fifteenth century and the first whose life has been documented. Although known primarily during his lifetime for his paintings, Schongauer also produced 116 engravings that impressed artists as diverse as Michelangelo and Albrecht Dürer. In his prints, Schongauer managed to find equivalents for the late Gothic painting of Germany and the Netherlands. In his *Ecce Homo*, one of twelve scenes illustrating Christ's Passion, he draws on German expressiveness to create a crowded and turbulent scene of Christ's gruesome tormentors. The entire Passion is conceived as a continuous narrative: many of the figures recur in other prints. The man with the rope over his shoulder and a hammer in his hand, who will nail Christ to the cross, appears in an earlier scene in the narrative, entitled *The Betrayal*, as the man who leads Christ out of the garden on a rope.

The art of engraving parallels the art of the printed book. Both art forms presuppose individual viewers who closely scrutinize a work and reflect on it in silence. The advent of prints and books in the fifteenth century heralded a major change in Western culture, a new era in which knowledge was transmitted privately and solitary research was the norm rather than the exception.

Giovanni Battista Tiepolo
Italian, 1696–1770

TOP:
Young Man Seated, Leaning Against an Urn
BOTTOM:
Three Soldiers and a Youth
From *Vari Capricci*, first published 1749
Etching: TOP 5½ × 7¼ *(14.0 × 18.1);*
BOTTOM 5½ × 7 *(14.0 × 17.8)*
Promised gift of Dr. and Mrs. Johann Ehrenhaft

Because this group of etchings is of particularly fine quality, it must have been one of the rare early sets issued by Zanetti before the regular published edition of 1785.

Unlike many of the frescoes that Tiepolo created throughout Europe, which deal with distinct literary and biblical scenes, the *Vari Capricci* are intended to be less specific and more generally allegorical. The use of the musical term "capricci," which usually designates an instrumental piece that is brilliant, lively, and irregular in form, indicates that this series is concerned with inventive fancies even if the subjects are not playful. The prints include depictions of soldiers, sages, and muse-like females. Throughout the series there is a gentle, melancholic quality; it is evident in the first plate picturing a young man leaning against a funerary urn. This melancholy becomes more apparent in the seventh plate, *Women and Men Regarding a Burning Pyre of Bones*, and the eighth, *Death Giving Audience*. In the second plate, *Three Soldiers and a Youth*, a gentle wistfulness pervades the image. Conceived in the grand tradition of the Renaissance and greatly influenced by the seventeenth-century prints of G. B. Castiglione, Tiepolo's *Vari Capricci* present monumental, classical figures that are also convincingly human.

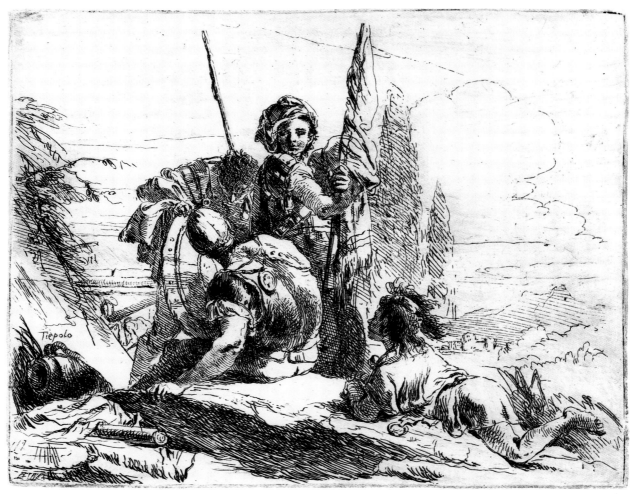

James Joseph Tissot
French-English, 1836–1902

Soirée d'été *1881*
[Summer evening]
Etching and drypoint, 9 × 15½ (22.9 × 39.4)
Museum purchase, 1977.55

In the last few years research has disproved the Victorian myth of the languorous female and has demonstrated that the Victorian woman could be an intrepid scholar, explorer, and social reformer. However, when one looks again at the full-blown myth of the coddled woman in Tissot's *Soirée d'été*, one can see how powerful and persuasive it is. The languorous female represented the crown jewel of luxury for an industrial and agrarian bourgeois society. Depictions of such women harked back to the great recumbent nudes of Renaissance and Baroque art and the sheltered fragile figures in Rococo painting and sculpture; they demonstrate that the late nineteenth century had discovered a similar elite. In this Tissot etching the position of the dangling arm is emblematic of a cultured being who does not need to work for a living, a creature of comforts, intimacy, and luxury, a modern-day and perhaps chaste counterpart to the harem girls who inhabited many nineteenth-century French canvases. Tissot's print also points to the romanticized view of illness popularized by Alexandre Dumas's *La Dame aux camélias*, which spiritualized the passions of a woman dying of tuberculosis.

An artist interested in the advanced ideas of the Impressionists, Tissot paralleled their use of atmospheric effects, and he shared their interest in Japanese prints and their willingness to use the camera as a sketching tool. It is thought that a photograph of his mistress Kathleen Newton served as a source for *Soirée d'été*.

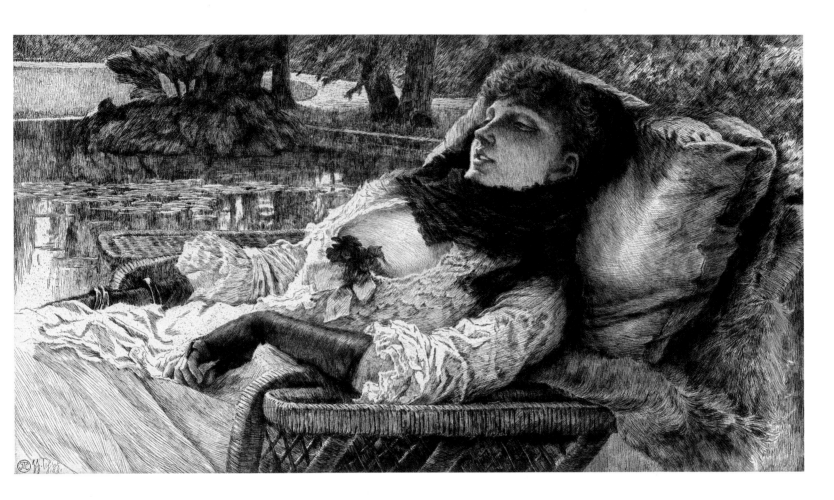

Henri de Toulouse-Lautrec
French, 1864–1901

La Revue blanche *1895*
[*The White Review*]
Lithograph [poster], 50¼ × 36¼ (127.6 × 92.1)
Gift of Owen and Leone Elliott, 1968.342

The title of the French literary magazine *La Revue blanche* ("The White Review") signified a blending of different opinions in much the same way that a white light is the sum of all the colors of the spectrum. However, even though the periodical intended to encompass different approaches, its main interests were Symbolist, and it was devoted to the art and life of the present. In its fifteen-year lifetime, *La Revue blanche* published work by Ibsen, Claudel, Flaubert, Maeterlinck, Mallarmé, Proust, Stendhal, Strindberg, Chekhov, Tolstoy, and Verlaine, and art by Bonnard, Toulouse-Lautrec, Vallotton, Vuillard, Jarry, Munch, and Signac. One of its guiding forces was Thadée Natanson, a member of the editorial board, who had studied with Mallarmé and who was devoted to his Symbolist ideas. In 1893 Natanson married Misia Godebski, the daughter of a Polish sculptor; she became the muse for many artists associated with the journal and the model for this poster by Toulouse-Lautrec. In the poster Misia Natanson is depicted gliding on skates; the rim of the rink is shown on the upper left near her hat, and an earlier state of the print includes a small, full-length figure of another skater. The skating figure in this poster advertises the lively tone of the journal itself and its emphasis on contemporary art and life.

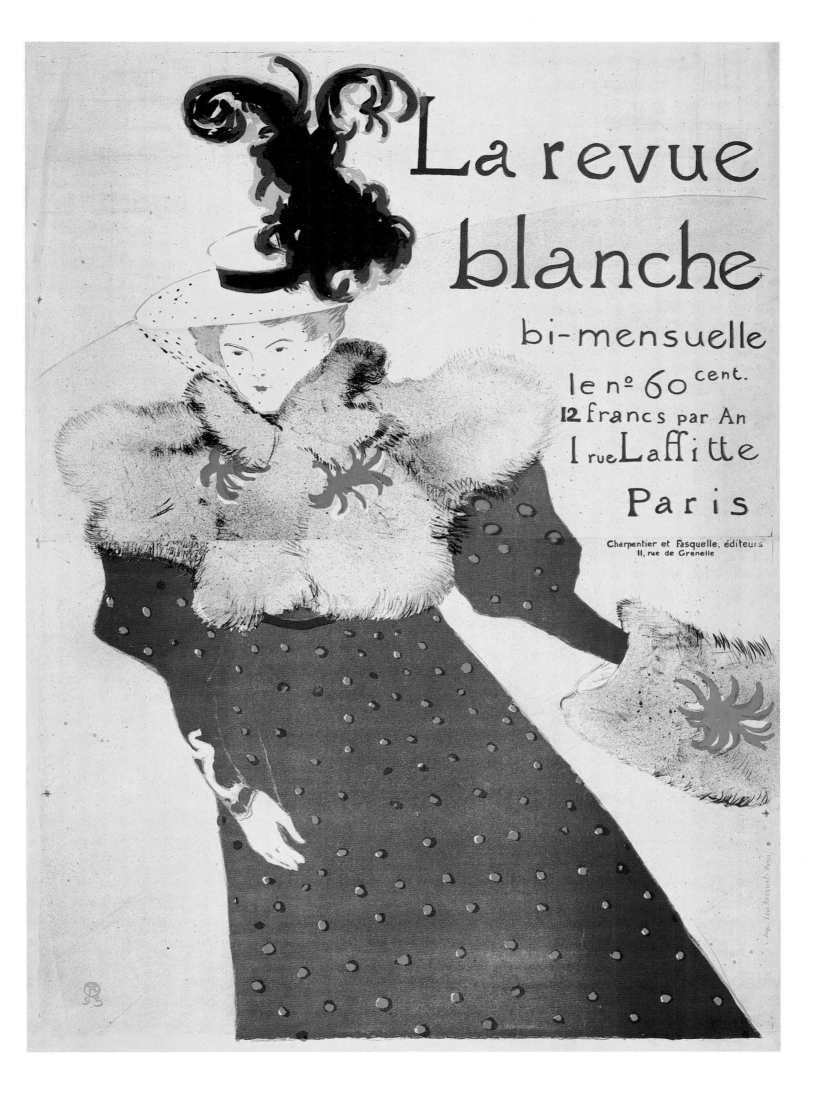

John Ahearn
American, born 1951

Tom *1983*
Painted cast plaster,
17½ × 24¾ × 9½ (44.4 × 62.9 × 24.1)
Gift of The Friends of the Museum, 1984.17

In recent years artists have been looking for new critics, for informed audiences composed of real people they might find on city streets. A case in point is New York artist John Ahearn, who has worked for several years in the South Bronx. Considering himself a modern version of the nineteenth-century itinerant portrait painter, Ahearn approached his present neighborhood by hanging up a life-size plaster bust painted in realistic colors. People in the neighborhood became fascinated with Ahearn's work, and he soon began to find persons willing to be cast in plaster right on the street, where passersby could stop, watch, make jokes, and offer opinions. Every time Ahearn makes a portrait he creates two versions: one he keeps, the other he gives to the sitter.

Because the people of the South Bronx collaborate in making Ahearn's art by becoming critics who offer suggestions and uphold the standard of truth to appearances, his work is a literal form of communication, a social contract with people in his neighborhood. *Tom* is remarkable because it is an unidealized, straightforward portrait of a black man puffing a cigar.

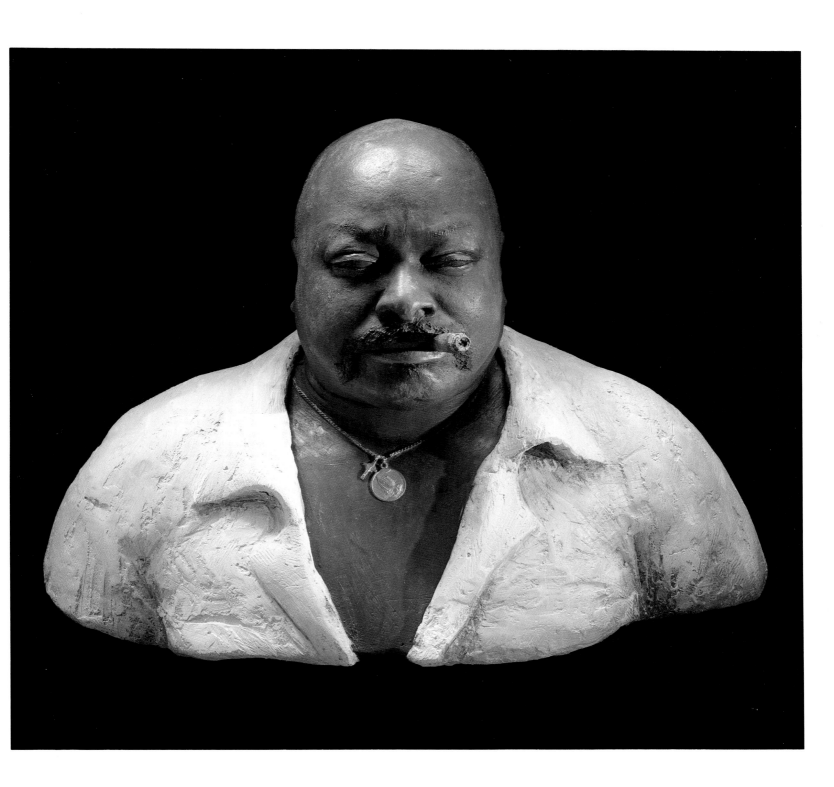

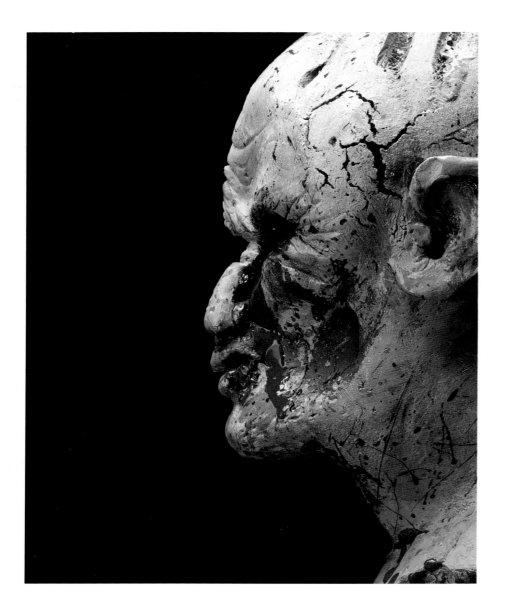

Robert Arneson
American, born 1930

Minuteman *1982*
Glazed ceramic, 48 × 31 × 15 (121.9 × 78.7 × 38.1)
Museum purchase, 1984.27

In *Minuteman*, a classical head reminiscent of those drawn by Leonardo is poised on a cross similar to the Christian grave markers at Arlington National Cemetery—except that Arneson's cross is black and has a nuclear warhead in relief on the front. Bleeding and bashed in on one side, the head has been turned into a target, as the "X" on its forehead suggests. Although *Minuteman* appears to be the depiction of an innocent victim, the words "Kill" and "Slaughter," stamped and written like commands on its back, indicate that the victim may well be the victimizer. The form of the sculpture is suggestive of the World War II practice of propping helmets on grave markers.

The classical head here represents reason cut off from feeling, reason gone mad, reason turned against itself. Even the title of this sculpture evokes a kind of perversion: *Minuteman* refers on the one hand to those volunteer defenders of rational democratic ideals, the Minutemen of the American Revolution, and on the other hand to the modern American missile that carries three multi-kiloton nuclear warheads. This sculpture communicates a powerful image of nuclear war; its overall intent is to teach a moral lesson, and its references to history are clear.

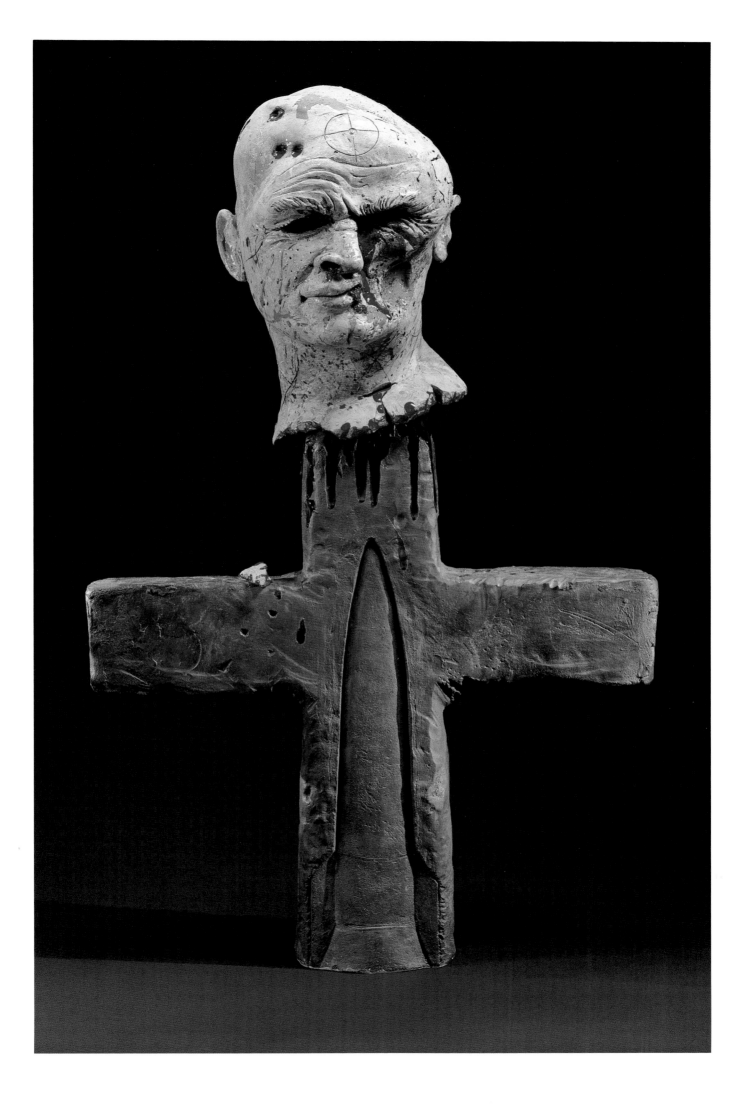

Jacques Lipchitz
American, born in Lithuania, 1891–1973

Sacrifice *1947*
Bronze, 18¾ × 10 × 10¾ (47.6 × 25.4 × 27.3)
Purchase, Mark Ranney Memorial Fund, 1949.2

Lipchitz's *Sacrifice* develops from his series of sculptures entitled *Prometheus Sacrificing the Vulture*. This group of highly charged images of the 1930s culminated in a monumental piece commissioned by the French government, designed to be placed over an entrance in the Grand Palais at the Paris exposition of 1937. Picasso's *Guernica*, which was also exhibited at the exposition, represents Picasso's first reaction to the evils of Fascism; but Lipchitz had been expressing his concern about war since 1932, when he created images of mothers protecting their children, and about Fascism since 1933, when he put a swastika on the chest of the giant in his *David and Goliath*.

Prometheus Sacrificing the Vulture is an inversion of the traditional story, which demonstrates Zeus's displeasure with the Titan demigod who had stolen fire from him and given it to humanity. The gods decreed that Prometheus should be chained to a rock and that an eagle should daily tear out his liver, which would grow again every night, thus making the torture unending. The fire in the myth is most likely a symbol for inspiration and knowledge, and the gnawing of the eagle an image of the guilt and foreboding that knowledge can bring. Lipchitz's *Sacrifice* becomes an image of humanity emulating the Titan Prometheus, who was himself the creator of humanity. Allegorically, the piece appears to be Lipchitz's call to his fellow Jews to follow Prometheus's example by defying death and to take advantage of his gift by using the fire that he had stolen from Zeus.

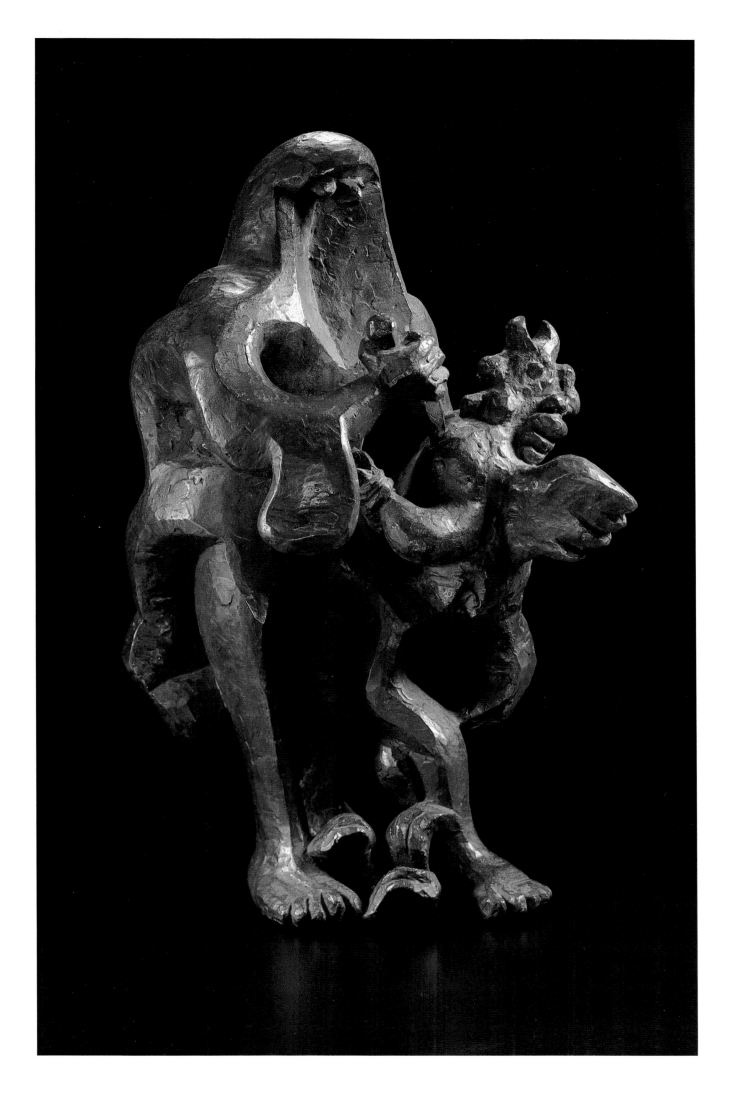

Henry Moore
English, born 1898

Leaf Figure No. 4 *1952*
Bronze, 18¾ × 4¾ × 3¾ (47.6 × 12.1 × 9.5)
Gift of Mr. and Mrs. James S. Schramm, 1968.399

Leaf Figure represents an aspect of Henry Moore's art that is too frequently glossed over and not clearly understood: his indebtedness to Picasso and Surrealism. Basically Moore is a surrealist sculptor whose work develops from the bone paintings that Picasso created in the late twenties and early thirties. These works, which frequently depict female nudes with pelvises forming their heads, call to mind strange and unsettling dreams. In his sculpture Moore frequently uses the same open forms that Picasso painted; in the process he gives rise to profound surrealistic images dealing with intimacy—private worlds, helmets, protective personae, and relationships between beings who open up some aspects of themselves as they close others from view. Although *Leaf Figure* does not deal with open and closed space, it is concerned with intimacy, imagination, and metamorphosis, and it reveals a knowledge of Picasso's Greek-inspired ceramic sculptures. *Leaf Figure* also relates to an important series of paintings by André Masson in which ants and praying mantises take on human characteristics. *Leaf Figure* is a minor masterpiece; its diminutive scale is a reflection of its intimate subject matter.

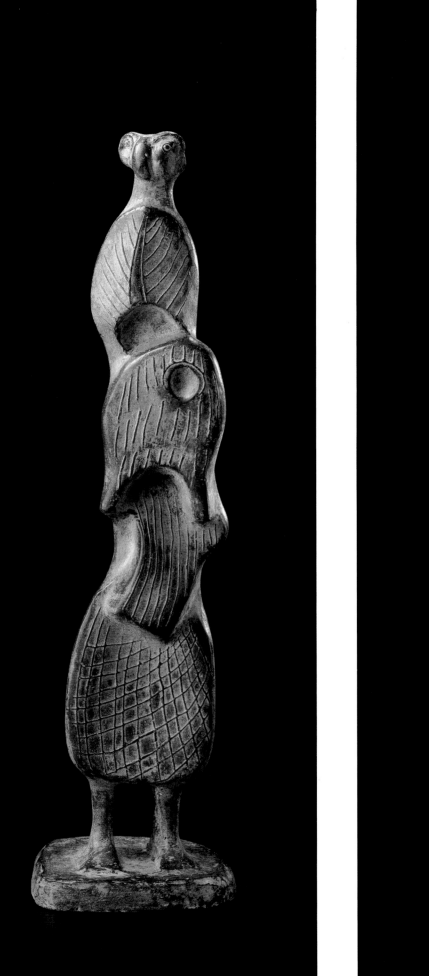
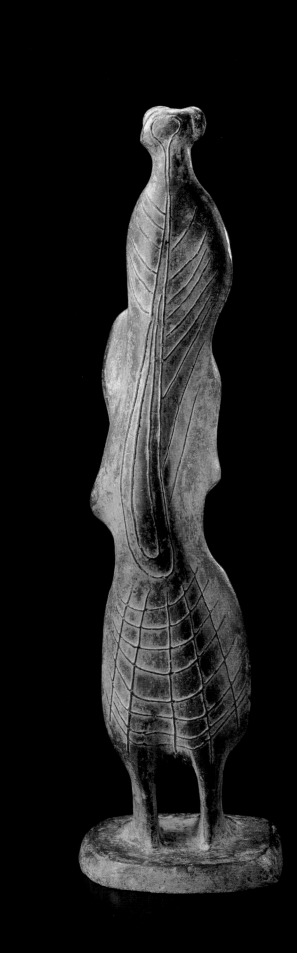

Louise Nevelson
American, born in Russia in 1900

Voyage *1975*
Cor-ten steel with black paint,
30' × 9' × 5'7" (9.1 × 2.7 × 1.7 m)
Purchased with University building funds, a grant from the National Endowment for the Arts, a grant from the Measurement Research Foundation, and other gifts through The University of Iowa Foundation; and gift of the artist, 1978.86

Voyage is an adventure in space, a reconciling of touch with vision. The arrangement of forms constituting *Voyage* is replicated in miniature so that people can feel with their hands the shapes they see above them. This sculpture becomes almost sublime at night when one reads the small composition and intuits the enlarged forms soaring above. In the course of looking, touching, and intuiting, the black shapes become enormous shadows, dark reflections of space.

Nevelson extols the merits of black, which she sees as the merging of all colors. To her it does not of necessity suggest death or mourning any more than white connotes life. Referring to herself as an Architect of Shadow, she has said: "Shadow is fleeting . . . and I arrest it and I give it a solid substance. I think I gave it as strong a form as the material object that gives me the shadow . . . probably stronger. More valid. And that satisfies me . . . that a shadow can have the weight and form of other things. I arrest it and I give it architecture as solid as anything can be." Louise Nevelson, *Dawns and Dusks: Conversations with Diane MacKown* (New York: Charles Scribner's Sons, 1976), 127.

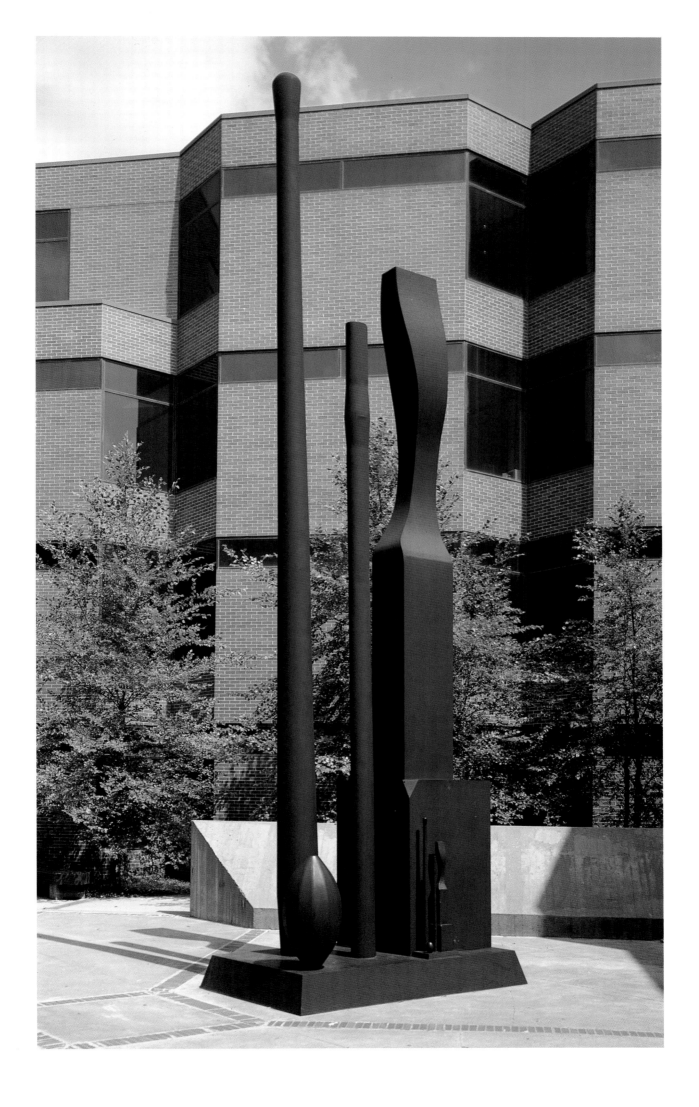

Isamu Noguchi
American, born 1904

Joy *c. 1960*
Anodized aluminum,
69½ × 36 × 15 (176.5 × 91.4 × 38.1)
Gift of Dorothy Schramm, 1982.63

In his sculpture Isamu Noguchi combines aspects of Eastern and Western art. From the East he has taken a feeling for the essence of specific materials, a reverence for gardens and stone, and, as is evident in *Joy*, a respect for the traditional arts of folding and cutting, origami and kirigami. He began to use surrealist forms in the 1940s in intersecting, anatomically suggestive silhouettes that served as vaguely human armatures for overlapping, bone-shaped forms. Remnants of these surrealist sculptures are apparent in *Joy*, in which the heavy materials and formal concepts of the earlier pieces are transmuted into a gracefully arching shape.

In the East a form is never considered to be isolated from space. In painting it is usual for artists to refer to the space surrounding a form and to determine if it has "spirit." Although such a concern with negative space, as it is called in the West, is not unknown, it is not a major focus. *Joy* is important not only for the bowing silhouette that it offers, but also for the ways that it endows the space around it with force and allows that space to become an active negative that cuts through the sculpture.

In the 1940s Noguchi reflected on the meaning of space in his work:

"The essence of sculpture is for me the perception of space, the continuum of our existence. All dimensions are but measures of it, as in relative perspective of our vision lie volume, line, point, giving shape, distance, proportion. Movement, light, and time itself are also qualities of space. Space is otherwise inconceivable. These are the essence of sculpture and as our concepts of them change, so must our sculpture change.

"Since our experiences of space are, however, limited to momentary segments of time, growth must be the core of existence. We are reborn, and so in art as in nature there is growth, by which I mean change attuned to the living. Thus growth can only be new, for awareness is the ever changing adjustment of the human psyche to chaos. If I say that growth is the constant transfusion of human meaning into the encroaching void, then how great is our need today when our knowledge of the universe has filled space with energy, driving toward a greater chaos and new equilibriums.

"I say it is the sculptor who orders and animates space, gives it meaning."

Isamu Noguchi, *A Sculptor's World* (New York: Harper and Row, 1968), 28.

In the East, unlike the West, artists create feelings, not objects; what is left out and only suggested is as significant as what is stated. *Joy* is as much a statement as a reaction, as much an assertion of the significance of space as it is a statement about the suggestiveness of form.

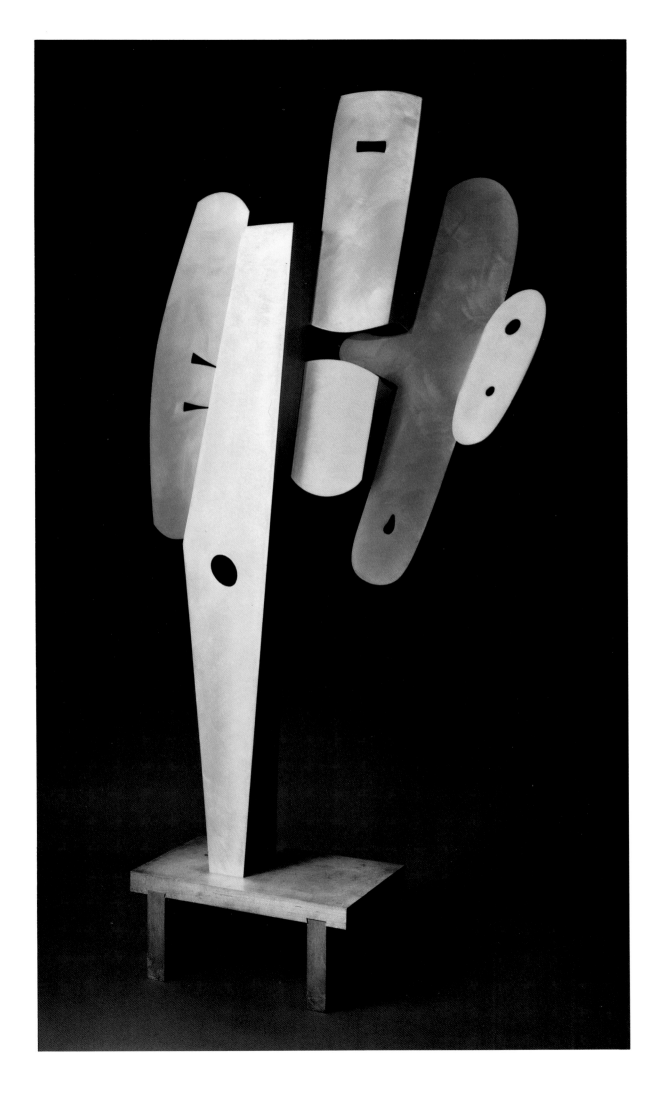

George Rickey
American, born 1907

Four Rectangles Oblique
Variation II *1972–75*
Stainless steel, wind-powered,
H 8′ 3″ to 9′ (251.5 to 274.3)
Museum purchase, 1978.42

An industrially fabricated sculpture, *Four Rectangles Oblique* looks like a machine. Conceived in polished metal, it rotates with the wind, and in the process it shimmers in the sunlight and radiates (pun fully intended) a positive attitude toward modern technology. Rickey's importance rests in his ability to make technological progress believable after almost two centuries of industrialization and one-third of a century of high technology.

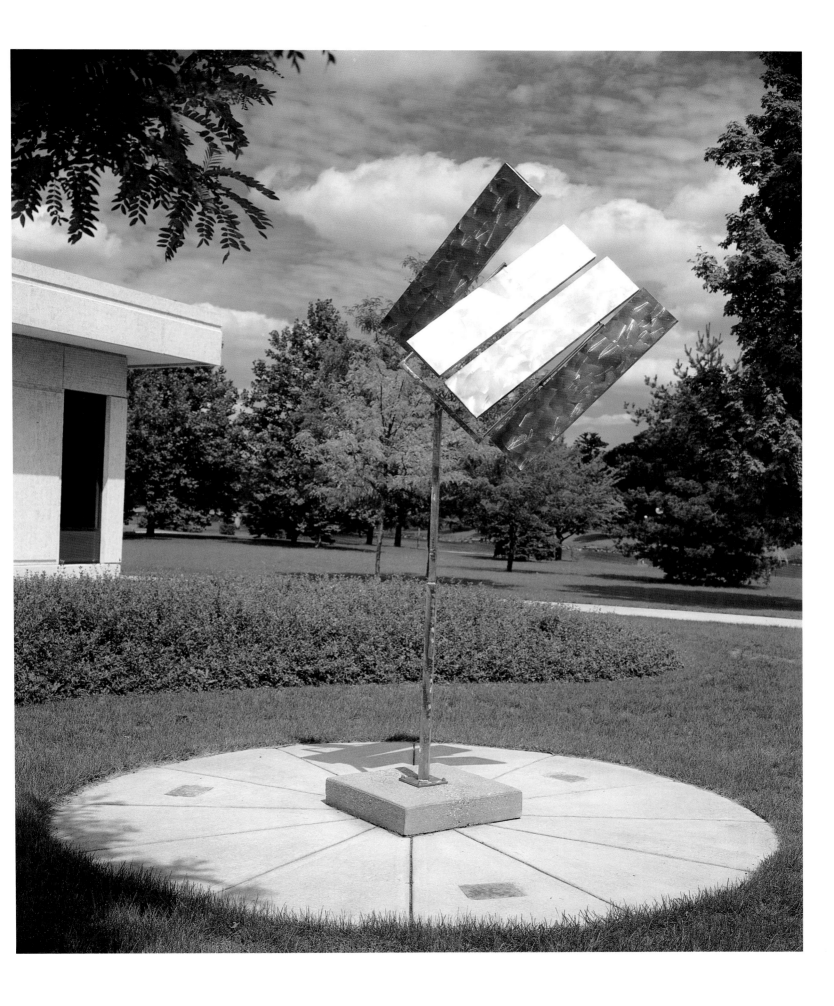

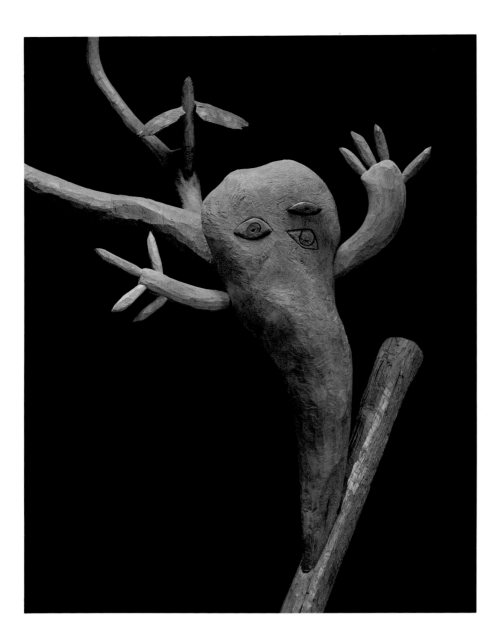

James Surls
American, born 1943

Timbers cross in hearts of men, sway aloft in whispering wind *1977*
Oak, sweet gum, and walnut,
76 × 61½ × 55 (193.0 × 156.2 × 139.7)
Museum purchase, 1985.31

In *Timbers cross in hearts of men, sway aloft in whispering wind* Texas artist James Surls has made a metaphor of creation and destruction. The tree stump, all that remains of the traditional symbol of the tree of life, is attacked by an ax; and the spirit of the wood from which the ax was made cries out in anguish when it realizes that it has a hand in the destruction of its own kind. To reinforce the tree spirit image, Surls has allowed its ghostlike form to sprout branches and the branches to form buds in the form of fleeing birds. Surls employs three kinds of wood in this piece to heighten the narrative and to demonstrate that all woods are part of the same life force and that all nature suffers in the wanton destruction of any one part of it. The destruction of trees provided material for the sculpture. Choosing not to view his medium as inert and unimportant before his transformation of it into art, Surls regards his material as filled with a life force and a meaning that he must respect and sustain in the work of art.

The symbol of the tree of life has a long tradition. It was important in the Middle Ages and in the Renaissance, especially when it became associated with Christ and the cross, and was an important image for such artists as Piero della Francesca and Michelangelo.

"Religions exist everywhere," Surls has reflected. "I don't really know that I encompass any of them. I do know that I am a religious person. I look for that sort of soft moment. You can't dwell there all the time but it sure helps keep the rest of your life in check. And I believe that art is healing. Why is it healing? How are you expecting to help the spectator? I'm expecting to help them because I'm going to give them an introspective view of themselves by looking at my art, using the art as a springboard, a springboard to what? Well, maybe it is a springboard to some kind of spirituality." Interview with Sue Graze, October 1984, in *Visions, James Surls, 1974–1984* (Dallas: Dallas Museum of Art, 1984), 28–29.

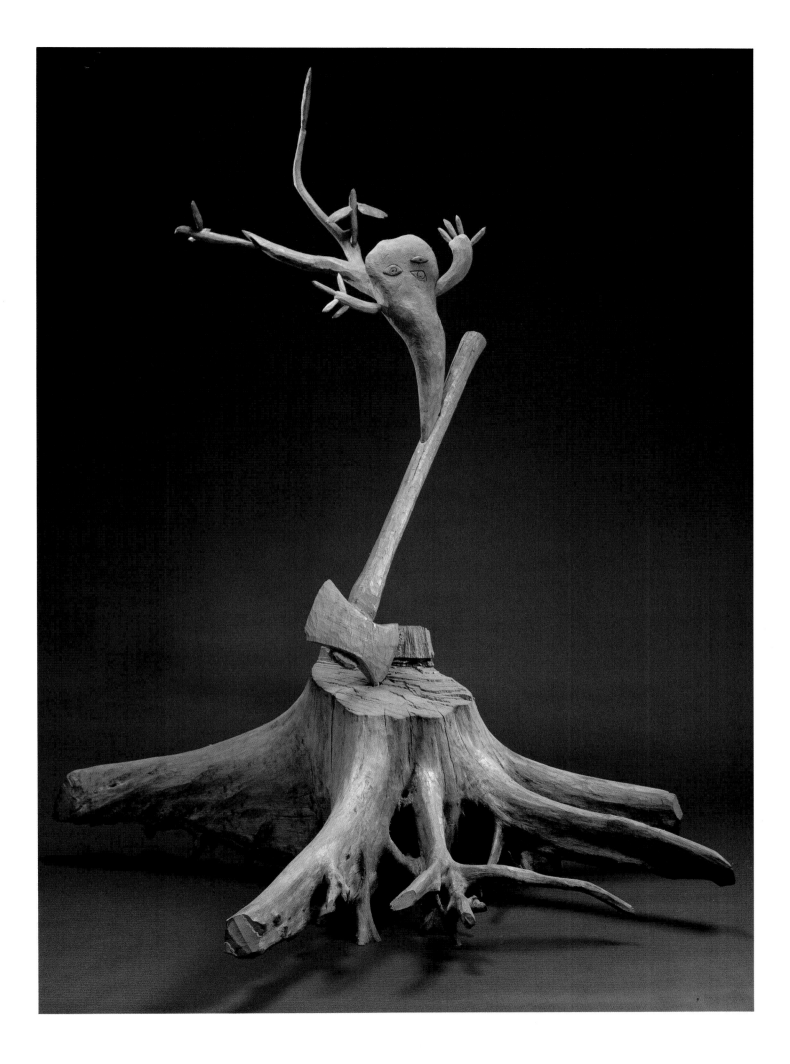

Paul De Lamerie

English, born in France, 1688–1751

Soup tureen 1747–48
Silver, 10⅞ × 18¼ × 11 (27.6 × 46.4 × 27.9)
Gift of Owen and Leone Elliott, 1969.58a–c

The son of a French officer who apparently fled France for religious reasons, Paul De Lamerie arrived in London when he was only a year old. At age fifteen he was apprenticed to the Huguenot silversmith Pierre Plattell, and fourteen years later, in 1717, he entered his first hallmark, signifying his independence as a recognized goldsmith. Within three years De Lamerie was appointed goldsmith to the King of England. De Lamerie's French connection enabled him to assimilate and to excel in the Rococo style, which had first appeared in the French court when an elaborate playhouse for the granddaughter of Louis XIV was created in a playful, miniaturized version of the Baroque. By 1726 De Lamerie was in full command of the Rococo idiom, and in the late 1730s and early 1740s he was one of its greatest exponents in metalwork.

Bearing the arms and coronet of George, First Baron Anson, the soup tureen in the Museum of Art sustains the high point of De Lamerie's Rococo period and combines it with a conceit aimed to compliment Anson. The handles partially cover lions' heads, and the cover of the tureen is surmounted by a large bird of prey eating a rabbit while it holds a bird in its talons. This bird of prey, perhaps an eagle, pays homage to the grand spirit of Anson and his family, who consume the broth placed in this vessel, while the animals and plants that decorate its surface, such as sheep, deer, waterfowl and other birds, and grain and corn, refer to possible ingredients for soup or stew. The tureen is both playful and ceremonial; it testifies to the grandeur of eighteenth-century taste and to the refinements accorded objects whose function is to sustain the purely secular ritual of superb domestic living.

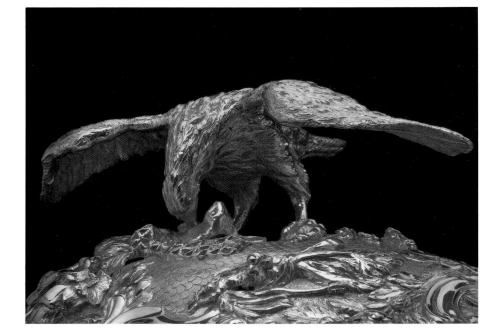

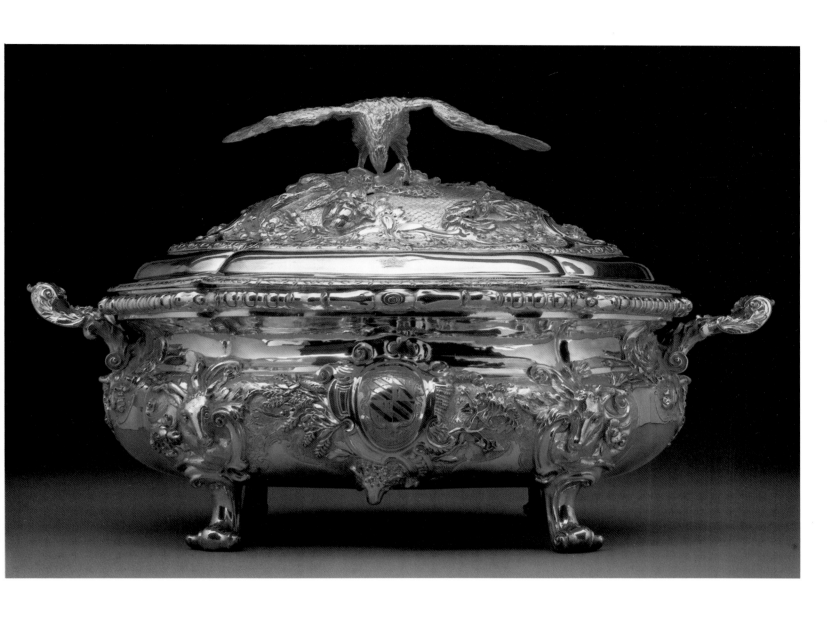

W H [Maker's mark]
English, active in London c. 1660

Charles II porringer with cover *c. 1660*
Gilded silver, 6¼ × 7¾ × 5¼ (17.1 × 19.7 × 13.3)
Gift of Owen and Leone Elliott, 1969.95a,b

Most likely this cup was intended for drinking hot beverages or perhaps some sort of porridge of a drinkable consistency; the cover would keep the beverage warm. In the seventeenth century both posset and caudle were popular, and both beverages may have been drunk out of this cup. Posset is made by curdling milk with ale or vinegar, caudle by mixing oatmeal and spices with wine, ale, or brandy. A white wine and tea caudle that also contained eggs and spices was generally administered to pregnant women.

The term "Charles II" is not a stylistic designation; it is merely a convenient way of indicating the time this piece was produced. Charles II reigned from 1660 to 1685. The gilding of this object may have taken place at any time after its creation; and an engraved message was added more than a century later: "Thanks to God 5 June 1810."

On both the bottom of this porringer and its rim inventory marks indicate that this piece belonged in the nineteenth century to the Earl, Duke of Cumberland, uncle of Queen Victoria, who selected him to become King of Hanover. Most likely this piece was included in the royal collection of silver, part of which the Earl took with him when he left England.

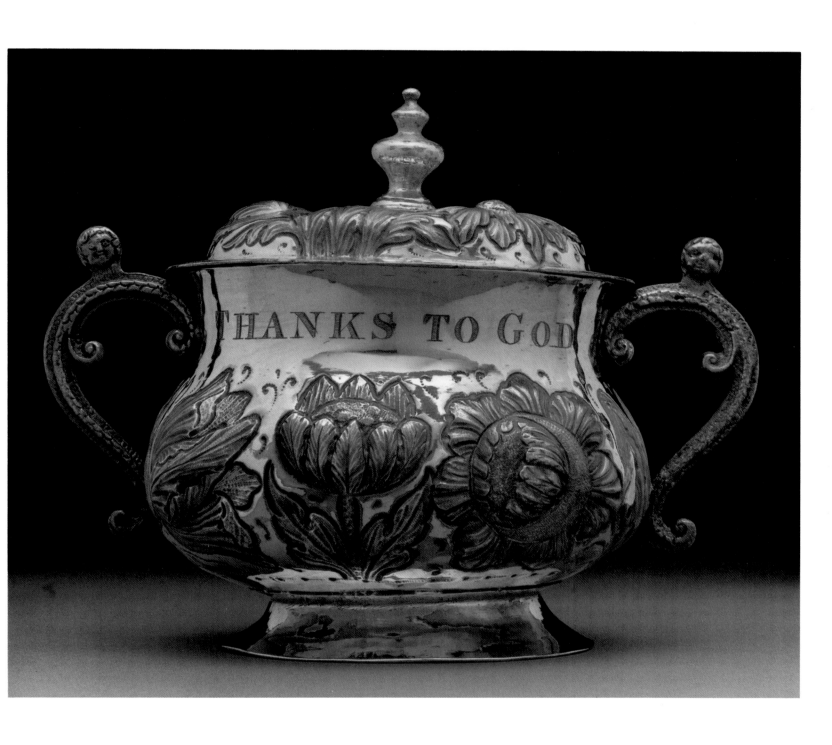

AFRICA AND THE AMERICAS

Africa

Mesoamerica

North America

South America

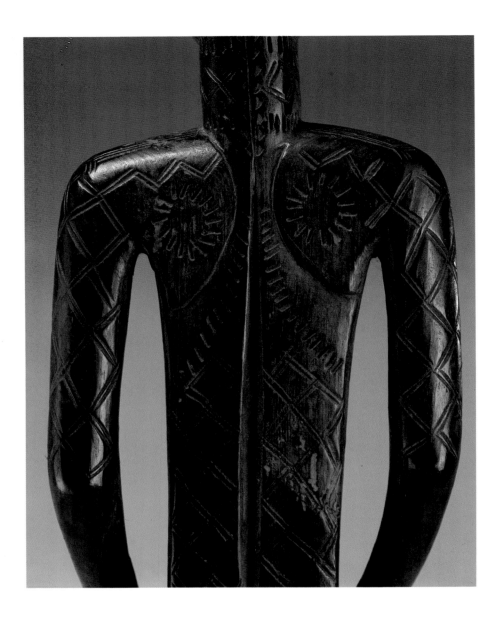

Africa
Bamana (Bambara), Mali, Western Sudan

Female figure
Wood and textile, H 23 (60.3)
The Stanley Collection, CMS 485

Figures like this are made by the Bamana for use by young male initiates in the *Jo* society. They are called *nyeleni*, and are carried from village to village by the initiates to show off their newly achieved status. Because blacksmiths are most frequently the sculptors in Bamana society, the young initiates from blacksmith clans carry beautifully carved figures in their performances. The wooden figures are placed on the dance area and are also held while dancing. The figures are jokingly referred to as the "girlfriends" of the young men, and the cloth and jewelry increase their attractiveness. These sculptures are usually lavishly ornamented with beads, metal rings, loincloths, and head ties, and have incised scarification marks covering the torso, chest, arms, backs of the legs, and face.

The style of this figure, with its sagittal crest and the heart-shaped face with protruding mouth, bears a strong resemblance to the northern Senufo sculpture style and indicates that it was carved by a Bamana artist in southern Mali, where Senufo cultural influences are particularly strong. The area in which the *Jo* society is found extends to the Ivory Coast border, where contact with the Senufo is likely.

C.D.R.

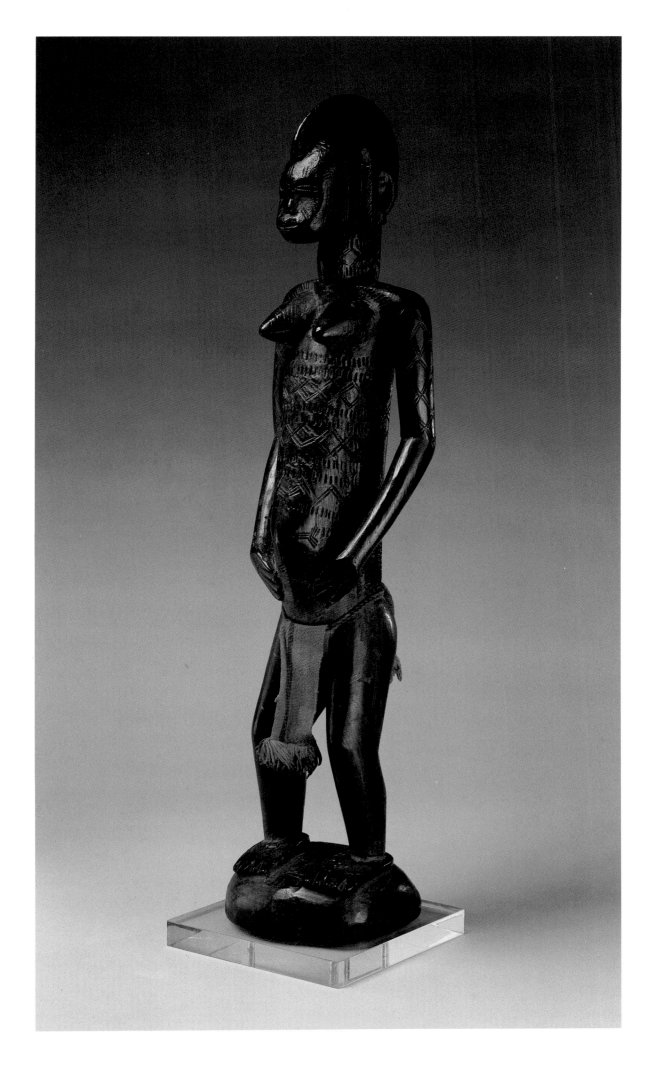

Africa

Senufo, Ivory Coast, Western Sudan

Face mask
[*kpeli-yëhë* or *kodöli-yëhë*]
Wood, H 14 (34.9)
The Stanley Collection, CMS 579

Masks of this type have been called *keplie* in the past, a French version of the Senufo *kpeli-yëhë*, which means "face mask." Face masks represent the female element, in contrast to the male helmet masks, in funeral performances involving Senufo blacksmiths. These are not intended to be naturalistic portraits, but the delicate details and the skill of the dancer are intended to express Senufo ideals of female beauty. A female mask of this sort is sometimes paired with a male helmet mask, and is called the "girlfriend" or "wife" of the male masquerader. Anita Glaze, *Art and Death in a Senufo Village* (Bloomington: Indiana University Press, 1981), 127–32.

With its broad, flat, curving horns, bulging forehead, and long, bovine snout, this face mask looks very much like a buffalo. In Poro symbolism the buffalo, *noo*, is very important— only a slight tonal change distinguishes the words for "mother" and "buffalo." Poro initiates are thought of as children of the "Ancient Mother"; as a result, buffalo masks and horns are very important iconographic elements among many Senufo groups. Anita Glaze in Susan Mullin Vogel, *For Spirits and Kings: African Art from the Paul and Ruth Tishman Collection* (New York: Metropolitan Museum of Art, 1981), 41–42.

This *kpeli-yëhë* is unusual for the severe simplicity of its forms, contrasting strongly with the cluttered, busy surfaces of most Senufo face masks.

C.D.R.

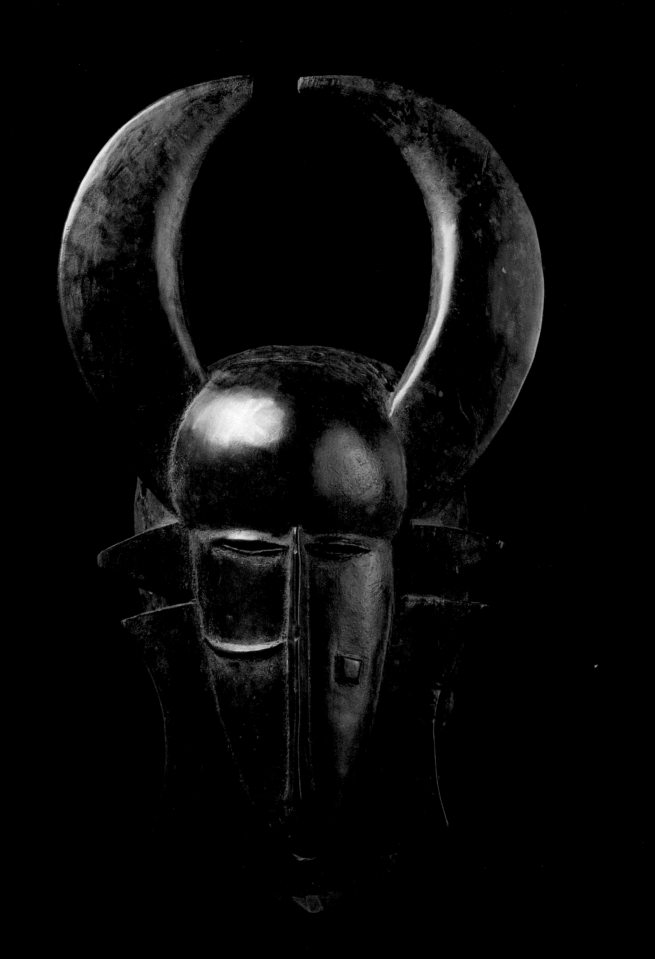

Africa

Kota-Obamba, Gabon, Equatorial Forest

Reliquary guardian figure
[*mbulu*]
Wood, brass, and copper, H 17 (43.2)
The Stanley Collection, CMS 507

The Kota are one of several Central African groups of the Equatorial Forest area who produce sculpture intended to be placed on woven bags or bark barrels containing important ancestral relics. The figure protects these relics from malevolent forces of witchcraft.

The metal that covers the figure was kept brightly polished by its owners, so that it would shine from the darkness of the ancestral hut when illuminated by firelight. The metal was cut from brass and copper pans obtained in trade with Europeans on the coast.

This figure was once in the collection of jazz musician George Gershwin, who was fascinated with Afro-American rhythms and African sculpture.

C.D.R.

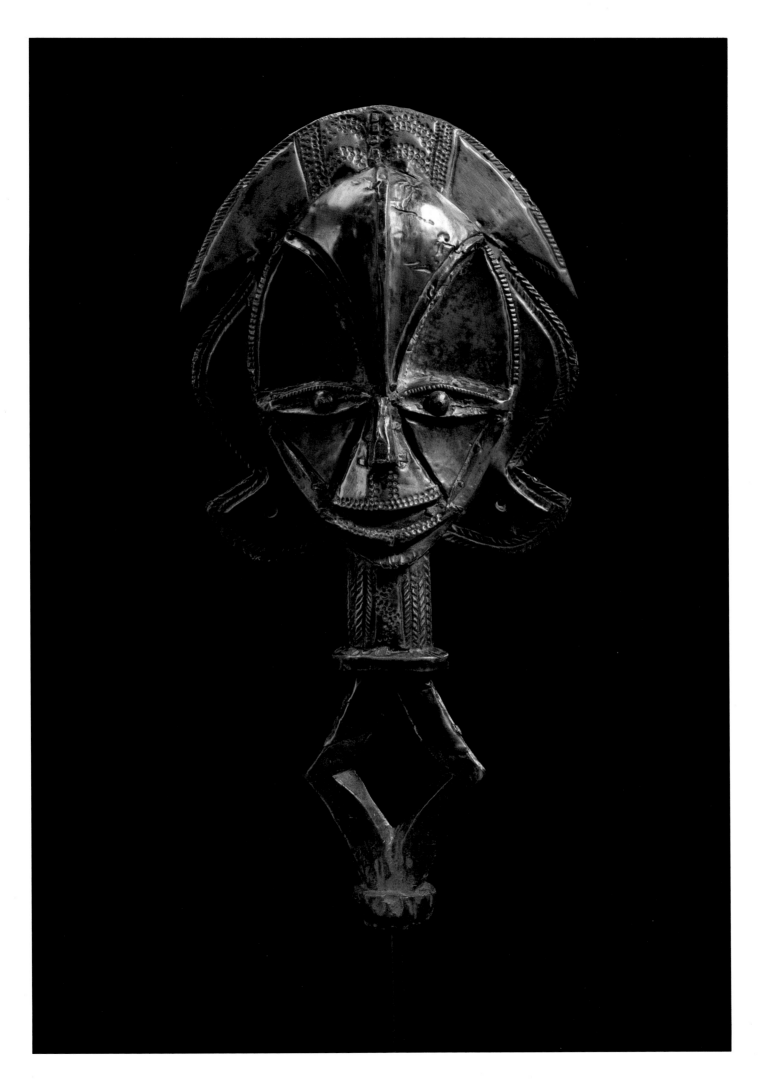

Africa
Lega, Zaire, Equatorial Forest

Mask
[*kayamba*]
Wood and fiber, H 22 (55.9)
The Stanley Collection, CMS 589

The Lega live in eastern Zaire, just west of the northern end of Lake Tanganyika. They do not have a system of chiefs or other hereditary rulers. Instead, political organization is provided by the *bwami* society, which has several grades. All men aspire to work their way upward from the lowest grade, through a series of initiations, to the two highest grades. Very few ever reach the highest level. The goal of membership in *bwami* is moral perfection, taught or symbolized by proverbs, dances, and objects.

Wood masks are used by members of the second-highest grade of the *bwami*. A mask can be displayed on the ground, in the palm of the hand, over the forehead, on the back or side of the head, or on an arm or leg, or it can be hung on a fence. The meaning of a particular mask depends on how it is displayed.

This mask may be of the rare type called *kayamba*, also used in the rites of the second-highest grade. Such masks are not individually owned but are stored in communally owned baskets, and they represent a clever and shrewd person. According to Daniel Biebuyck, they may also be used in pairs to represent a confrontation between Kabimbi, the Clever One, and Kalulunga, the Liar. *Lega Culture: Art, Initiation, and Moral Philosophy among a Central African People* (Berkeley and Los Angeles: University of California Press, 1973), 214.

This object is certainly unusual, even for the Lega. The back is perfectly flat, with no eye-holes. There was once a raffia beard, but most of the fiber is gone. The facial features are restricted to a small area high on the face, with an enormous chin beneath. The incised patterns between the bases of the horns are not characteristic of the Lega.

C.D.R.

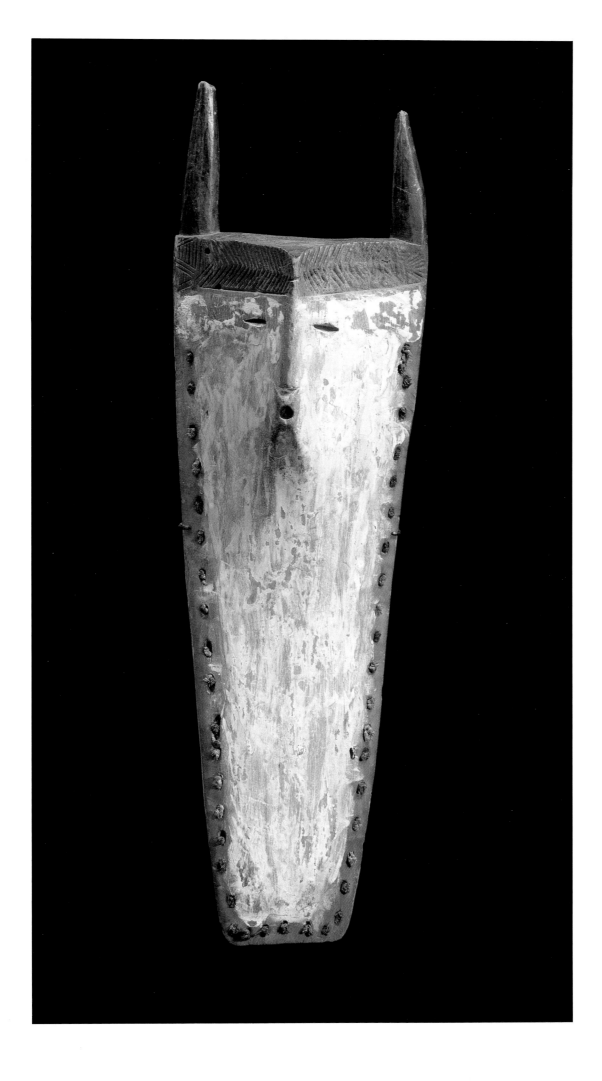

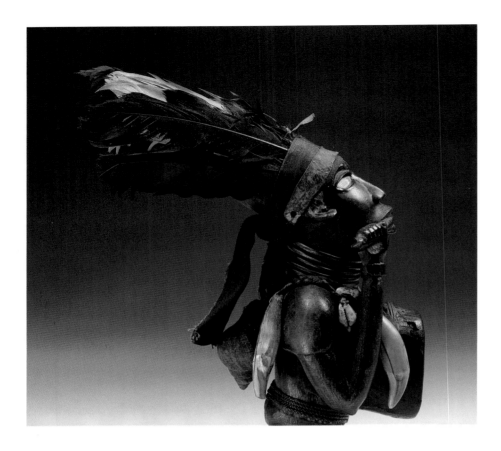

Africa
Kongo, Zaire, Southern Savannah

Magical figure
[*nkisi*]
*Wood, feathers, glass, metal, animal teeth, shell, and
cloth, H 11½ (29.2)*
The Stanley Collection, CMS 508

Ethnic groups throughout the Southern Savannah style area are linked by the common use of objects like this figure, which has been given magical curative or destructive powers in the form of effective materials selected by a ritual specialist. These materials may be placed in a horn that projects from the top of the head, in a rolled snakeskin belt or necklace, or in a cylindrical resin container that projects from the abdomen and is sealed with a "mirror of mystic vision, indicating the ritual expert's power to see beyond the glassy surface of the river, or the sea [beneath which the underworld lies]—to penetrate the secrets of the dead." Robert Farris Thompson in Susan Mullin Vogel, *For Spirits and Kings: African Art from the Paul and Ruth Tishman Collection* (New York: Metropolitan Museum of Art, 1981), 210.

Such objects may act as positive or negative forces on behalf of the client, protecting his family from diseases and spells or from witches and thieves, and bringing confusion and death to his enemies. Such objects can be used by a client for a specific purpose and then be returned to the ritual specialist, who can then remove the magical materials and reuse the figure for another client.

This figure, which has accumulated a feather crown, metal anklets and collars, and several shells and leopard teeth, holds a medicinal plant to its mouth. The ritual specialist may chew this plant to produce a viscous green sap that he spews over his clients as part of the healing ritual. The spiral shell is an important Kongo symbol of the continuity of life and the perpetual cycle of birth and death.

C.D.R.

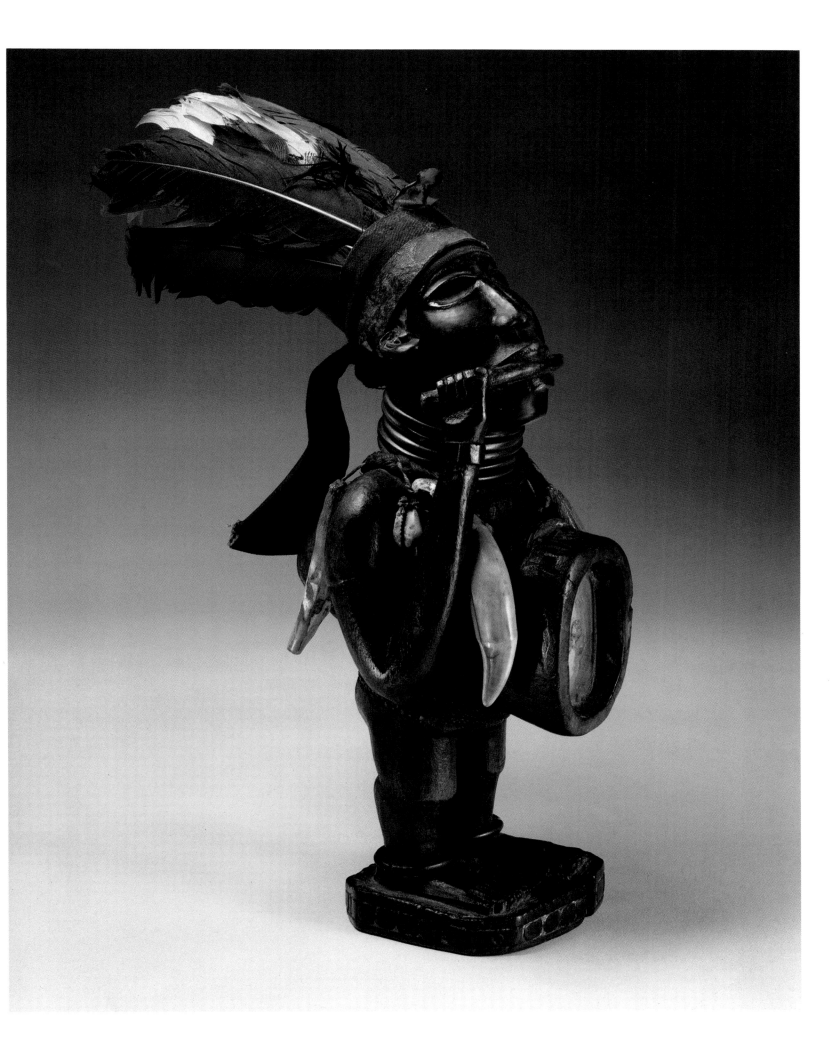

Africa

Pende (eastern or Kasai), Zaire, Southern Savannah

Magical figure
[*nzinda*]
Wood, shell, horn, cloth, and beads, H 40 (102.3)
The Stanley Collection, CMS 505

Like other groups across the Southern Savannah from the Atlantic to the Great Lakes, the Pende produced magical figures that were given power by the addition of materials prescribed by a diviner/ healer called *ngongo*. This figure, in the style of the Kasai Pende, was called *nzinda* and was a powerful magical fetish used in divination. Heavy cords were attached to both arms to permit it to deliver oracles: in the darkness of its hut it would lean either to the left or to the right. It was said to be able to transform the bullets of the white colonial forces into water, and it could indicate the number of warriors the village should send into battle against the whites by making marks in the sand with the horn attached to the top of its head.

All of the five known Kasai Pende figures share the long, triangular nose with protuberant, almost conical eyes. The arms are bound with heavy cords, and each figure has a turtle shell suspended at the waist. A heavy horn containing magical materials projects from the top of each head, and all the figures are colored red. The figure in the Stanley Collection had been kept wrapped in paper in an attic in Belgium since the 1930s; as a result, the bright red pigment with which it was covered has been preserved.

C.D.R.

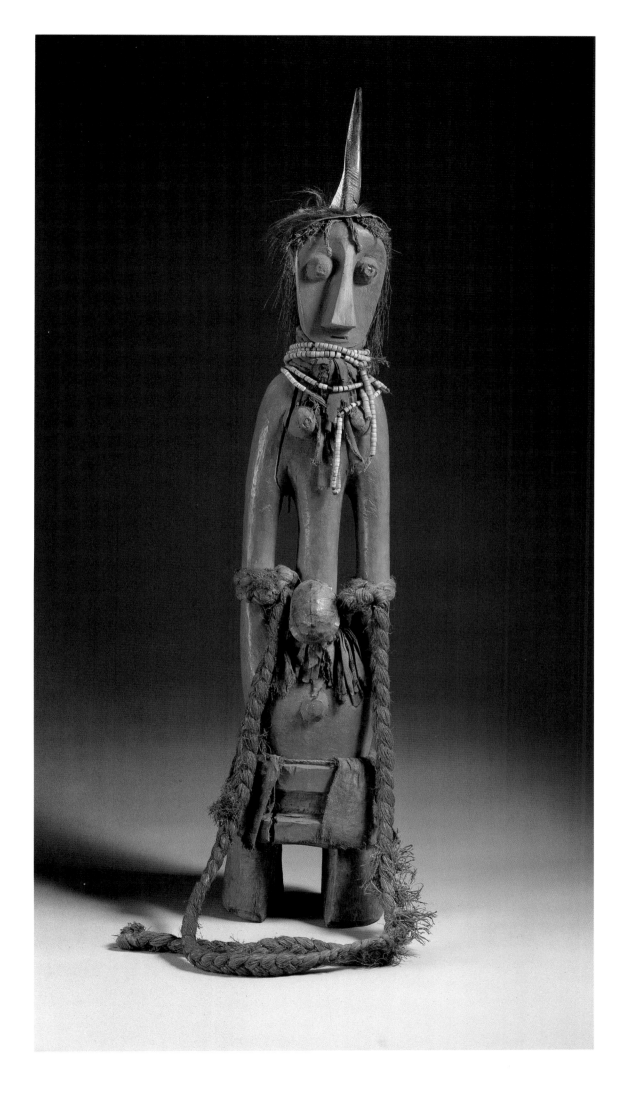

Africa

Lwalwa (Lwalu), Zaire, Southern Savannah

Male mask

[nkaki]
Wood and pigment, H 11½ (29.2)
The Stanley Collection, CMS 525

Among the Lwalwa, masks of four types are used in the ceremonies of a society that is responsible for the initiation and circumcision of young men. Both male masks and female masks are worn by men in dances that are intended to pacify the spirits of the human victims required for entrance into this secret society. Each performer commissions the mask type that he prefers from the carver, who may often be the village chief and who organizes the mask dances.

Of the type called *mvondo*, this male mask was once held in place on the wearer's face by a cord that passed through the hole beneath the nose and was clamped between the teeth. This piece is remarkable for the care given to the geometric patterns in the coiffure, for the fine definition of the features of the face, especially the nose, scars, and mouth, and for its very fine, smooth surface. The simple yet powerful composition, with a diamond-shaped face bisected vertically by the nose and horizontally by the eyes, represents the best of African sculptural expression.

C.D.R.

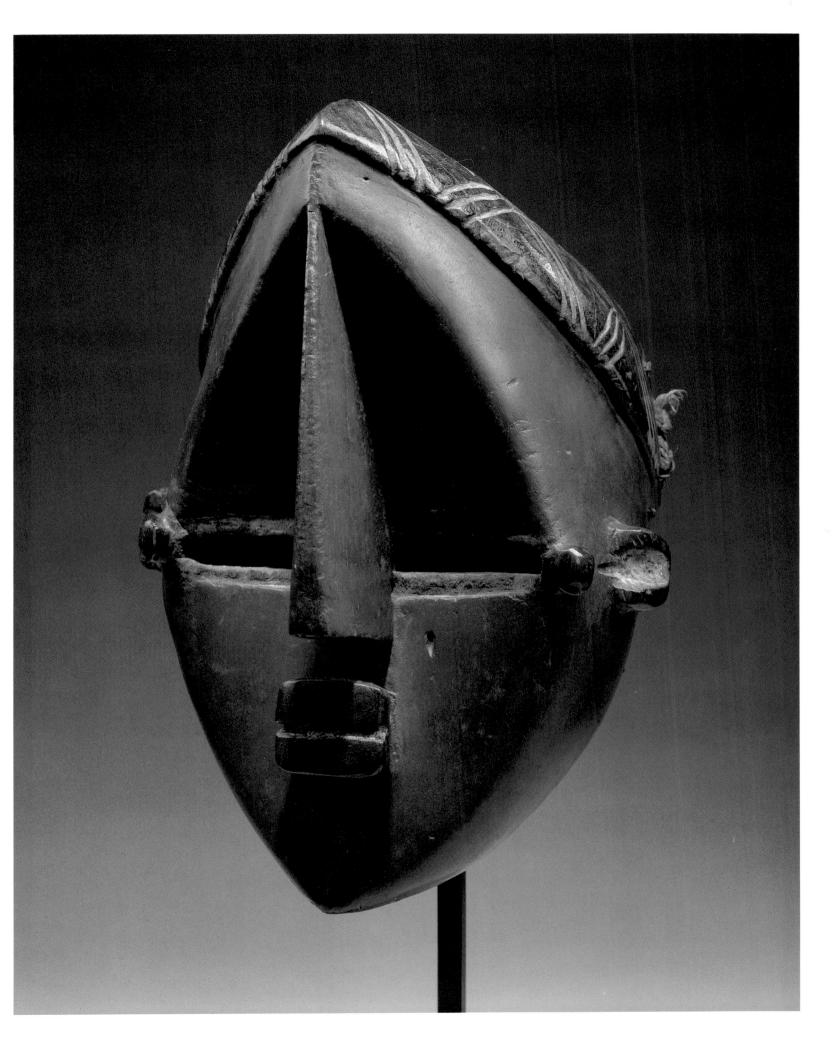

Africa
Luba, Zaire, Southern Savannah

Royal stool
Wood, H 15 (37.5)
The Stanley Collection, CMS 457

The nineteenth-century Scottish explorer V. L. Cameron reported that when a Luba chief dies, "a woman is placed on her hands and knees, and upon her back the dead chief, covered with his beads and other treasures, is seated, being supported on either side by one of his wives, while his second wife sits at his feet." *Across Africa* (London, 1877), 2: 333.

One writer has concluded from these descriptions that "the figure represented on [Luba] stools is not literally either a slave or a person of high rank, but is instead a compound symbol, which refers to a founder of a tribe or a family. Among the matrilineally-oriented BaLuba, the function of the stool can be seen quite clearly to be that of a symbolic statement of the continuance of power." Jack D. Flam, "The Symbolic Structure of Baluba Caryatid Stools," *African Arts*, 4: 2 (1970), 56–57.

This beautiful small stool was collected at the end of the nineteenth century by Cecil Rhodes, the English founder of the colony of Rhodesia, and was given to the captain of the steamship on which Rhodes returned to England. The ship captain's daughter, who sold the stool at auction a few years ago, remembers it from her childhood as her father's footstool. The helmet shape of the face and the heavy scarification on the body indicate that it was produced by the Luba Shankadi. The shapes that surround the base and seat are stylized cowrie shells, symbols of the wealth of leadership.

C. D. R.

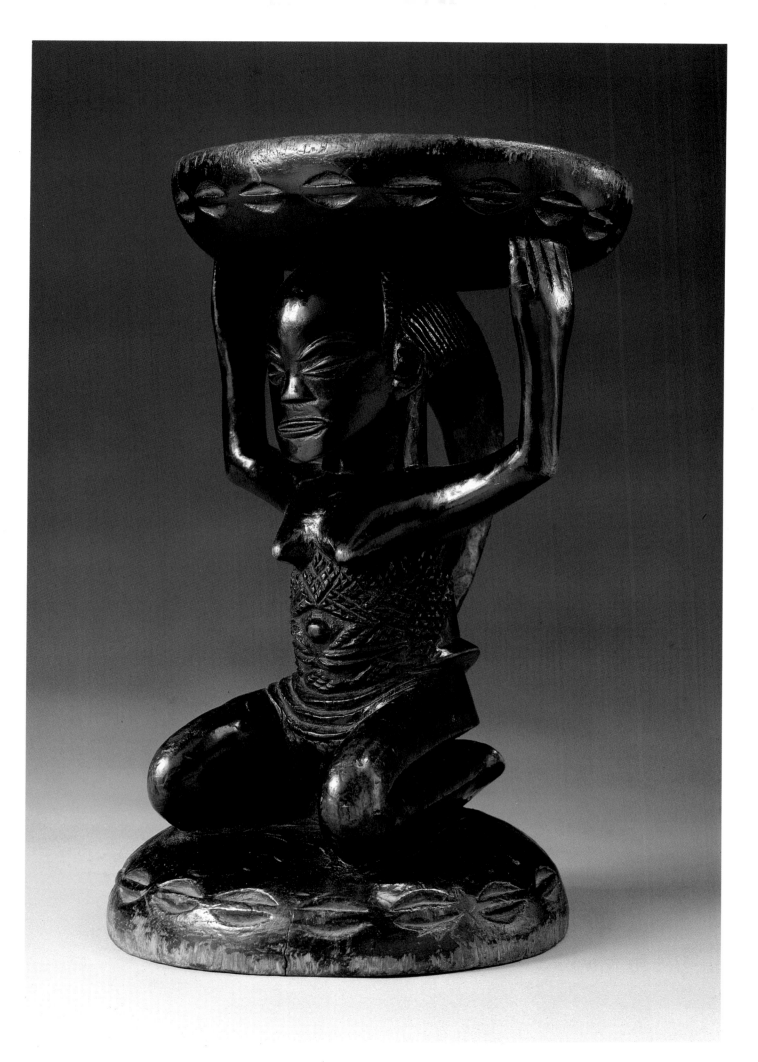

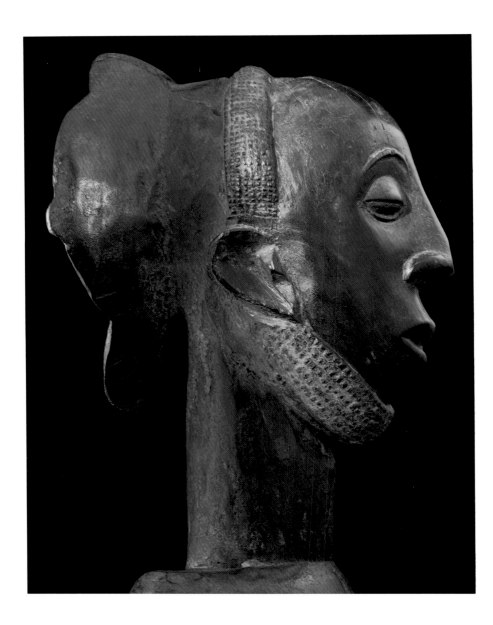

Africa
Hemba, Zaire, Southern Savannah

Male ancestor figure
[*singiti*]
Wood, H 29 (73.7)
The Stanley Collection, CMS 313

This serene and dignified figure was carved in the southern Hemba area, between the Lualaba River and Lake Tanganyika. Figures from this area are characterized by an ovoid head, an elongated neck, a large, swelling abdomen, and squared shoulders. The delicate eyebrows are crescent-shaped, and the eyes are almost closed, contributing to the impression of composed serenity. Since the explorations of Robert Livingstone and V. L. Cameron in the late 1870s, the Hemba have been known for their complex and beautiful hairstyles, built up in a cross form at the back of the head with oil, red powder, and a framework of raffia.

The Hemba place wooden ancestor figures, called *singiti*, in small huts that protect the figures from the elements. Many of these huts contain several figures. "The figure expresses the dependence of the world of the living on that of the dead—and is thus a funerary and religious symbol—and indicates the ownership of the land and the possession of social authority, both of which are based on the organization of clans and lineages. Even the wood out of which many of these figures are carved, *iroko*, possesses a religious significance." François Neyt in Susan Mullin Vogel, *For Spirits and Kings: African Art from the Paul and Ruth Tishman Collection* (New York: Metropolitan Museum of Art, 1981), 217.

C.D.R.

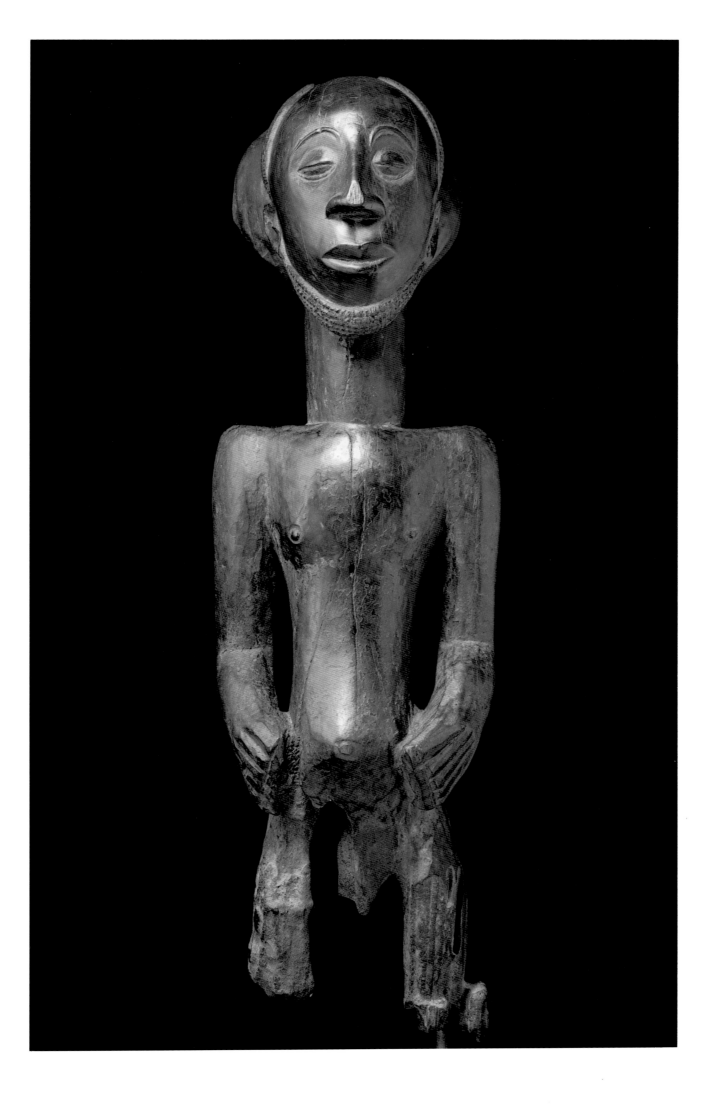

Mesoamerica
Mezcala, Guerrero, Western Mexico

Figure 300 B.C. – 300 A.D. (probable)
Mottled brown stone, H 6⅝ (16.8)
Gift of Webster and Gloria Gelman, 1972.45

Mezcala burial sculpture comes from a region south of the Balsas River in the Mexican state of Guerrero. Most likely this type of abstract figurative sculpture was used by a particular cult, since it is found in burial sites and appears to derive from the forms used for stone ax heads. The perpetuation of this ax form as a schema for human figures suggests that the figures may relate to some type of ax cult, or to a view of the ax as symbolic of supernatural power. The use of red paint to delineate the eyes of this figure may also have a symbolic meaning, perhaps related to blood or the sun.

This piece of sculpture was painstakingly made, first by chipping and pecking the stone, then by slowly grinding and polishing it.

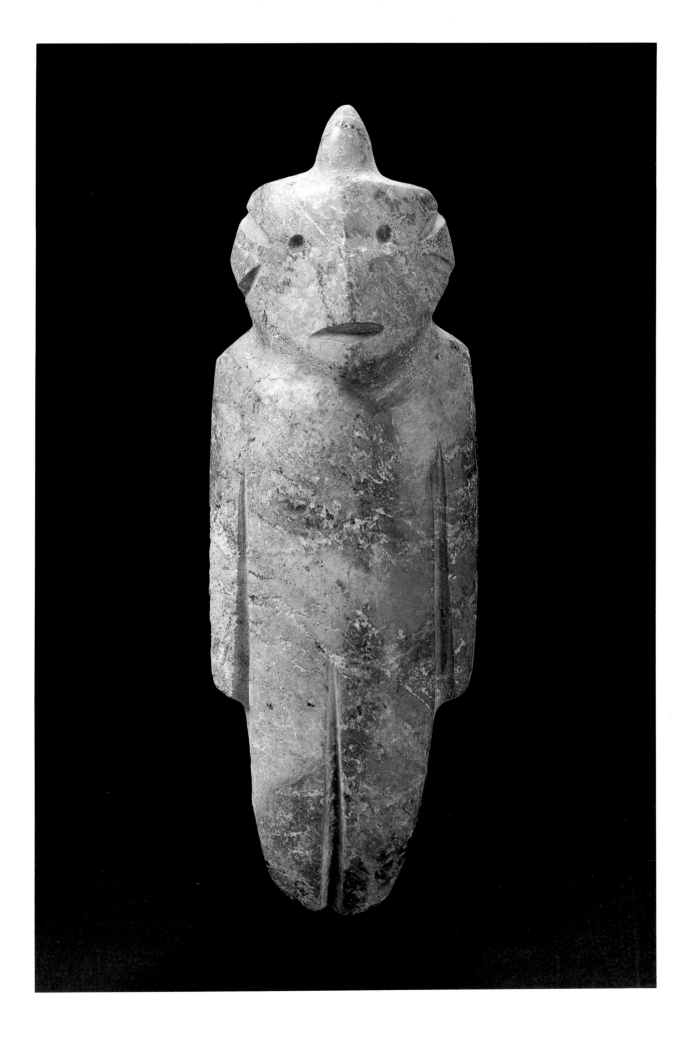

North American Indian
Ojibwa, Woodland / Great Lakes

Bandolier bag *c. 1865*
Cotton cloth, glass beads, and wool yarn,
38¼ × 11 × ½ (97.2 × 27.9 × 1.3)
Gift of Kathleen E. S. Wild, 1980.154

Bandolier bags may have first developed from European shot pouches or from functional native bags used by travelers needing to transport provisions quickly. Usually worn over the shoulder and diagonally across the chest by men, these bags were used in many parts of North America and were considered to be essential decorative accessories. They were particularly important for Great Lakes groups. This bandolier bag, which is distinguished by its small-scaled pouch, fine geometric pattern, and subtle interplay of harmonious designs on the strap and pouch, most likely dates from the 1860s.

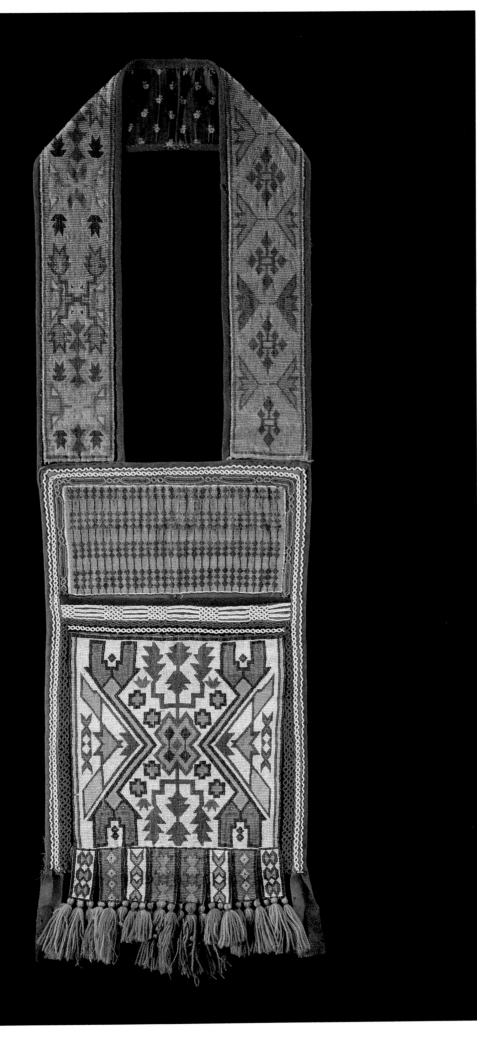

North American Indian
Navajo, Southwest

Rug *c. 1885*
Wool, 85½ × 62½ (217.2 × 158.8)
Promised gift of Webster and Gloria Gelman

Fascinated by the commercial aniline-dye yarns available after 1870 from Germantown, Pennsylvania, Navajo weavers expanded their repertory of designs. By the 1880s they were creating intricate patterns that incorporated both closely aligned hues and striking value contrasts. These complex pieces became known as "eye-dazzlers."

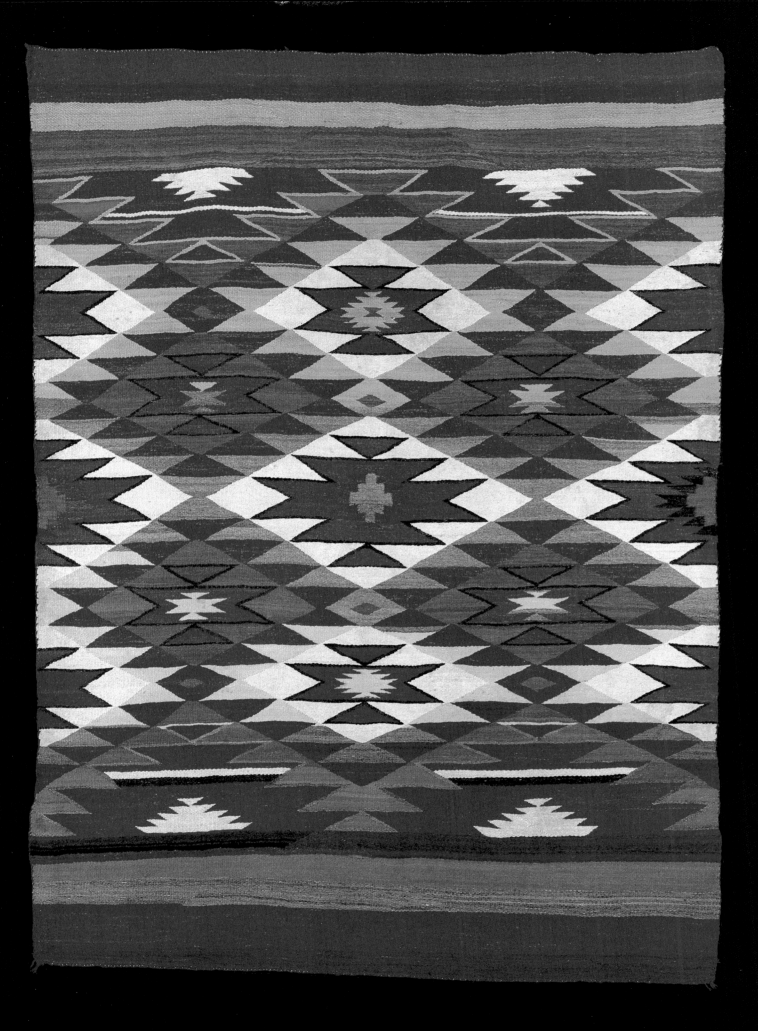

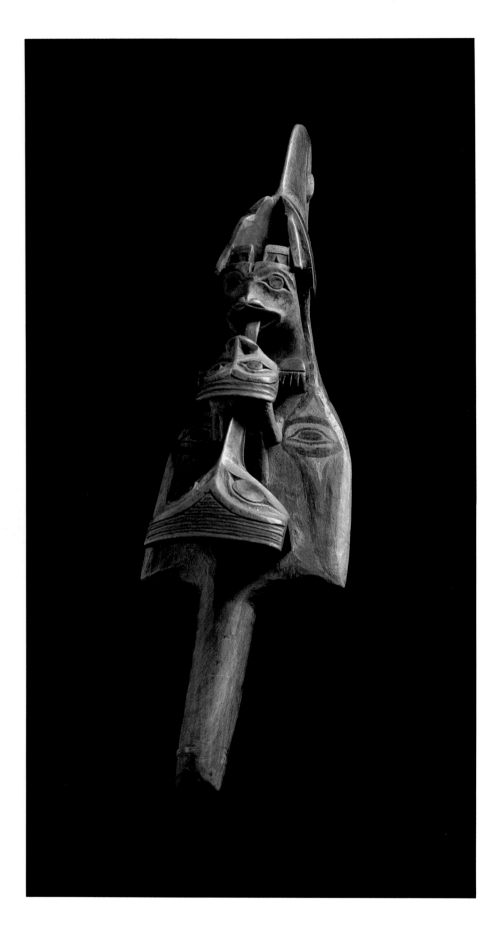

North American Indian
Tlingit, Pacific Northwest Coast

Shaman's rattle *c. 1875*
Polychromed wood,
13⅝ × 3⅝ × 4½ (34.6 × 9.2 × 11.4)
Museum purchase, 1971.200

Raven rattles are thought to have originated among the Tsimshians, a Northwest Coast tribe, but their use was widespread among many groups from this area by the end of the nineteenth century. This rattle is in the form of a raven in flight, with the body of a hawk carved on its breast. It is likely that the figure resting on the back of the raven represents a human, and that the joining of his tongue to that of a frog symbolizes a transference of spiritual power.

The Great Shaman of the First Times, Raven is revered as both creator and trickster. He liberated the sun from the underworld and discovered humanity in a clamshell, but his black color and scavenging habits associate him with the underworld. Raven is both positive and negative, a power to be reckoned with and appeased. And the shaking of his rattle activates his power.

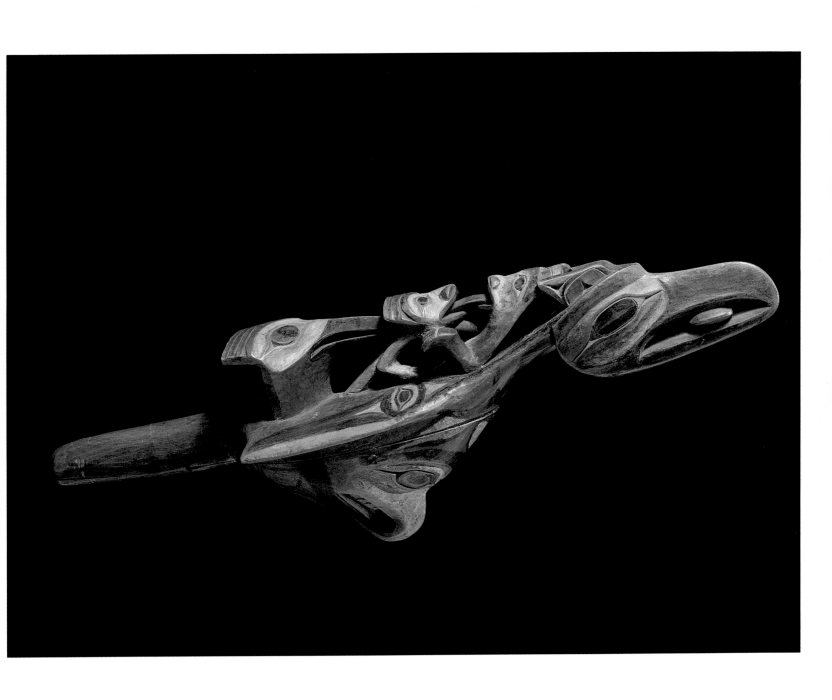

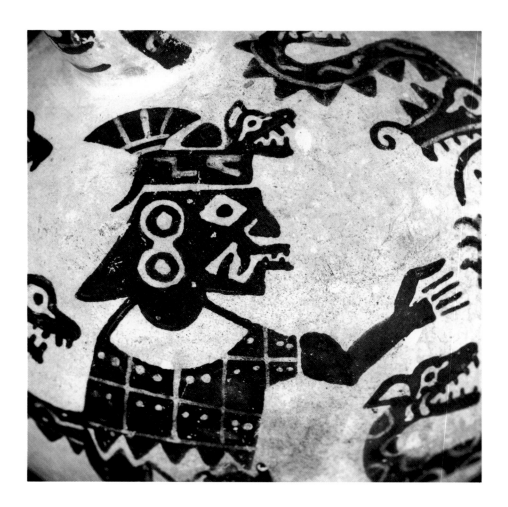

South American Indian

Moche culture, north coast of Peru

Stirrup-spout bottle *c. 350–650 (Mochica III)*
Slip-painted fired clay, 7¹⁵⁄₁₆ × 5⁹⁄₁₆ (20.2 × 14.1)
Gift of Mr. and Mrs. Raymond Wielgus, 1960.11

The Moche culture occupied the river valleys on the dry northern coast of Peru from about 100 B.C. to 800 A.D. The Mochica pottery style is characterized by a large, spherical body and a stirrup-shaped spout, in which two curving tubes join to form a common spout. Most artifacts from the Mochica have been found associated with human burials, usually of high-ranking people who were interred with rich offerings of cloth, jewelry, and pottery.

This pot is remarkable for its complex slip-painted decoration, including a large, fanged figure with a tail and a crest that end in serpents' heads. The second figure appears to be human, but it too has a serpent tail and wears a crown with a reptile head. The anthropomorphic figure may represent a deity that descended from the mountains to the coast to teach man the techniques of farming and craft production. He watches over villages, protecting them from disasters represented by the fanged beast. Moche art is noted for combining natural and supernatural forms into visual puns in which a tail turns into the body of a serpent.

C.D.R.

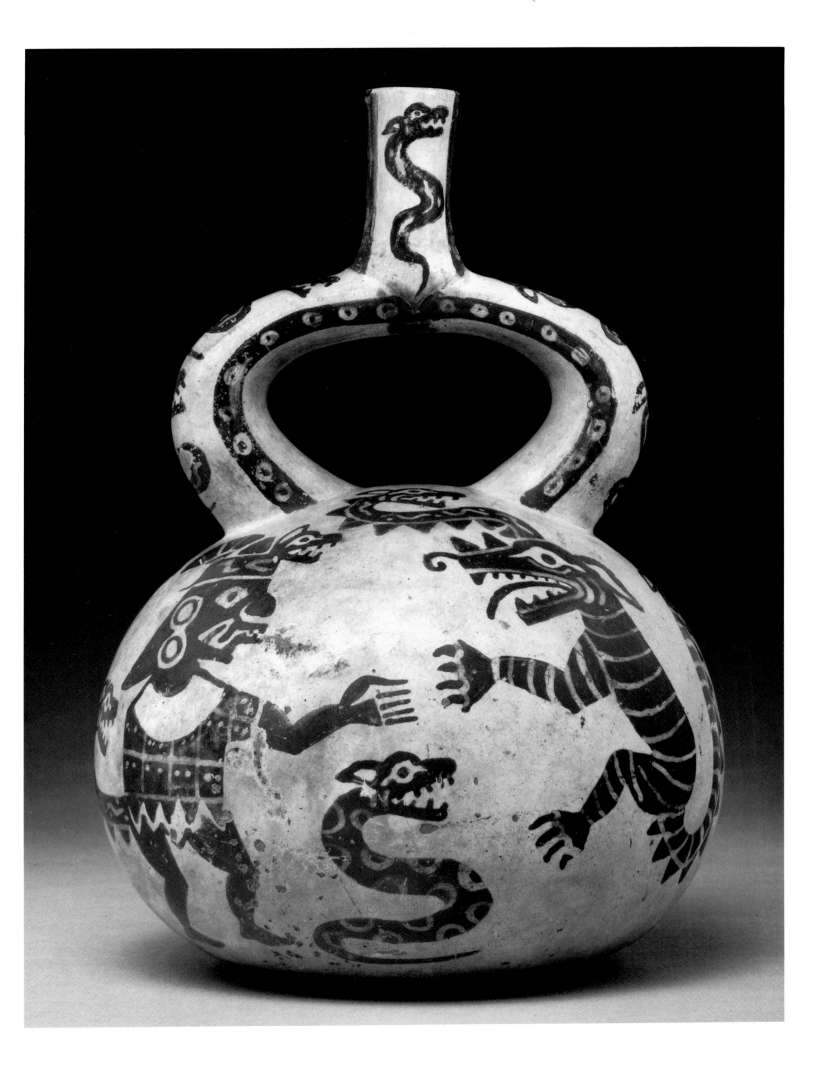

Index

Credits

COLOR PHOTOGRAPHY *by C. Randall Tosh except pp. 48, 49, and 123, by Quesada-Burke, New York; pp. 78 and 79, by Steve Sloman, New York; and p. 83, by Prudence Cumming Assoc. Ltd., London.*

BLACK-AND-WHITE PHOTOGRAPHS *by Steve Tatum except pp. 31, 35, 135, 158, 159, 167, and 220, by Mark Tade; and frontispiece, by Gary Jones.*

DESIGNER: *Joyce Kachergis, Joyce Kachergis Book Design and Production, Bynum, N.C.*

RESEARCH ASSISTANT AND COPYEDITOR: *Gail Parson Zlatnik*